Art Directors' Workbook of Type Faces

THIRD EDITION

In addition to the 75 featured type faces shown in full font on double-spread pages, as well as 940 one-line specimens, this new edition includes a supplement of 16 modern and traditional faces reflecting strong current typographic favorites, as well as a special section of modern photo-lettering designs.

ARCO PUBLISHING COMPANY, INC., 219 PARK AVENUE SOUTH, NEW YORK, N.Y. 10003

Art Directors'

WORKBOOK OF

TYPE FACES

For Artists, Typographers, Letterers, Teachers & Students

J. I. BIEGELEISEN

Introduction by Robert L. Leslie

Book designed by the author

Third Edition, 1976

Copyright © J. I. Biegeleisen, 1963, 1970, 1976

Published by Arco Publishing Company, Inc.

219 Park Avenue South, New York, N. Y. 10003

Printed in the United States of America

Composition by The Composing Room, Inc.

Library of Congress Cataloging in Publication Data

Biegeleisen, Jacob Israel, 1910–
 Art directors' workbook of type faces.

 First ed. published under title: Art directors' work
book of type faces; 2nd ed., under title: Art directors' book
of type faces.
 Includes index.
 1. Printing—Specimens. 2. Type and type-founding.
I. Title. II. Title: Workbook of type faces.

Z250.B56 1976 686.2'24 76-17128
ISBN 0-668-04041-6 (Flexible Binding)

In this age of specialization it is rare to find a man whose interests and talents are as wide in scope or in depth as those of my good friend and associate

BEN CLEMENTS

to whom this book is affectionately dedicated

CONTENTS:

Page

1 | **INTRODUCTION**
by Dr. Robert L. Leslie

2 | **ABOUT THIS BOOK**
A note to the reader to explain why and how this book originated—what its purpose is and how this purpose is achieved.

4 | **INDEX OF 75 FEATURED TYPE FACES**
A listing of the 75 featured type faces, arranged alphabetically for easy reference.

6 | **INDEX OF 16 SUPPLEMENTARY TYPE FACES**
A listing of 16 type faces, some traditional as well as modern favorites in today's advertising typography.

7 | **FACTS ABOUT TYPE AND TYPOGRAPHY**
Questions asked and answered to help clear up many puzzling aspects of the point system, type identification, etc. Also an explanation of the major type setting systems, copy fitting methods, and the structure and anatomy of type forms.

27 | **PRESENTATION OF FEATURED TYPE FACES**
Each of the 75 type faces is presented in jumbo size and in a complete font, with a facing page which shows reduced sizes superimposed on a self-measuring pica scale. A detailed analysis points out the uses and identifying characteristics of each type face.

179 | **PRESENTATION OF SUPPLEMENTARY TYPE FACES**
Each of the 16 type faces is presented in jumbo size and in a complete font. Among the type faces shown are traditional faces as well as current favorites.

199 | **PRESENTATION OF MODERN PHOTO-LETTERING**
A sampling of typographic designs showing use of photo-lettering styles set up in words.

215 | **DIRECTORY OF STANDARD TYPE FACES**
A showing of 940 body and display type specimens arranged alphabetically.

239 | **GLOSSARY OF TERMS**
A short definition of words and terms which comprise the special language of the typographer.

245 | **STANDARD PROOFREADERS' MARKS**

246 | **TYPE IDENTIFICATION AID**

247 | **TYPE FACE CLASSIFICATIONS**

INTRODUCTION

The most important feature of this book is the systematic approach undertaken by Mr. Biegeleisen in presenting a library of typefaces with such clarity and consistency. The book contains over 800 typefaces but only 75 have been featured for large viewing and analysis. This selection represents a good one from the practical point of view of the typographer, artist and layout man. Each featured typeface is shown in its entirety from A to Z and in jumbo size, so that it may be clearly studied, analyzed, copied or traced. In addition—and this is a most helpful feature—there is a thorough analysis of each type in terms of its design origin, characteristics and practical uses. A unique self-measuring pica scale tells at a glance the casting width of 6 or 7 sizes of each typeface shown, in a graduated reduction scale.

Mr. Biegeleisen comes well qualified by professional background and personality to prepare a work of this kind. He is a highly skilled technician in lettering and typography and is a born teacher. He knows how to organize his subject matter and present it clearly and systematically. Until his recent retirement, he headed the art department of one of the most important art high schools in the world, the High School of Art and Design, a school I have the privilege of serving in the capacity of Chairman of the Advisory Commission.

Mr. Biegeleisen has written several other books which have during the course of years become the standard texts in the field. His book, *The A B C of Lettering* has been widely acclaimed as the basic workbook on hand lettering and has had five editions and numerous printings since 1940 when it was first published.

I predict that this book too will in time become the basic book in the field.

DR. ROBERT L. LESLIE

Chairman, Planning Committee, New York University
Center for Publishing and the Graphic Industries
Chairman, Advisory Commission,
High School of Art and Design

ABOUT THIS BOOK

The idea of a book of this kind has been germinating in my mind for many years. During the course of my long association with the High School of Art and Design, both as classroom teacher and department chairman, I have observed and sympathized with the problems that students in typography invariably encounter in their search for large, clear specimens of current typefaces. This is also the identical problem which confronts many professional typographers, layout artists and designers. Their needs have not been completely met by published books of type specimens or by printers' brochures, one-line type sample sheets, type cards or other heterogeneous material issued by printers and composing rooms. There are of course a number of excellent privately issued specimen books, but they are in most cases expensive and not easily available.

There are a number of fine scholarly books on typography in existence which, although of inestimable value and inspiration to the researcher and typophile, make no consistent attempt to present complete alphabets from A to Z. A mere sampling of a few letters is often used to demonstrate some salient feature of the alphabet structure. Other books fail to display the letters of the alphabet in a size large enough to graphically dramatize the subtle differences which distinguish one typeface from another. Often several unrelated typefaces are quite arbitrarily crowded on one page without regard to consistency of presentation or organization. Still others do not make any attempt to arrange the typefaces in graduated point sizes. And too few books present a detailed analysis of the outstanding characteristics or the commercial applications of each typeface.

These and many other shortcomings of commercially available books have prompted the author of this present volume to make a very conscientious effort to integrate in one book the following practical features:

The letters of the alphabets are shown in complete fonts from A to Z. No letters are omitted. The companion lower case is also shown in its entirety in all faces which have a related lower case.

The letters are printed in jumbo size. In order to readily reveal the fine nuances which make each typeface unique, all alphabets are presented as large as they will comfortably fit on the page, without regard to actual point size. Even those faces which are cast no bigger than 36 points are here enlarged so that their structural characteristics can be the more easily distinguished and, if needed, traced by the user of the book.

A written description accompanies each of the featured typefaces. "About This Typeface" tells about the designer of the face, the practical applications of the alphabet, as well as a rather detailed analysis of its characteristics. Attention is called to the specific recognizable clues which help to pin-point the identity of each face.

A range of graduated point sizes of each of the selected typefaces is shown superimposed on a self-measuring pica form. This serves as a comparison scale for relating the point size of the typeface to the measure or width of the alphabet.

Related information about each typeface includes the complete range of point sizes available, lists the "look-alikes" of related typefaces, and shows actual examples of the variations of each family of faces shown.

A "Directory of Typefaces" catalogues specimens of more than 800 typefaces in use today. This serves as a handy dictionary of faces, for easy reference.

Special section on contemporary photo-lettering alphabets created by America's leading lettering artists and designers; includes 16 pages showing a variety of inspirational job layouts produced with photo-lettering alphabets.

A simple, easy-to-read one-page Index of the 75 featured typefaces, arranged alphabetically makes it a simple matter to immediately locate the name of the type. This makes it unnecessary to wade through a complex system of type classification which is usually arbitrarily fixed by a particular author.

Basic information on typography is presented in an informal question-and-answer format. There is expository material on copy fitting as well as a comparative thumbnail analysis of photolettering and the more traditional typecasting systems.

The above is by no means intended to be a complete table of contents, but serves to point out some of the unique and salient features of this book which make it different (and, we hope, more practical) from any other book in the field.

And now a word about how and why the featured typefaces shown here were selected. A complete listing of all typefaces in existence would probably run into the thousands. It would not be feasible or even desirable to crowd them all into a collection which is primarily planned to serve as a practical workbook.

At the outset, the publishers and I agreed on a practical, workable limit of 75 basic typefaces, with special emphasis on those suited for advertising. The big problem was which ones were to be included and (to put it the other way) which ones were to be excluded. A long and extensive survey of current advertising and publications helped to single out the ones which were at last selected. This list I submitted to many of my colleagues in the profession—typographers, artists, art directors, letterers, etc. They substantially agreed on the basic list of 75 but each one had several personal "favorites" which to him should have been definitely included. The trouble was that the special "favorites" of one did not entirely correspond with those of another. I continued to make as many adjustments in the basic selection as I could without increasing or decreasing the quota of 75. The inevitable conclusion I finally arrived at was that it would be quite as impossible to unilaterally satisfy all diverse tastes and sentiments here as it would be in any other area involving aesthetics or judgment based on personal preference. Indeed, a number of typefaces I had included in my original list were selected not because they particularly reflect my own personal aesthetic preference or prejudices but rather because they are widely accepted as traditional typographic work horses quite regardless of their intrinsic design value.

However, after the book had seen several successful printings and minor revisions, everyone agreed that current typographical trends make it absolutely necessary to add additional type faces. This second edition, therefore, was enlarged by 16 pages to include a further 16 faces reproduced in jumbo size and complete font.

I hope that the reader will find most of his own personal "favorites" included in this collection, but be that as it may, he at least can be sure that he now has in his possession a well-organized workbook which includes a wide and varied assortment of practical typefaces to serve his needs as a typographer, layout artist, letterer, teacher or student.

To all those who have been so patient with my demands and so helpful in their criticism, many, many thanks. Special thanks to Mr. Arnold Shaw of The Composing Room, Inc. who has labored so tirelessly in the production of this book, and whose counsel I sought in the matter of format and styling. To Mr. Fred Honig, I express my appreciation for the active interest he has taken in this project, not merely as the editor of Arco Publishing Company, the publishers of this book, but as a well-informed typographer whose knowledge and good taste I deeply respect. To Mr. Abe Mazur, thanks for sharing with me the vast practical knowledge he has acquired in copy fitting as a supervisor of the O. B. Johnson Press, Inc. My sincere appreciation to Al Seymore who has assisted and advised me in the initial stages of this book and to Joseph Lombardo and Frank Ombres who have been so helpful with the many chores involved in the preparation and checking of the mechanicals. Special thanks to Mr. Edward Rondthaler and Photo-Lettering, Inc. for permission to reprint selected examples of photo-lettering designs. And most of all, to my wife, my heartfelt appreciation for so willingly and ably serving in the capacity of fellow researcher, typist, critic and sympathetic "listening post" during the many months it took to collate all reference material which evolved into the book as you see it today.

J. I. B.

INDEX OF FEATURED TYPE FACES

Page		Page	
28	**Airport Black**	66	Century Schoolbook
30	*Allegro*	68	Cheltenham Medium
32	Alternate Gothic No. 2	70	Chisel
34	*BALLOON EXTRA BOLD*	72	**Clarendon Bold**
36	*Bank Script*	74	Cloister Black
38	Barnum, P. T.	76	**Cooper Black**
40	Baskerville	78	COPPERPLATE GOTHIC HEAVY EXTENDED
42	*Bernhard Cursive Bold*	80	*Coronet Bold*
44	Bernhard Modern Roman	82	Corvinus Medium
46	*Bernhard Tango*	84	**Craw Modern Bold**
48	**Beton Extra Bold**	86	Dom Casual
50	BETON OPEN	88	Egmont Medium
52	Bodoni	90	**Egyptian** EXPANDED
54	*Bodoni Italic*	92	ENGRAVERS ROMAN
56	**Bodoni Ultra**	94	**Fortune Bold**
58	Brody	96	**Franklin Gothic**
60	*Brush Script*	98	Freehand
62	Caslon No. 540	100	**Futura Display**
64	*Century Expanded Italic*	102	Futura Medium

4

Page

104 Garamond

106 Goudy Old Style

108 Grayda

110 Grotesque No. 9

112 Hellenic Wide

114 HUXLEY VERTICAL

116 Kaufmann Script

118 Latin Wide

120 Legend

122 LIBRA

124 Lilith

126 Lydian

128 Lydian Cursive

130 Lydian Italic

132 Metropolis Bold

134 MICROGRAMMA NORMAL

136 NEULAND

138 News Gothic

140 Onyx

Page

142 Palatino

144 PROFIL

146 Radiant Heavy

148 Repro Script

150 Rondo Bold

152 Standard Medium

154 STENCIL

156 Stradivarius

158 Studio

160 Stymie Bold

162 Times Roman Bold

164 Torino

166 Tower

168 Trafton Script

170 Twentieth Century Ultrabold Cond

172 Typewriter

174 Venus Extrabold Ext

176 WEISS INITIALS NO. 1

INDEX OF SUPPLEMENTARY TYPE FACES

The following list of 16 type faces represents an addition to those featured in the main section of the book.

Included in this Supplement are several traditional type faces as well as a number of new designs which reflect strong current favorites in today's advertising typography.

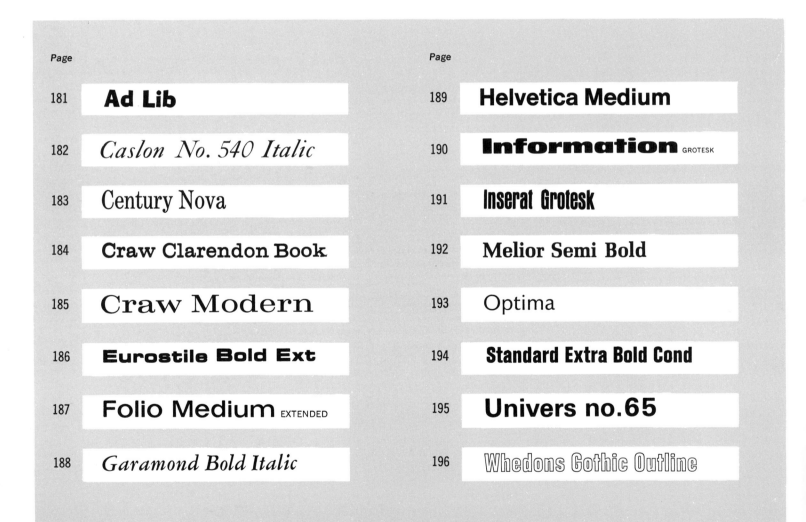

Page

181 **Ad Lib**

182 *Caslon No. 540 Italic*

183 Century Nova

184 **Craw Clarendon Book**

185 Craw Modern

186 **Eurostile Bold Ext**

187 Folio Medium EXTENDED

188 *Garamond Bold Italic*

Page

189 **Helvetica Medium**

190 **Information** GROTESK

191 **Inserat Grotesk**

192 **Melior Semi Bold**

193 Optima

194 **Standard Extra Bold Cond**

195 **Univers no. 65**

196 Whedons Gothic Outline

SUPPLEMENT OF PHOTO-LETTERING

Pages 199–212 show a variety of modern photo-lettering styles, set up in words.

FACTS ABOUT TYPE AND TYPOGRAPHY

FACTS ABOUT TYPE AND TYPOGRAPHY

At the outset it might be well for us to review some of the basic facts about type and typography as a check on the understanding of the fundamental concepts and direct references made throughout this book. But let us start off by first answering some of the most frequently asked questions which represent the diverse and often puzzling aspects of type and typography.

Why are points rather than inches used in printers' measurements?

Origin of the point system

Because type matter comes in a wide range of sizes which does not conveniently correspond to the fractional decimation based on the linear inch. If type were made in only a few evenly graduated sizes, then it would be easy enough to use fractional designations such as ¼″, ⅜″, ½″, etc. Century Schoolbook, for instance, comes in more than 15 different sizes from 6 to 72 points. It would be more cumbersome to express this array of varied sizes in terms of odd fractions of an inch than by means of the point system, devised specifically for typographic measurement.

Has the point system always been used for typographic measurements?

No, and there was a lot of confusion before the special point system was devised and adopted.

How then were type sizes designated before?

Typefaces used to be given individual designations by the various foundries who classified type sizes by such romantic (and quite arbitrary) names as Diamond, Agate, Nonpareil, Brevier, Great Primer, etc. The trouble was that these names were not always agreed upon nor clearly understood, and as a consequence, type issued by different foundries did not correspond in size. This made it impractical to mix types of the various foundries. It was not until 1886 that the American foundries nominated a committee to consider a type-measurement system based on points, which had been devised by a French typographer, Pierre Fournier, way back in 1737. In 1887, the Fournier system was adopted by the United States Typefounders Association and is today accepted throughout the United States and (with some deviations) throughout the world.

What is the relationship of one point to one inch?

Inches, points and picas

Roughly speaking, one point is 1/72nd of an inch, or to put it the other way, 72 points equal one inch. I said "roughly speaking" because actually 72 points measure only 0.9962 inch, or just a wee bit less than a full inch. This basic unit of 1/72nd of an inch is used in multiples to denote not only sizes of type but other typographic measurements as well. This includes leads, slugs, borders, rules, ornaments and other material used in a composing room.

Two questions. First: what is one pica in terms of one inch? Second: how did a pica measure get its name?

The answer to the first: one pica is approximately ⅙ th of an inch. As to the second question: a pica was the original name given to any 12-point type. We no longer use names to designate specific sizes of type, but the term pica has remained as a 12-point unit of measure.

And how does the term "pica" relate to "point?"

One pica is 12 points, or one point is 1/12th of one pica. *Pica* is the unit for designating the length or "measure" of a line of type, or the depth of a column of type, whereas the term *point* is used in relation to the type itself. For example, you say that the type is 30 *points* in size, but when referring to a line of printed type matter you say that the line measures 18 *picas* across. Expressed in terms of inches, one inch equals 6 picas. Thus a column of type matter which measures 3 inches across and 10 inches in depth would be designated as 18 picas (3 x 6) by 60 picas (10 x 6).

The following table summarizes this concept and will help to fix it in your mind:

1 point	= 1/12 pica	or approximately	1/72 inch
6 points =	1/2 pica	or approximately	1/12 inch
12 points =	1 pica	or approximately	1/6 inch
72 points =	6 picas	or approximately	1 inch

What is meant by agate line?

The term "agate line" is a measure of vertical space with special reference to newspaper and magazine advertising. There are 14 agate lines to one inch. In the early days of newspaper advertising, most ads were usually printed in very small type, pretty much like the personal and classified columns of today. Agate was the name of the small 5½ point type used for that purpose. It was the custom of advertisers in those days to crowd in as much copy as possible within a vertical column. A column of 14 lines of agate type took up about one inch in depth. Although today advertisers are no longer concerned with crowding so much matter into so little space, the "agate line" has persisted as a unit of measure with reference to the depth of a newspaper ad and the cost of advertising space in newspaper is computed on the number of agate lines. For instance, the cost of an ad three columns wide by 6 inches deep is computed on the basis of three columns by 84 (6 x 14) agate lines or a total of 252 (84 x 3) lines. If the rate is $2.00 per agate line, then the cost for this ad would be $504 (252 x 2).

What is the standard range of point sizes for typefaces—or is there a "standard"?

There is no "standard" size range which applies to all typefaces. Spartan Black, for example, comes in the following sizes (measured in points): 6, 8, 9, 10, 12, 14, 16, 18, 24, 30, 36, 42, 48, 60, 72, 84, 96 and 120. Lilith, on the other hand, is made only in five sizes (24, 30, 36, 48 and 60.)

Why aren't all typefaces made in the same number of sizes?

Simply because there is a greater demand for some faces than for others. Spartan Black, for instance, mentioned above, happens to be an extremely practical type which can be used for many occasions; Lilith, on the other hand, an exotic display face having limited application, is cut in fewer sizes.

I notice that when you listed the extensive range size of Spartan Black, the point sizes were mostly in even numbers. Is this true of all type size listings?

No, not quite. Some of the very popular typefaces, especially body text alphabets used for book and newspaper work, come in many odd sizes as well. Times Roman is a good example. This typeface is not only available in odd and even sizes, but is also to be had in fractional sizes such as 4½, 5½ and 6½ points. As the demand for a type increases new sizes are added to the list and these are not necessarily all even numbered.

What does the term "em" mean?

Meaning of em, en, and other space terms

Actually this word has two meanings. Before the point system was adopted, a piece of 12-point type was commonly referred to as "pica." A "pica em" always meant the space occupied by the 12 point letter M. Since the body of a Roman letter M is pretty nearly square in proportion, the term "em" got to mean a square unit of space measuring 12 points by 12 points. The term "em" or "em quad," however, more strictly speaking, also means the square of *any* body size, no matter what point size. It is therefore correct to refer to a 12-point em, a 30-point em, a 60-point em, etc. In each case reference is made to a space equivalent to the square of the point size of the letter.

When a printer says, "the measure of a type layout is so many ems," just what size of em is he actually referring to?

He would ordinarily mean 12 point (pica) ems unless another particular size is given. In that case the printer would specifically state the particular point size of the em. Half an em is referred to as an "en." This represents half the body size. A 12-point en is 12 points in height and only 6 points in width; and like ems, ens too are cast as spaces in every size of type. In the jargon of the print shop an em space is referred to as a "mut," or "mutton," and an en space is known as "nut." These word substitutions make one term more phonetically distinguishable from the other.

Spaces are further subdivided into ⅓ rd, ¼ th and ⅕ th body size. The ⅕ th size is called "thin" space; five of them together would make one em. There are also hair spaces which vary from ¼ th to one point in thickness.

These space terms apply to units of non-printing space metal used to space words or letters horizontally, that is, in width. What about space matter which is placed between lines to add extra white space? What basis of measure applies to such vertical spacing material?

Vertical spacing, called leading (pronounced ledding), is based on the point unit

Leading:
how it is specified
and how it is used

of measure. The strips of line spacing metal which are used as separators, when additional open areas between lines are desired, are known as leads. They come in various thicknesses, and are designated as 1, 1½, 2 and 3 points, etc. The larger the space, the larger the number.

If 72 points are supposed to be the equivalent of one inch, why is it that when you put a ruler against a 72-point upper-case letter shown in printers' specimen books, the so-called 72-point size hardly ever measures a full inch? — and that short changing applies to all other sizes as well!

You must remember that the point size refers to the body of the block of type metal and not to the actual printing surface. The obvious disparity between the point size as it is listed in specimen books and the actual height of the printed letter is a source of perplexity to most beginners. To help clear up this confusion, you must understand the basic structure of the lower case alphabet, since it is the lower case which is a major factor in determining the point size of the entire font (upper case, lower case, numbers, etc.).

The lower case alphabet, as you know, includes letters some of which have ascenders, and some have descenders. The b, d, f, h, k, l all have strokes which rise above the main element of the letter, while the g, j, p, q and y have strokes which go below the main element of the letter.

The point size of a typeface is governed to a great extent by the space between the topmost point of the ascenders to the lowest point of the descenders. This, combined with the shoulder or platform of the piece of type on which the printing face is positioned determine the point size of the type.

In that case one cannot always know for sure what point size any type is merely by looking at it, or even by measuring one letter of the alphabet of its font. Is this correct?

That is quite true and even an expert cannot always tell the exact point size of an unfamiliar type.

What does one actually have to do to check the point size of a printed specimen?

There are several ways to establish the point size of a printed typeface. One is to take two lower case letters one of which has a descender and one an ascender and align them along side of each other. The letters d and p would be a good combination. Carefully measure the distance between the top of the ascender of the d to the lowest point of the descender of the p. This would come quite close to the actual point size of the typeface.

You say quite close. Is there a more accurate way to determine the point size of a type?

Yes, the other and more accurate way to determine the point size is to refer to an official foundry encyclopedia of type specimens. This shows printed examples of all typefaces in graduated scale in a complete range of sizes. The sample to be judged is placed over the corresponding line in the book and matched up visually.

It must be remembered, however, that the seasoned typographer who handles the same typefaces day in and day out gets to know the characteristics of type

so well that he can tell at a glance the point size of all popular faces. He rarely has to check, but when he does he will check it against the encyclopedia of specimens mentioned before.

What is meant by "Titling" when it has reference to a typeface? We see the word Titling used to designate certain upper case typefaces, shown in specimen books.

Meaning of titling

"Titling" indicates that the alphabet is cut specifically for display titles only and does not have a corresponding lower case. Incidentally, Titling alphabets usually occupy almost the full shoulder of the type metal so that a face listed as 72 point measures approximately one inch in height. Though Titling faces are cast "full face" on the body, the printed size actually measures a whisker less, owing to the fact that it is physically impossible to have the printing face go to the exact edge of the shoulder on which it is mounted.

Why is it that when you compare two typefaces in a printer's specimen book, there is often a marked difference in height of letters though both may be listed as the same point size? This is especially obvious (and confusing) in most lower case alphabets. For example, 36 point Nicholas Cochin looks so much smaller than the same point size in Goudy Old Style.

Two types having the same body size may appear to have two noticeably different letter sizes, depending to a great extent, on the length of the ascenders and descenders of the lower case. What is not visible when you look at the printed specimen of any given typeface is the non-printing "shoulder" which is needed on the piece of type metal for the descenders and ascenders.

What is meant by the expression "x height" of a typeface?

"x" height of
a letter form

X height has reference to the lower case only and means the height of the main element of the letter structure, such as the height of the bowl of the b and the p, the height of the c, e, etc. In other words, the x height is the size of the body of the letter, not counting the ascenders and descenders.

Why has the letter x been singled out for this purpose? Why not another letter such as the o, s, etc?

Simply because the x fits squarely and snugly within the imaginary base and waist guide lines of the lower case letter form. The x contacts the guide lines at four definite evenly spaced points and is therefore easy to measure.

It is the x height of the letter not the length of the ascenders and descenders which conveys the visual impact of size of the lower case.

Why is there such apparent chaos (to a beginner, anyway) when it comes to identifying typefaces by name? There are many typefaces which look alike yet are known by entirely different names. Beton and Stymie, Airport and Futura, are typical examples.

This question has been voiced by printers and typographers for many years, but nothing effective has been done to relieve the situation. To a great extent, this confusion is caused by the fact that though names of typefaces can be copy-

*Why there are
different names
for the same typeface*

righted, the actual designs do not lend themselves as easily to copyright law enforcements. Different type foundries throughout the world often issue by agreement, or otherwise, closely resembling typefaces, with hardly anything changed but the name. Many European typefaces are issued in the United States under altered names and, similarly, a number of American designs are re-cut (though not necessarily redesigned) by European foundries. And to compound the confusion, an identical typeface may be given different names when issued as a foundry type, a linotype, a monotype or Ludlow version.

When a popular typeface is issued in a wide range of sizes, say from 10-point to 96-point, is the large size always an exact photographic duplicate of the smaller version?

No, the larger sizes are not necessarily photographic reproductions of the smaller ones. A type design which looks good in 10-point, may not appear aesthetically or structurally correct in 48, 72 or 96 points. The reverse is similarly true. A typeface which has been designed and cut for 48 points may develop structural shortcomings and suffer design-wise when photographically reduced to 10 or 12 points. For instance, the counters may close up, the thin serifs and hairlines may tend to disappear, etc. Consequently for popular type designs which are issued in many sizes, the basic structural elements of the letter are slightly modified in a number of intermediate sizes so that excessive enlargements or reductions will not be limited to one master design.

Printing specimen books often indicate, next to each typeface shown, whether the particular face is a foundry, lino, mono or Ludlow face. Of what practical use is this information to the typographic designer or layout artist?

This information serves as production guide in selecting the proper typeface. The artist must consider not only the aesthetic appearance of his layout, he must also pay close attention to the technical production requirements of the job on hand. For example, if he were to select a foundry type for a book production job, the selection will be impractical since foundry type can be set only by hand, and for a full-sized book this would obviously be prohibitive in cost. For books and other massive text matter, a monotype or linotype face would be the more practical selection. For work to be reproduced by photo offset, a new version of "cold" photo-set style might perhaps prove to be the ideal selection, and so on. The facts about type, and differences between them, are of paramount importance to everyone who deals with commercial typography.

It would be well at this point, to briefly describe the various ways in which type is cast and touch upon the salient factors which determine the kind of type used, whether it be foundry, mono, lino, etc.

Foundry type is produced by foundries such as American Type Foundry, Bauer Foundry, Amsterdam Continental, etc. Foundry-cast type is issued in fonts of individual characters in complete alphabets and is intended to be set by hand. The compositor picks the characters from corresponding compartments of a

type case, spells out the copy as he places each letter in a composing "stick" until a line fills up. The process is repeated until the entire copy has been composed. After printing, each individual piece of type is returned into the case, ready for use again on another job.

The chief advantage, and limitation, of foundry type lies in the fact that it is the strongest and sharpest metal printing type available. It has to be because it is intended to be used over and over again. To give it extra strength, the metal in foundry type is made of a finely balanced alloy which has a greater proportion of tin, antimony and copper and a smaller proportion of lead than the metal used by other casting systems. In addition to sharpness and durability, foundry type has another advantage. Since it is set as individual characters, it is comparatively easy to make typographic and spelling corrections by merely replacing a letter or series of letters where needed, without disturbing the rest of the composition.

The chief disadvantage in the use of foundry type is the cost of setting copy by hand. It is for this reason that foundry type is issued mainly for advertising display faces, letterheads, business forms and other limited text material.

Monotype

This is a system of setting single characters of type by machine, rather than by hand. Actually two machines are required to accomplish this. One, equipped with a typewriter-like keyboard is used to "type" out the copy by manipulating keys which punch out tiny holes on a paper tape. The roll of perforated tape, when completed, is placed on another machine called the caster. The caster is activated by the perforations in the tape so that each letter of the copy is molded individually and in proper sequence.

Type produced by the monotype system resembles foundry type characters, except that the metal is not quite as durable. The individual characters of monotype, after printing, may be melted to form the base metal for the casting machine in the production of new type matter.

One of the outstanding advantages of monotype is the speed of type setting. It frees the printer from the laborious and time consuming task of setting and redistributing type by hand. Many books and commercial jobs with extensive copy are therefore produced by monotype. The word "monotype" applies to the system of producing the type as well as to the type produced by this system.

Linotype and Intertype

In the linotype system, both the composition and casting of type are performed simultaneously by the same operator and the same machine. The operator works a keyboard very much similar to that of a typewriter, only it is larger and more complex. As he presses the keys, corresponding brass matrices of individual type characters continue to drop into an assembler until a line of the required measure is filled up. The line of matrices is then raised into position over a mouthpiece through which hot molten lead is pumped. Thus a solid lead slug is cast of the entire line of characters, ready for printing. After the printing is finished, slugs may be remelted, or may be saved for a re-run of the same job.

Linotype has a number of inherent advantages over monotype. Since only one operation is required (compared to two for monotype) lino is less expensive and faster. It is mainly for these reasons that most daily newspapers are printed by linotype. Its chief shortcoming is the fact that type cast by linotype is not nearly as durable or as sharp as foundry type. Also, corrections in copy are not as easily made as in foundry or monotype, since the simple substitution of even one character means that the entire line, sometimes perhaps more than one, must be recast. Linotype is used for massive text matter which must be produced quickly and at a low budget.

Intertype is basically the same as the linotype system, except that the machine which casts the type is produced by another firm, the Intertype Corp. For all practical purposes, what has been said about linotype applies to Intertype as well.

Ludlow

Ludlow is really a combination of hand and linotype composition. Here, in brief, is how it works: the compositor selects from a case of individual matrices of type characters, those which correspond to the words of his text. He sets these matrices, one-by-one into a special composing stick in a manner similar to that of setting foundry type. As each line is finished, it is inserted into the Ludlow caster which pumps molten lead into it. This produces a solid slug of a line of type, ready for printing.

There are several advantages inherent in this system of type casting. The printing type here (as in lino and monotype) is always "brand new" since the matrices are made to serve only as master molds, and are not subjected to continued stress and wear of foundry type. Also Ludlow, though it can be used for casting small type, is especially designed for casting large display faces (larger than is generally feasible with foundry or linotype). Although the maximum point size of Ludlow is 96 points, it is possible, with some modifications, to cast jumbo-size characters up to 240 points. One of the chief limitations of Ludlow is that it is a comparatively costly process since manual composition and special handling are necessary.

Wood type

Wherever very large types are needed, beyond the easy range of other resources, wood type becomes practical. Wood type is often used for work for large posters for the theatre, election campaigns, truck advertising, subway platform billboards, imprinting of names on twenty-four sheet posters, etc. Wood type is made of specially processed, close-grained boxwood; it is durable and light in weight compared to its size. It is frequently used by the sign and display divisions of department stores for quick set-ups for signs needed for windows and interiors.

Photocomposition

In all the other type composition systems (foundry, linotype, monotype and Ludlow) the type employed consists of metal blocks or slugs which carry a raised printing surface. Photocomposition works on a different principle entirely. It uses no metal type whatever. Instead, employing the process of photography, it

shoots a beam of light through a transparent image of a photographic negative, onto a sensitized paper or film. This negative contains the entire font of an alphabet, upper case, lower case, numbers, special characters, signs, etc. and comprises the "matrix" used in the photocomposition system. The synchronization and positioning of exposure of the matrix under the lens operates on the letter-by-letter principle of photographing each character individually. The matrix automatically shifts into position, is held momentarily stationary during the almost instantaneous exposure and swiftly shifts into the next position. Each shift represents a character in the copy.

There are a number of different photocomposing systems; the Monophoto, Fotosetter, Linofilm, Photon, Typesetter, etc. The operational principle is nearly the same on all, but the structural design of each machine varies greatly in complexity and versatility.

It will suffice here to describe in some detail the first of these machines — the Monophoto — to make the operational principle of all photosetting systems easier to visualize.

In essence, the Monophoto composes type in much the same way as the Monotype caster. The operator "types" on a keyboard which punches holes in a paper tape. This perforated tape is then placed into another machine which is a "caster." The dramatic difference is that instead of casting letters in metal type, this machine photographs images on film. The "caster" is really a miniature foundry with a built-in and highly efficient automatic photographic machine which is set into motion by the perforations in the tape.

The Monophoto sets lines of type up to 60-pica measures. It handles all sizes of type from 6- to 12-point in one-point steps, and from 12-point to 24-point at two-step intervals, including fractional and odd sizes. Type larger in size can be stepped up by special camera enlargements. The Monophoto possesses other practical features: by means of photographic enlargements or reductions one set of character negatives can produce as many as eleven different sizes of type. It uses standard typefaces such as Baskerville, Bembo, Times Roman, Century Schoolbook, etc. As time goes on new faces especially designed for this system will be made available.

No doubt, one of the outstanding features of Monophoto (and other photocomposing systems) is the fact that type can be set directly on transparent film, resulting in a good, sharp positive to meet the needs of offset lithography and engraving plate-making processes. In conventional hot type printing processes employing metal type, a "repro proof" is first pulled on paper which in turn must go before the camera to get a transparent positive film needed for making plates. With the Monophoto and similar systems, this intermediate step can be completely eliminated. The result is a substantial saving of time and money. What is more, the precision and quality achieved by photocomposing "cold type" systems compare very favorably with that of conventional "hot" metal composition in sharpness of line and clarity of detail. Photocomposition is also infinitely more versatile.

Other photosetting machines, such as the Linofilm Phototype Setter, are

designed to produce type images from 4 to 108 points, in measures up to 96 picas and at speeds several times that of conventional linotype casting.

The Photon composing machine sets up display faces as well as the smallest text matter, and with accessory devices can be used to print the composition of entire advertisements. The versatility and sophistication of these modern type-casting machines reflect the continuing technical advances in electronics as applied to the graphic arts.

There is no one fixed procedure which applies to all copy fitting problems. Varied conditions determine the ways by which space and copy are made to fit each other.

The two major variations to the problem are: A) when a typographic layout is designed first, and the copy is written specifically to fit the space and other requirements of the layout; this assumes that the amount of copy can be changed to fit the layout. B) When the copy is written first and the layout is made to fit the amount of copy; this assumes that the size of the copy area on the layout can be changed to fit the copy.

In either case, a definite mathematical computation must be made by the layout artist or the typographer (or both, working together) before the job is ready for the typesetter. This computation, to be reliable and accurate, must be based on the following set of related factors: the amount of copy; the style and point size of the typeface; leading between lines of type; the dimensions or area reserved for the copy.

Because words vary in length, the amount of copy must be based on a character count, rather than on a word count. The term "character" as it is used typographically, refers to the individual letters which comprise the words, plus the spaces between words, plus all signs, numbers and punctuation marks.

Because a character count is an important factor when copy fitting, let us describe some methods by which this is achieved. This will enable us to compute the hypothetical copy-fitting problems which will follow later on. The method you use will depend on the amount of copy fitting you have to do and the nature of the job on hand.

In editorial departments of many newspapers and publishing houses, special typing paper with a vertical guide line printed on the right hand side is used to prepare copy. Each line of the text is typewritten exactly flush to this justifying line, regardless of where the words break. Since all typewritten lines are uniform in length, every line will contain the exact same number of characters. It is thus a simple matter to compute the total number of characters on the page by multiplying the characters per line by the number of lines. Adding the number of typewritten pages will give the total number of characters of the manuscript or text.

Another method frequently used involves drawing a vertical line down the right-hand side of the page at a point where most of the typewritten lines end. This establishes the "average" length of a copy line. The characters of any one

line which touches the vertical guide are counted. This count is multiplied by the number of lines on the page. To this sum is added or subtracted the number of characters on any line which extends beyond or falls short of the vertical guide.

Perhaps the most accurate way to compute the number of characters in the copy is by measuring each line with a ruler. A typewritten line has in most cases either 10 or 12 characters to an inch. If the copy is typed with the elite typewriter face (small size) there will be 12 characters to the inch. If a pica typewriter (larger size) is used, there will be 10 characters to the inch. To get the total character count for the copy, add the number of characters for each line. Another way of getting a character count faster, though perhaps not quite as accurate, is to strike an "average" length of line in the copy as a basis for computation. For instance, in a typewritten sheet of 20 lines with length of lines varying from 5 to 7 inches, the average would be 6. Using 6 as a basis, multiply this by the total number of lines. In this case, the total would be 120 inches. Assuming the copy is typed on a pica typewriter, and the unit of measure being 10 characters to the inch, then 120 inches would total 1200 characters for the page.

Now let us consider a practical situation to illustrate each of the two aspects of copy fitting.

Situation A

Given:

A copy panel on the layout measuring 2 inches wide by 4 inches deep.

The type specified is 12 point News Gothic Condensed, lower case, with 4 point leading between lines.

Problem:

How many words of copy will fit the above specifications?

Procedure:

1. *Change the dimensions of the copy panel from inches to picas.*
 There are (approximately) 6 picas to an inch, therefore a panel 2 inches by 4 inches becomes 12 picas by 24 picas. (Typographic dimensions of copy panels in layouts are generally expressed in terms of picas rather than inches.)

2. *Convert the depth of the copy panel from picas to points.*
 In copy fitting computations, the depth of a copy panel is always figured in points. A pica equals 12 points, therefore 24 picas (depth of copy panel) equal 288 points, (12 x 24).

3. *Add the point thickness of leading to the point size of the type.*
 Thus 4 point leading added to 12 point type makes each line 16 points deep.

4. *Compute how many lines will fit into the specified depth of the copy panel.*
 To do this, divide 288 (depth of copy panel in points) by 16 (depth of line in points). The answer is 18. This means that 18 lines fit into the copy panel.

5. *Refer to a copy fitting chart or a Haberule Copy-Caster to find how many characters of the selected typeface will go into the specified length of line.*
 In this case, a line of 12 point News Gothic Condensed measuring 12 picas

in length will contain 33½ characters.

6. *Multiply the number of characters which go into the line of the specified type by the total number of lines of the copy panel.*

 33½ (characters per line) multiplied by 18 (total number of lines) gives a total of 603 characters for the entire copy panel.

7. *Convert the total character count into words.*

 Statistical tests show that there are on the average 5½ characters to a written word used by adults. Children's words average 4 characters. Technical words average 7 characters.

 Dividing 603 (total number of characters) by 5½ (average character count per word) will give approximately 109 words as the total word count.

This computation is adequate for most purposes, but because of variables in the nature of the copy, relation of capitals to lower case, size of words, variations in spacing, short lines and indentions, one hundred per cent accuracy cannot be expected. However, slight adjustments make this method a workable procedure to follow.

Situation B:

Given:

A piece of typewritten copy consisting of 200 words.
The type specified is 14 point Caledonia with 2 point leading.
The width of the copy panel is 24 picas.

Problem:

How deep will this panel be, expressed in picas?

Procedure:

1. *Get an accurate character count of the typewritten copy.*

 Let us assume that this count is 1104 characters.

2. *Find how many characters will fit the given width of line of the selected typeface, by consulting a copy fitting chart or Haberule Copy-Caster.*

 (48 characters of 14 point Caledonia will fit into a 24 pica line.)

3. *Divide the total number of characters in the typewritten copy by the character count per line. This will give the total number of lines it will take to set up the copy in type.*

 Thus 1104 (total number of characters in the typewritten copy) divided by 48 (character count per line) is equal to 23 lines.

4. *Add the specified point thickness of the leading to the point size of the type to get the total depth of the printed line.*

 In this case, 2 points (specified leading) added to 14 points (type size) gives a total depth of 16 points per line.

5. *Multiply the number of lines of copy by the depth of the line to get the total depth of the column.*

 23 (number of lines) multiplied by 16 (depth of line) equals 368 points.

6. *Convert the points into picas.*

 To do this divide 368 points (total depth of column) by 12 (12 points = 1 pica). The result is 30.6 picas.

Fitting space to copy

Thus copy consisting of 200 words set up in 14 point Caledonia with 2 point leading, with a measure of 24 picas, will be 30.6 picas deep.

The chart below will help you in calculating the vertical dimension or depth of a column of type. It shows how many lines of type of any specific type size will go into one inch of vertical space.

POINT SIZE	LINES OF TYPE TO THE INCH (SET SOLID)
4	18
5	14.4
6	12
7	10.285
8	9
9	8
10	7.2
11	6.545
12	6
14	5.143
16	4.5
18	4
24	3
30	2.4
36	2
42	1.714
48	1.5
72	1

The computation on the chart is based on the ratio of 72 points to the inch. Thus 4 points is $\frac{72}{4}$ or 18. 10 points is $\frac{72}{10}$ or 7.2, etc.

Example:
If you specify 16 point type, you will get 4.5 lines of type per vertical inch of copy space, assuming that the lines are set solid.

If you specify 2 point leading between lines, then add 2 points to the 16 point type size and compute the space based on 18 points. In this case, you will get 4 lines of type to the vertical inch.

Essential Parts of a Piece of Type

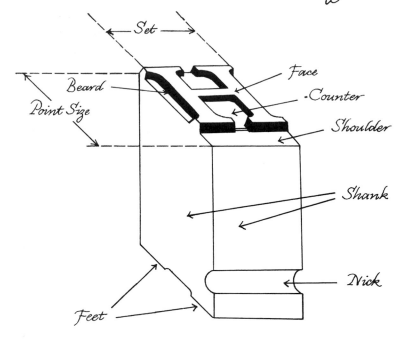

FACE:
The elevated printing surface which receives the ink and transfers it to paper.

BEARD:
The raised edge of the letter, slightly beveled for extra strength. Sometimes referred to as the "neck."

SHANK:
The rectangular block of metal on which the letter structure is mounted.

COUNTER:
The "void" space between the stems of the H, the inside area of the O, D, etc.

SHOULDER:
The space between the base line and the front edge of the block of type metal.

FEET:
The two supports on which the block of type metal rests.

POINT SIZE:
The vertical dimensions of the top surface of the block of metal type on which the letter is mounted. (The point size is sometimes erroneously identified with the letter size.)

NICK:
A visual guide which helps the typographer to detect a foundry letter belonging to a different font, or one which is not set in the composing stick correctly.

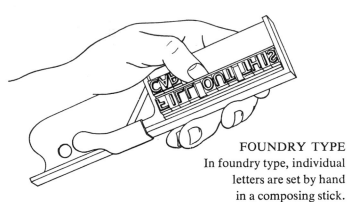

FOUNDRY TYPE
In foundry type, individual letters are set by hand in a composing stick.

MONOTYPE
In monotype, type matter is set by machine as individual letters.

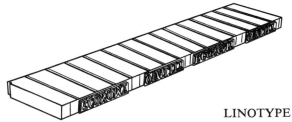

LINOTYPE
In linotype, type matter is set by machine not as individual letters but in connected and solid lines of type.

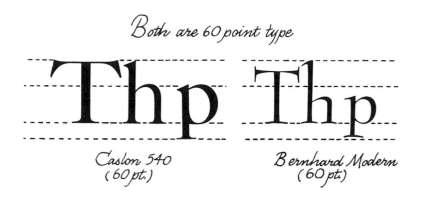

Both are 60 point type

Caslon 540
(60 pt.)

Bernhard Modern
(60 pt.)

The point size of a type face cannot be determined by measuring any one individual letter without relationship to other letters of the font. It is often possible to arrive at an approximation of the point size of a type face by measuring the total space between the top-most part of the ascender of one letter and the lowest part of the descender of another. This method, while reliable in many instances, is not always accurate because some faces are cast on a larger body. It must be remembered that it is the vertical dimension of the top surface of the block of metal and not the printing face of the letter which determines the given point size of a type face.

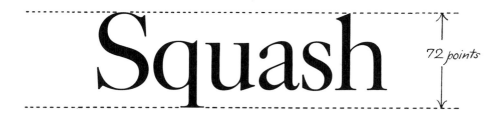

72 points

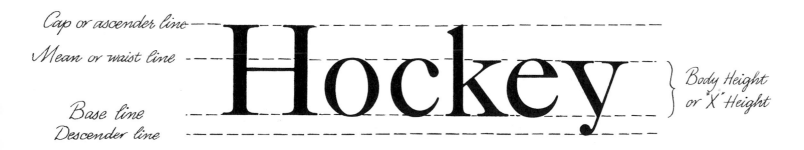

Cap or ascender line
Mean or waist line
Base line
Descender line

Body Height or "X" Height

Names of lettering guide lines which mark the relative heights of the various parts of upper and lower-case letter forms. The space relationship of these lines varies considerably with each lettering style or type face.

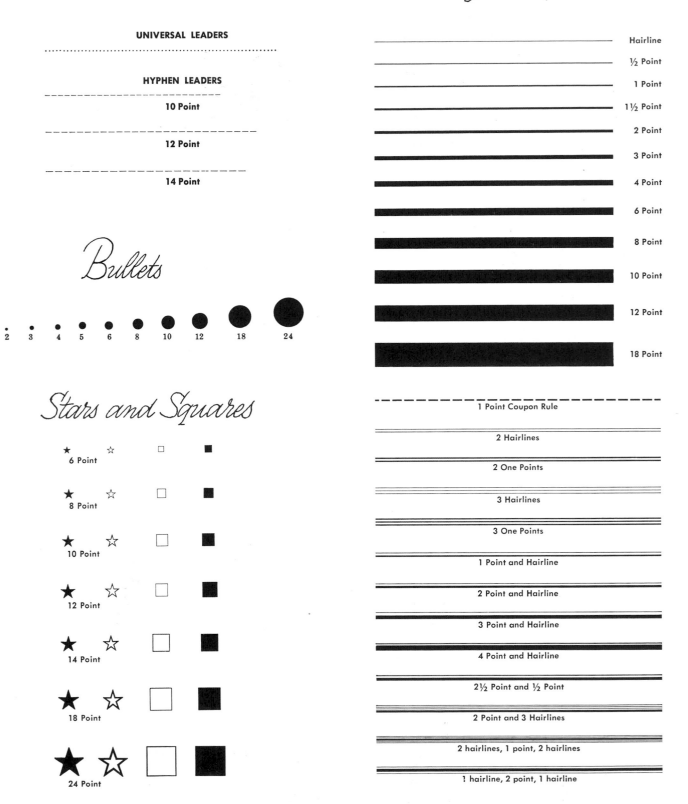

Leaders

UNIVERSAL LEADERS

. .

HYPHEN LEADERS

- -

10 Point

- - - - - - - - - - - - - - - - - - -

12 Point

- - - - - - - - - - - - - - - - -

14 Point

Bullets

2　3　4　5　6　8　10　12　18　24

Stars and Squares

★　☆　□　■
6 Point

★　☆　□　■
8 Point

★　☆　□　■
10 Point

★　☆　□　■
12 Point

★　☆　□　■
14 Point

★　☆　□　■
18 Point

★　☆　□　■
24 Point

Monotype Rules

Hairline

½ Point

1 Point

1½ Point

2 Point

3 Point

4 Point

6 Point

8 Point

10 Point

12 Point

18 Point

- - - - - - - - - - - - - - - - -
1 Point Coupon Rule

2 Hairlines

2 One Points

3 Hairlines

3 One Points

1 Point and Hairline

2 Point and Hairline

3 Point and Hairline

4 Point and Hairline

2½ Point and ½ Point

2 Point and 3 Hairlines

2 hairlines, 1 point, 2 hairlines

1 hairline, 2 point, 1 hairline

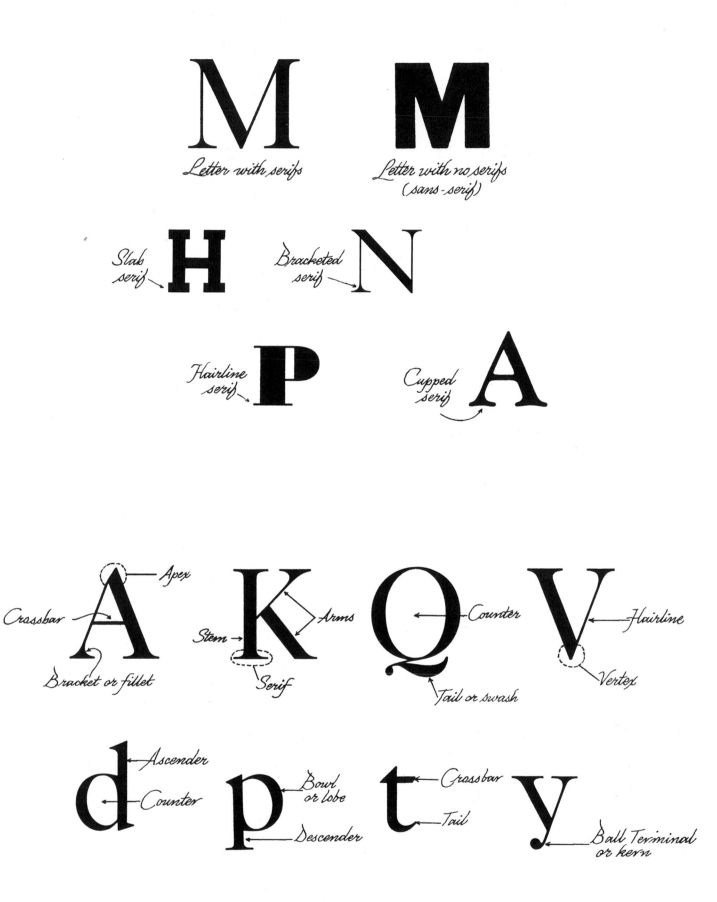

Letter with serifs

Letter with no serifs
(sans-serif)

Slab serif

Bracketed serif

Hairline serif

Cupped serif

Apex

Crossbar

Stem

Arms

Counter

Hairline

Bracket or fillet

Serif

Tail or swash

Vertex

Ascender

Counter

Bowl or lobe

Crossbar

Tail

Descender

Ball Terminal or kern

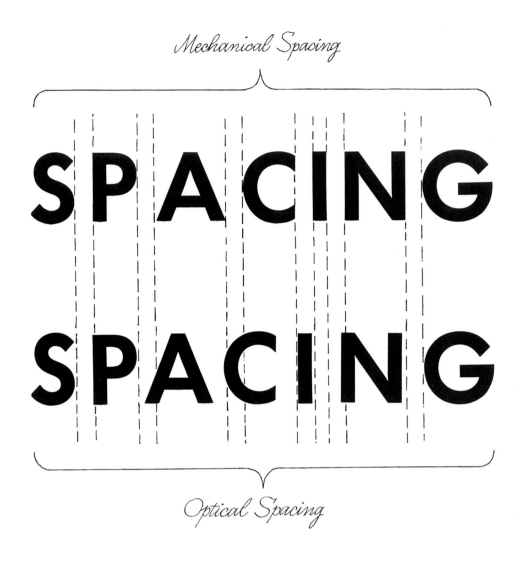

Mechanical Spacing

Optical Spacing

Since the letter structure varies with different letters of the alphabet and different type faces, spacing must to a large extent depend upon optical judgment rather than mechanical measure. In good spacing, the white area between the combining letters of a word is well distributed, producing an effect of uniformity of "color" throughout the word.

- ■ em quad (mutton), the square of the body.
- ■ en quad (nut), ½ body or two to the em.
- ▪ thick space, ⅓ body or three to the em.
- ι middle space, ¼ body or four to the em.
- ι thin space, ⅕ body or five to the em.
- ι hair space, ¹⁄₁₂ body approximately.

PRESENTATION OF FEATURED TYPE FACES

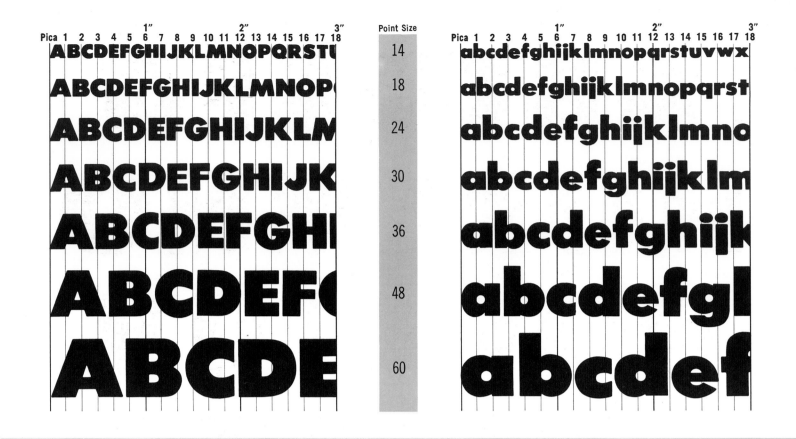

ABCDEFGHIJKLMNOPQRSTU

ABCDEFGHIJKLMNOP

ABCDEFGHIJKLM

ABCDEFGHIJK

ABCDEFGHI

ABCDEFG

ABCDE

14
18
24
30
36
48
60

abcdefghijklmnopqrstuvwx

abcdefghijklmnopqrst

abcdefghijklmno

abcdefghijklm

abcdefghijk

abcdefgl

abcdef

• VARIATIONS OF THIS TYPE:

Airport Extra Bold Condensed *Airport Extra Bold Cond. Italic* *Airport Bold Italic*
Airport Bold Condensed

ABOUT THIS TYPE FACE

Almost identical to Futura Bold, designed by Paul Renner, Airport Black was copied from the former. It is a sans serif typeface of rugged simplicity and power. Generally a monotone letter form, it cannot consistently retain its uniform weight, simply because it is so massive that it would be structurally impractical to give equal stress to the integral elements within the confines of the letter structure. This is quite evident in such letters as the A and E but it also holds good for some of the other letters of the capitals, as well as for many of the lowercase letters. The cross strokes of the A, B, E, F, G, H, etc., are considerably thinner than the main strokes. Also note that the extreme side strokes of the M are slanted. In the lower case, the counters of the round letters are practically perfect circles, but they are not concentric with the outer rim. The a typifies that structural characteristic clearly. The dots of the i and j are elliptical and placed very close to the body of the letter. The j, you will note, is nothing more than an elongated i, devoid of the traditional terminal associated with that letter.

Airport Black is one of the best typefaces to choose for posters, especially those that are to be viewed from afar or from moving vehicles. This typeface has a high degree of legibility and excellent carrying power. It prints well on any kind of stock, either direct or reverse and is suitable for all commercial printing processes. The Airport family has many variations, including Italics, Condensed, Condensed Italics, Condensed Title, Display, Extra Bold Condensed, etc.

ABCDEFG
HIJKLMNO
PQRSTUV
WXYZ
abcdefghijk
lmnopqrst
uvwxyz
1234567890

	Point Size	
ABCDEFGHIJKLMNOPQRSTUVWXYZ	14	abcdefghijklmnopqrstuvwxyz
ABCDEFGHIJKLMNOPQRSTUVWXY	16	abcdefghijklmnopqrstuvwxyz
ABCDEFGHIJKLMNOPQRSTU	18	abcdefghijklmnopqrstuvwxyz
ABCDEFGHIJKLMNOPQ	24	abcdefghijklmnopqrstuvw
ABCDEFGHIJKLMNO	30S	abcdefghijklmnopqrst
ABCDEFGHIJKLM	30L	abcdefghijklmnop
ABCDEFGHIJ	42	abcdefghijklm

ABOUT THIS TYPE FACE

A novelty type fat face, designed by Hans Bohn in 1936, Allegro is somewhat in a class by itself. It possesses a rugged charm and personality distinctly its own. If it is to be compared to any other typefaces, there might be some basis for relating it to a sort of blend of Stencil and Corvinus, in an italic version. It has the elongated contrasty thick-and-thin elements of Corvinus, tall, condensed and flattened bowls. At the same time it reminds one of Stencil since it conveys a feeling of interrupted forms because of its disjointed stems and open counters.

It is easy to identify Allegro because of what was pointed out before; it has a stencil effect, reflects some of the elongated characters of Corvinus and is a modified italic form. Allegro has a "musical look" because of the predominance of the ball terminals which bear a resemblance to music notes, a characteristic especially evident in the capital letters.

The lower case retains the essential characteristics of the capitals. The letters are condensed, elongated and constructed with very narrow counters. The ascenders and descenders are quite short. This typeface is ideal for copy dealing with the concert hall, stage or similar cultural pursuits. However it is not limited to these narrow and obvious uses. Its sparkling elegance makes it an appropriate typeface for distinctive book jackets, letterheads and packaging. The thin hairlines make it inadvisable for printing on poor quality paper or for any kind of reverse printing. Though Allegro comes in a wide range of sizes, it is available only in one face, without variants.

ABCDEFGH
IJKLMNO
PQRSTUV
WXYZ

abcdefghijklm
nopqrstuvwxyz

1234567890

ABCDEFGHIJKLMNOPQRSTUVWXYZ **18** abcdefghijklmnopqrstuvwxyz

ABCDEFGHIJKLMNOPQRSTUV **24** abcdefghijklmnopqrstuvwxy

ABCDEFGHIJKLMNOPQRS **30** abcdefghijklmnopqrstuv

ABCDEFGHIJKLMNO **36** abcdefghijklmnopqr

ABCDEFGHIJKLM **42** abcdefghijklmno

ABCDEFGHIJKL **48** abcdefghijklm

• VARIATIONS OF THIS TYPE:

Alternate Gothic No. 1 **Alternate Gothic No. 3** *Alternate Gothic Italic, No. 2*

ABOUT THIS TYPE FACE

There are more than a half-dozen typefaces which bear a resemblance to the Alternate Gothic specimen shown here, classified as Alternate Gothic #2. There is also #1 and #3 in the series. The number refers to the width of the letter form. #1 is condensed, #2 is medium and #3 is somewhat extended. Alternate Gothic (or a variation thereof) may be said to be among the most popular display typefaces in use today. Some of the members of this sans serif gothic family include Railroad Gothic, Standard Bold Condensed, Gothic Condensed and Monotype Poster. Equally varied is the broad range of type sizes, from 6 to 72 points. In addition, almost all sizes and variations are available in patented lettering transfer sheets, photolettering, and 3-dimensional letters cut out of wood or paper, or molded in plastic.

General characteristics of this group of typefaces cover the following structural points of identification: the capitals are practically one thickness throughout, but the letters of the lower case show some compromises in thickness of strokes, specifically in the a, b, d, g, h, m, n, p, r and u; dots over the i and j are square; the letters, usually made round, are condensed to form a rectangular shape, with the sides flattened and made parallel to each other.

This alphabet, like the others in the same generic family, reproduces well on any printing surface and possesses a high degree of legibility.

ABCDEFGHIJ
KLMNOPQRST
UVWXYZ

abcdefghijklmn
opqrstuvwxyz
1234567890

THIS TYPE
RESEMBLES:
STANDARD BOLD CONDENSED,
VENUS BOLD CONDENSED,
GOTHIC CONDENSED #11,
MONOTYPE POSTER #700

ALTERNATE GOTHIC NO. 2 **33**

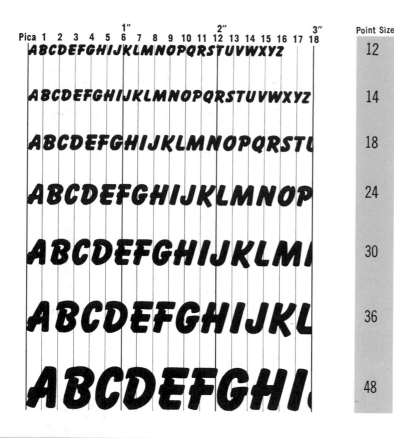

Pica					1"							2"						3"	Point Size

ABCDEFGHIJKLMNOPQRSTUVWXYZ — 12

ABCDEFGHIJKLMNOPQRSTUVWXYZ — 14

ABCDEFGHIJKLMNOPQRSTU — 18

ABCDEFGHIJKLMNOP — 24

ABCDEFGHIJKLM — 30

ABCDEFGHIJKL — 36

ABCDEFGHI — 48

THIS TYPE FACE DOES NOT
COME WITH A LOWER CASE

● VARIATIONS OF THIS TYPE:

BALLOON LIGHT **BALLOON BOLD**

ABOUT THIS TYPE FACE

The name "Balloon" which identifies this typeface is derived from the casual Speedball-pen type of lettering which appears as the spoken words within the balloon-shaped areas in comic strips. An informal sans serif italic, Balloon has become a standard face, widely used and readily available at most print shops. It has a "look-alike" in several other typefaces, principally Cartoon, Flash and Dom Bold. While the others are available in both upper and lower case, Balloon comes in upper case only but is to be had in a generous assortment of sizes, ranging from 10 to 96 points and in variations called Balloon Light and Balloon Bold.

To retain the casual pen-lettered effect, some of the strokes are disjointed as if done hastily, leaving the counters and bowls not completely closed. The structures of the B, E, F, H, O, P, Q, R and T show this clearly. Note that the cross strokes of the A, E, F and H are run through as if rendered casually and at a rapid pace.

Balloon, in spite of its apparent informality, retains a constant uniform thickness of stroke and slant. In this respect, Balloon is different from Cartoon, Flash and Dom, which are less disciplined and far more personalized in treatment and effect.

Balloon was designed in 1939 by Max Kaufmann who also created Kaufmann Script. See pages 116 and 117.

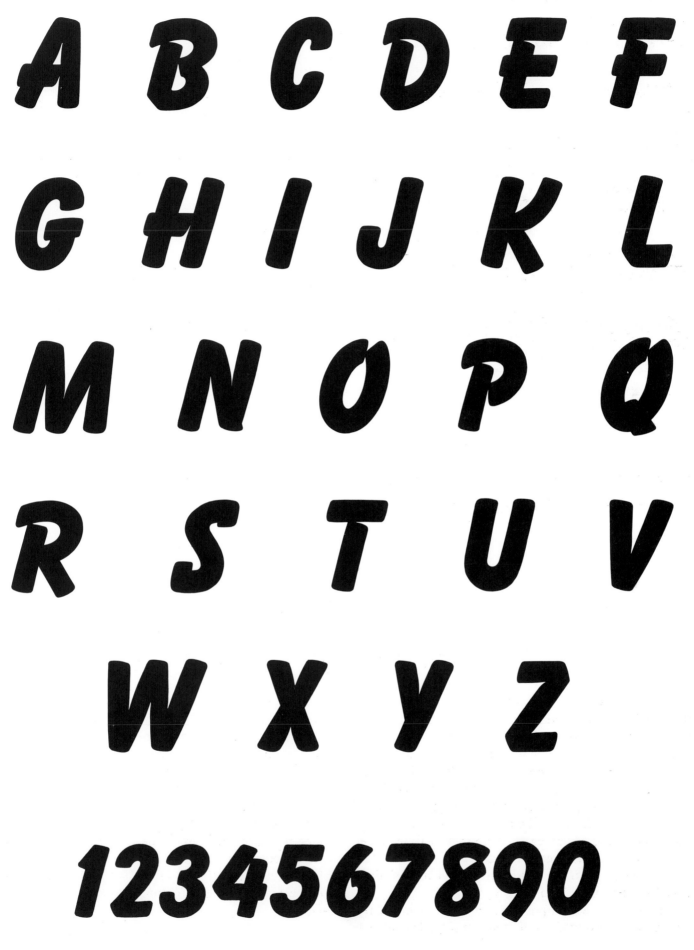

THIS TYPE
RESEMBLES:
CARTOON BOLD,
FLASH BOLD,
DOM BOLD

BALLOON EXTRA BOLD 35

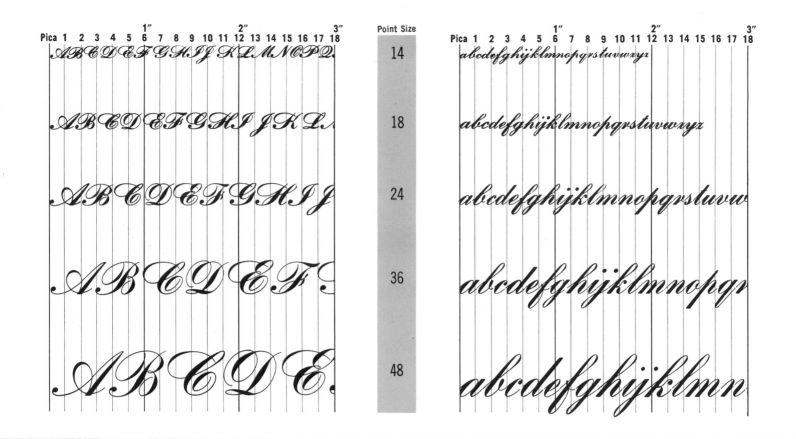

ABOUT THIS TYPE FACE

This is one of the traditional typefaces epitomizing the calligraphic elegance of Spencerian penmanship. It is structurally designed to make the letters in a word appear to almost touch each other in an unbroken link. In many respects Bank Script is similar to Commercial Script, Typo Script, Bond Script, Excelsior Script and Marina. Bank Script, shown here, is somewhat more balanced in weight and color than some of the other formal script types and is characterized by delicately accented stresses and flourishes. The capitals have many flourishes, but the lower-case letters show greater restraint. In the main, the Bank Script letter form is composed of two thicknesses; the hairline and the modulated stress stroke. The maximum stress in the center of the stroke, produced by the full pressure of the flexible

nib of the lettering pen, is so accented that the greater stress of the stroke is in the optical center of each of the heavy strokes. Even the thin hairlines show a delicately shaded semblance of pressure and flexibility.

The natural uses of Bank Script are announcements of festive or formal occasions. It is the "tuxedo and silk hat" representative of formal typefaces. Caution: Think twice before planning a formal script for reverse printing. The thin lines could turn out to be a source of anguish to the printer.

Bank Script is available in only one face and in a limited number of point sizes (14, 18, 24, 30, 36 and 48.) Commercial Script which is quite similar is available in point sizes which go up to 60.

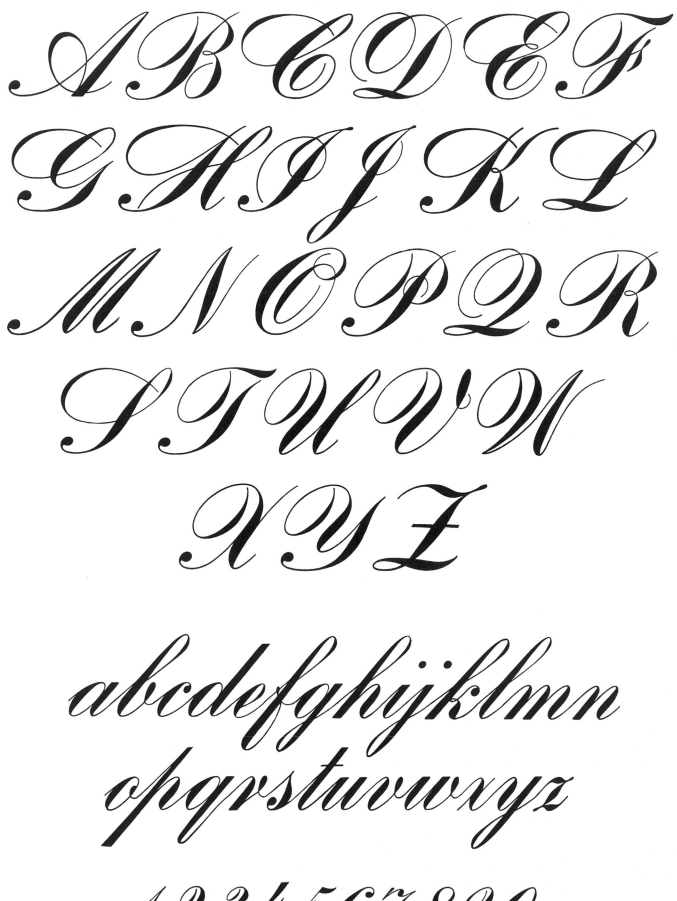

	Point Size	
ABCDEFGHIJKLMNOPQRSTUVWXYZ	8	abcdefghijklmnopqrstuvwxyz
ABCDEFGHIJKLMNOPQRSTUVWXYZ	10	abcdefghijklmnopqrstuvwxyz
ABCDEFGHIJKLMNOPQRSTUVWXYZ	12	abcdefghijklmnopqrstuvwxyz
ABCDEFGHIJKLMNOPQRSTUVWX	14	abcdefghijklmnopqrstuvwxyz
ABCDEFGHIJKLMNOPQRSTUVW	18	abcdefghijklmnopqrstuvwxyz
ABCDEFGHIJKLMNOP	24	abcdefghijklmnopqrstuvw
ABCDEFGHIJ	36	abcdefghijklm

● VARIATIONS OF THIS TYPE:

Barnum Condensed

ABOUT THIS TYPE FACE

The Barnum type, shown here, named after the circus impresario, is reminiscent of a romantic and colorful era in American history. Wood letter typefaces similar to Barnum were the favorites for hand bills and posters advertising the "Greatest Show on Earth" or similar theatrical spectaculars of the gaslight era of days gone by. Barnum is one of a long series nineteenth century revivals of condensed reversed Egyptian display faces where the serifs are heavier than the main strokes. This includes Monotype's Figaro, Amsterdam's Hidalgo, a German face called Pro Arte, as well as a very popular face known as Playbill which was cast in 1938 by the Stephenson Blake Foundry and was reissued in this country by the Baltimore Foundry.

The artistic quality of these faces is questionable, but the fact remains they add color and impact to a typographic layout. Barnum (or the others in the series) is most effective when it is confined to one or two words or in an isolated line and in sizes no smaller than 14 point. It is cast in sizes 6, 8, 10, 12, 14, 18, 24, 30, 36, 48 and 60 in upper and lower case, and in two versions, P. T. Barnum shown here and in Barnum Condensed.

The most obvious uses of Barnum are for things with a flavor of the theatre, the Wild West, antiques, the "good old times," sawdust and spangles of the circus world. However its application can be extended to copy dealing with contemporary themes if the type is employed for its impact value purely as an anachronism and novelty.

ABCDEFGHIJ KLMNOPQRST UVWXYZ

abcdefghi jklmnopqrst uvwxyz

1234567890

THIS TYPE
RESEMBLES:
PLAYBILL,
HILDALGO,
FIGARO

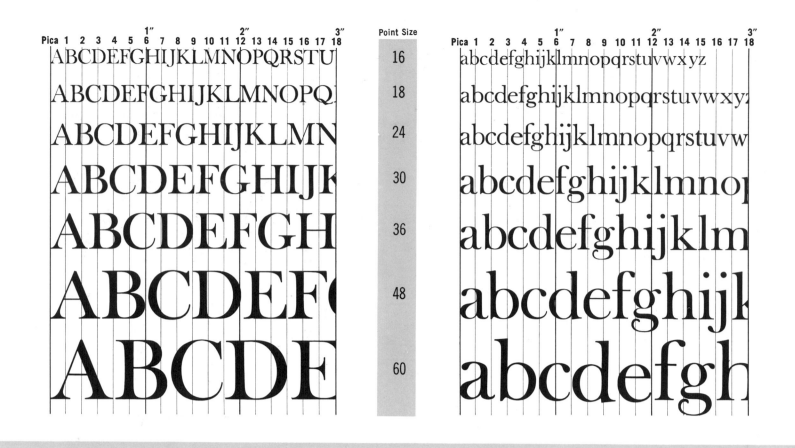

	Point Size	
ABCDEFGHIJKLMNOPQRSTU	16	abcdefghijklmnopqrstuvwxyz
ABCDEFGHIJKLMNOPQ	18	abcdefghijklmnopqrstuvwxy
ABCDEFGHIJKLMN	24	abcdefghijklmnopqrstuvw
ABCDEFGHIJK	30	abcdefghijklmno
ABCDEFGH	36	abcdefghijklm
ABCDEF	48	abcdefghijl
ABCDE	60	abcdefgh

• VARIATIONS OF THIS TYPE:

Baskerville Italic **Baskerville Bold** Baskerville Roman

ABOUT THIS TYPE FACE

There are as many versions of Baskerville as there are of Caslon, Garamond and the other basic forms. The original Baskerville was designed by an English calligrapher of that name in about 1760. At that time Caslon was the favorite alphabet and the Baskerville design represented a threat to it and the old style faces which were based on the lettering pen. Baskerville had originally ranked as a "transitional" type because it came between the soft old face calligraphic designs and the "modern" sharp Bodoni which showed the influence of the engraver's tool more than that of the brush or pen.

Baskerville's identifying characteristic is the crisp definition of the thick and thin strokes. The thin strokes are hair-thin, while the heavy ones are positive and black. The serifs emerge from the main stems wedge-shaped but end up whispy-thin. This effect also char-acterizes the joinings of strokes as in the lower arm of the E, the L, and the rather low-slung spurred crossbar of the G. The E is unusual because of its greatly extended bottom crossbar; the J goes well below the alignment of the other letters; the tail of the R makes a slight curve in its diagonal direction.

In the lower case, the g is the "clue" letter because of its open lower loop and curled tail. The letter carries a jaunty little swirl top on the side of its upper bowl.

Baskerville is normally a wide-set typeface, an important factor in planning space in the layout when one doesn't have much to say and a lot of space to say it in. This type is versatile both as a book face (in its smaller sizes) and as a display letter for newspaper and magazine advertising. It is not good as a poster letter because the thin lines tend to fade in the distance.

ABCDEFG
HIJKLMN
OPQRSTU
VWXYZ

abcdefghij
klmnopqrst
uvwxyz
1234567890

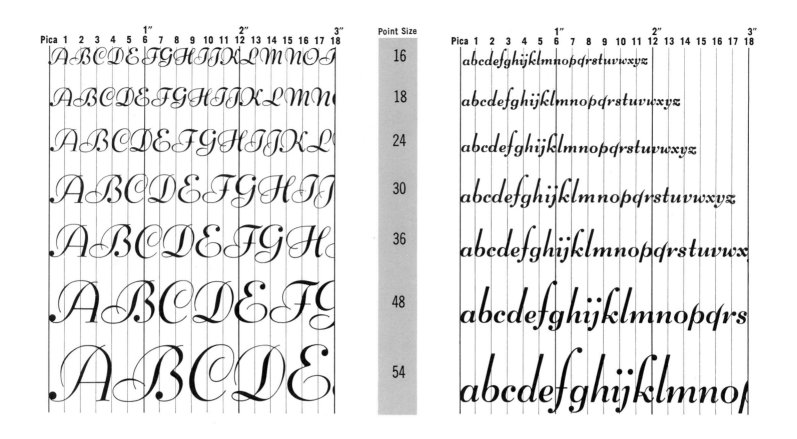

Pica 1 2 3 4 5 1″ 6 7 8 9 10 11 2″ 12 13 14 15 16 17 3″ 18
Point Size
Pica 1 2 3 4 5 1″ 6 7 8 9 10 11 2″ 12 13 14 15 16 17 3″ 18

16
18
24
30
36
48
54

• VARIATIONS OF THIS TYPE:

Bernhard Cursive

ABOUT THIS TYPE FACE

Lucian Bernhard, greatest of our contemporary type designers has during his long professional life created more than 50 typefaces, many of them accepted as modern classics. Bernhard Cursive Bold, shown here, was designed by him in 1922 for the Bauer Type Foundry. This type, like many of his others, possesses the "light touch" which is one of the recognizable hallmarks of a good many of the Bernhard faces.

Bernhard Cursive has a buoyant quality to it, yet it is not overly ornate. The letters of the upper case are free-flowing and remind one of the natural grace of a ballet dancer. The delicate yet accented swashes and curves seem as perfectly shaped as if they were rendered with a French curve. The lower case is considerably more restrained. The serif-less ascenders (which are one of the strongly identifying elements of this face) are majestically tall, but the descenders are relatively puny. Also there is a more consistent, though less exciting treatment evident in the lower case, in the balanced relationship of thick and thin strokes and the fixed angle of inclination. The k is designed with a decorative interlacing loop; the f extends its curious elongated giraffe-like neck high above all other ascenders; the vertical strokes of the p and q project high above the bowls; the z is quite unique in its multiple interlacing loops and its ball terminals.

There is something especially gay and almost musical about the capitals of Bernhard Cursive which makes each letter suitable as a decorative initial to be embroidered on fine Irish linen. The lower case letters do not reflect quite the same grace or *joie de vivre*.

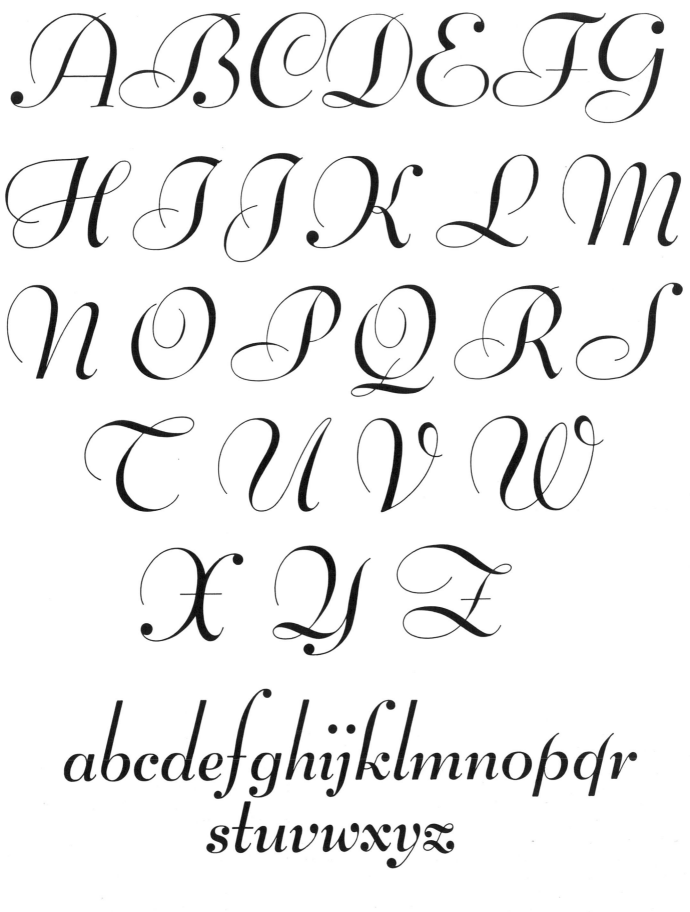

ABCDEFG
HIJKLM
NOPQRS
TUVW
XYZ

abcdefghijklmnopqr
stuvwxyz

1234567890

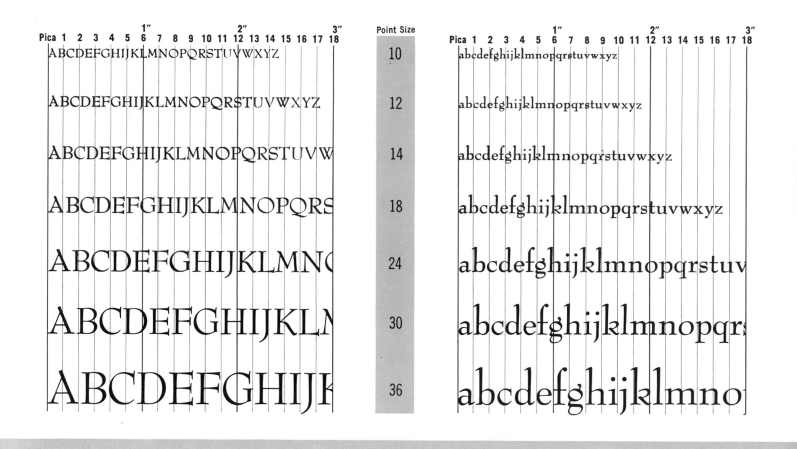

Point Size
10
12
14
18
24
30
36

• VARIATIONS OF THIS TYPE:

Bernhard Modern Italic **Bernhard Modern Bold** ***Bernhard Modern Bold Italic***

Bernhard Roman *Bernhard Italic*

ABOUT THIS TYPE FACE

The real beauty of Bernhard Modern Roman typeface can be perhaps best appreciated when this typeface is viewed in its larger point sizes. Some typefaces make their best showing in the diminutive sizes but look unhappily out of proportion, sometimes quite grotesque, in point sizes larger than 36 point. Not so with this typeface! The beauty of the Bernhard specimen shown here is enhanced with enlargement; this is especially true of the capital letters.

This type is easily distinguishable because of its grace, exquisite relationship between thick and thin, and the quality of its tapered thin lines and serifs. Note the arms of the E, the beautiful tapered accents which terminate with equally graceful serifs. Other distinguishable features include the "cross over" W with its interlocking V's, the extension of the diagonal to the left side of the N, the tilted O, and the R with the open end of the bowl which joins the swash diagonal tail. All are beautifully shaped with the accents on a slanted axis. Also note the right diagonal stroke of the A which extends beyond the apex, and the splayed M with its short center element. The lower case is distinguished by its high ascenders, some of which are taller than the full height of the caps.

Bernhard Modern Roman is both a display alphabet and a text alphabet. In either case this type, designed in 1937 by Lucian Bernhard, spells elegance and refinement. The Bernhard face shown here is cast as a foundry type in the following sizes (upper and lower case) 8, 10, 12, 14, 18, 24, 30, 36, 42, 48, 60 and 72 points. Its family variations are Bernhard Modern Italic, Bold, Italic, and Bernhard Roman.

ABCDEFG
HIJKLMN
OPQRST
UVWXYZ

abcdefghijklmn
opqrstuvwxyz

1234567890

	Point Size	
ABCDEFGHIJKLMNOPQRS	18	*abcdefghijklmnopqrstuvwxyz*
ABCDEFGHIJKLMN	24	*abcdefghijklmnopqrstuvwxyz*
ABCDEFGHIJKL	30	*abcdefghijklmnopqrstuv*
ABCDEFGHII	36	*abcdefghijklmnopqr*
ABCDEFG	48	*abcdefghijklmn*
ABCDEF	60	*abcdefghijkl*

ABOUT THIS TYPE FACE

This face, designed by Lucian Bernhard in 1933 for American Type Foundry, possesses a charm and gaiety which makes it an ideal typeface for happy occasions. Though it seems to lack consistency when clinically analyzed, if one letter is carefully compared with the next, the total effect in terms of tone and color is harmonious. The O is full-bodied and round, yet the C has a flattened bowl. The capital F follows the lower case format, while the G shows an ornamental swash element resembling a descender. The M and N remind one of the traditional lower case structure. The Z is designed with a calligraphic flourish swash, made distinctive and continental by a thin cross line going through the thin diagonal.

The lower case shows considerably greater consist-ency. The ascenders are high in relation to the body of the letter and some descenders terminate in hooks. The lower case z is a miniature of the large Z.

Bernhard Tango is an ornamental typeface appropriate for occasions reflecting a gay and light and twinkle-toe atmosphere. Though it is classified as an italic, it is almost upright, with abrupt change-over in color, from fine hairlines to positive accents. One of the identifying characteristics of Tango is the hairline upstrokes which take off from the feet of the downstrokes. Of particular interest are the connecting elements of the lower case k and r, as well as in the capital B, P and R. Bernhard Tango has its double in the Amsterdam Type Foundry version called Aigrette.

A B C D E F G
H I J K L M N
O P Q R S T U V
W X Y Z

abcdefghijklmno
pqrstuvwxyz

1234567890

THIS TYPE
RESEMBLES:
AIGRETTE

BERNHARD TANGO

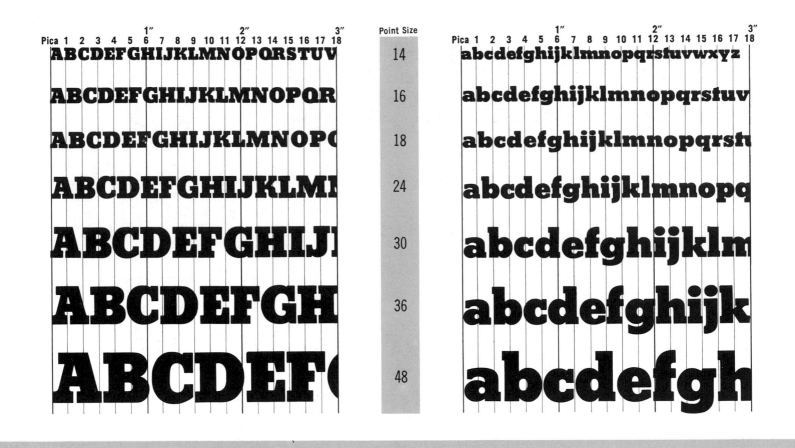

			Point Size		
Pica 1 2 3 4 5 6 7 8 9 10 11 12 13 14 15 16 17 18				Pica 1 2 3 4 5 6 7 8 9 10 11 12 13 14 15 16 17 18	
ABCDEFGHIJKLMNOPQRSTUV			14	abcdefghijklmnopqrstuvwxyz	
ABCDEFGHIJKLMNOPQR			16	abcdefghijklmnopqrstuv	
ABCDEFGHIJKLMNOP			18	abcdefghijklmnopqrst	
ABCDEFGHIJKLM			24	abcdefghijklmnopq	
ABCDEFGHIJ			30	abcdefghijklm	
ABCDEFGH			36	abcdefghijk	
ABCDEF			48	abcdefgh	

• VARIATIONS OF THIS TYPE:

Beton Bold Condensed **Beton Bold** *Beton Extra Bold Oblique*

ABOUT THIS TYPE FACE

This typeface, designed by Heinrich Jost for the Bauer Foundry in 1930, is one of the most frequently used of all fat display alphabets. Its popularity is well-deserved. It is structurally strong; in addition, it possesses massive impact value and reproduces well in direct or reverse printing.

An analysis of the type shows it to be of a thick-and-thin variety, although the general effect is of an overpowering allover weightiness. The serifs are slab-like, heavy and for the most part the same weight as the thin part of the letter form. You will note that there are really three different types of serifs to the Beton. One is a square rectangular stroke that juts out of the main stem, as shown in the letter I. The other is a bracketed type of

serif which blends softly into the stroke as in the lower left serif of the A. The third species of serifs is a tapered variety as on the E, F, L, T and Z. The one-sided serif on the top of the A is one of the identifying clues of the Beton.

The lower case carries the family identity: stocky slab serifs, general massiveness and compact strength. The g has an open tail, the t has an oblique top and a slab serif, and the y has a foot serif extending to the right.

Beton's popularity is attested to the fact that it is a stock item in most type houses in a wide assortment of sizes and variations from 12 point up to 84. It so closely resembles Girder, Memphis Bold and Stymie Bold that one can be mistaken for another.

ABCDEFG HIJKLMNO PQRSTUV WXYZ

abcdefghijk lmnopqrst uvwxyz 1234567890

THIS TYPE
RESEMBLES:
STYMIE BOLD,
MEMPHIS BOLD,
GIRDER

BETON EXTRA BOLD **49**

Pica 1 2 3 4 5 6 7 8 9 10 11 12 13 14 15 16 17 18	Point Size
	18
	24
	30
	36
	48
	60
	72

THIS TYPE FACE DOES NOT
COME WITH A LOWER CASE

● VARIATIONS OF THIS TYPE:

BETON OPEN CONDENSED

ABOUT THIS TYPE FACE

This is an outline three dimensional form, with a heavy accented shadow to the right and lower side. The slab serifs are square, blocky and short. Although a casual glance gives one the impression of a single-weight block letter, a closer inspection will show that this is a thick-and-thin letter. The variation of thick and thin is evident in the W. Note particularly the one-sided top serif of the A and the flush-on-the-line tail of the Q. The deflected angle stroke of the thin side of the X does not cross the heavy side in one direct stroke, but is broken as it were, into two distinct segments. Although the serifs are for the most part square and blocky there are some varia-tions in shape and style. Look closely at the serifs of the A. The lower left one is somewhat tapered, while the right cuts across the upright stroke squarely. Also note

still another variety of serif structure in the E. The serifs of the main upright stroke are square, while the serifs of the arms are tapered. Also note the absence of any serif whatever in the center arms of the E and F.

Designed in 1931 by Heinrich Jost for the Bauer Foundry in Germany, Beton Open has had a number of "look alike" versions and variations. It has its almost exact counterpart in Stymie Open, Rockwell Shadow and Superba Illustra. Beton Open does not come with a lower case.

Used in moderation, Beton Open can be very effective in display advertising, headings, and occasionally on book jackets. It has good possibilities as a two-color letter—a light color within the outline form, black as a key color.

ABCDEF
GHIJKL
MNOPQ
RSTUV
WXYZ
1234567890

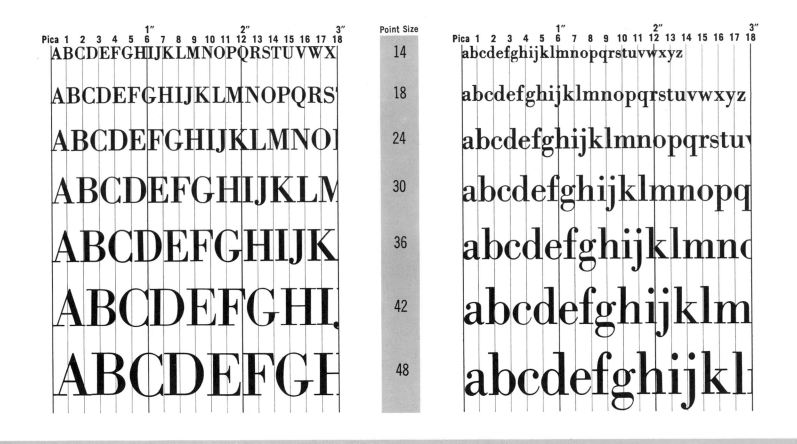

ABCDEFGHIJKLMNOPQRSTUVWX **14** abcdefghijklmnopqrstuvwxyz

ABCDEFGHIJKLMNOPQRS **18** abcdefghijklmnopqrstuvwxyz

ABCDEFGHIJKLMNO **24** abcdefghijklmnopqrstuv

ABCDEFGHIJKLM **30** abcdefghijklmnopq

ABCDEFGHIJK **36** abcdefghijklmn

ABCDEFGHI **42** abcdefghijklm

ABCDEFG **48** abcdefghijkl

• VARIATIONS OF THIS TYPE:

Bodoni Italic **Bodoni Bold** ***Bodoni Bold Italic*** **Bodoni Bold Condensed**

ABOUT THIS TYPE FACE

Originally created by the 18th century Italian designer, Giambattista Bodoni, the typeface which bears his name is considered by many typophiles to rank among the most "letter perfect" type creations of all time. Historically, it is the forerunner of modern type. Bodoni has a pristine beauty perhaps unmatched by anything that has been designed before or after. It is completely devoid of typographic eccentricities or artificial excesses. A Roman alphabet in the true sense of the word, Bodoni's intrinsic beauty lies in the clean-cut relationship between the thick and thin elements. The hairlines are thin and serve as foils to the heavy strokes. The serifs are long and pencil thin and go square across the stems without transitional brackets. The accented stresses of the round elements such as in the B, C, G, etc., are well modulated and balanced beautifully on the center crest of the curve. The

perfect oval symmetry of the outer shell of the O is reflected in the beautifully balanced counter within the letter. Identifying letters are the A which has a pointed apex, and the K, the pointed juncture of which is formed by the diagonals barely touching the main stem. This characteristic is also discernible in the lower-case k. The W is formed by an overlapping of two V's with one common hairline serif uniting the interlocking strokes.

Bodoni, like Caslon, is one of the "safe" typefaces to use for almost any occasion intended for close viewing. The extremely fine hair-line elements however do not have the carrying power for far-off viewing. It is the choice alphabet for book covers, newspaper and magazine advertising, letterheads, brochures, etc. It needs a good slick well-polished paper stock for best printing results.

ABCDEFG
HIJKLMN
OPQRSTU
VWXYZ

abcdefghijk
lmnopqrstu
vwxyz
1234567890

THIS TYPE
RESEMBLES:
BAUER BODONI

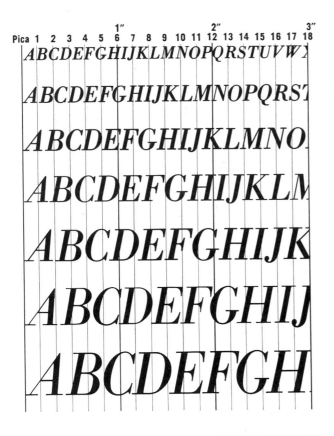

	Point Size	
ABCDEFGHIJKLMNOPQRSTUVW	14	*abcdefghijklmnopqrstuvwxyz*
ABCDEFGHIJKLMNOPQRST	18	*abcdefghijklmnopqrstuvwxyz*
ABCDEFGHIJKLMNO	24	*abcdefghijklmnopqrstuv*
ABCDEFGHIJKLM	30	*abcdefghijklmnopq*
ABCDEFGHIJK	36	*abcdefghijklmn*
ABCDEFGHIJ	42	*abcdefghijklm*
ABCDEFGH	48	*abcdefghijkl*

● VARIATIONS OF THIS TYPE:

Bodoni Book Italic

ABOUT THIS TYPE FACE

One of the best-remembered characteristics of all Bodoni typefaces is the clean sharp contrast of weight between its thin and thick strokes. The Bodoni Italic shown here retains that family identity. The Italic caps are essentially the same as in the basic Roman style; the lower case undergoes changes, which are not merely confined to the slant of the letter but which apply to the basic structure as well. But these changes in no way diminish the pristine purity of the basic letter form. Some of the lower-case letters, such as the a, f, k, etc., are altered from that of the Roman, shown on page 52. The main stems are straight as a ruler, mechanically even in thickness. The upper serifs are additive and square, that is they do not blend into the letter at all. The lower serifs, such as in the i and l are rounded extensions of the stroke itself which turn into hairlines. Among the key identifying letters of the lower-case Bodoni Italic are the following: the musical clef-shaped f, beautifully balanced and terminating with a ball-shaped hook at both ends; the whimsical feather-in-the-cap curleque protruding from the side of the g; the k with its thin hairline french-curved element ending in a ball; the square line serifs which sharply define the ends of the descenders of the p and q and the diagonal hairline of the z which unites the heavily accented horizontal strokes.

Bodoni Italic is also available in a book face, in a prodigious array of point sizes from 6 to 72 point in foundry and monotype versions. It has remained throughout the years one of the most basic italic typefaces in the typographer's palette.

ABCDEFG
HIJKLMN
OPQRSTU
VWXYZ

abcdefghij
klmnopqrstu
vwxyz
1234567890

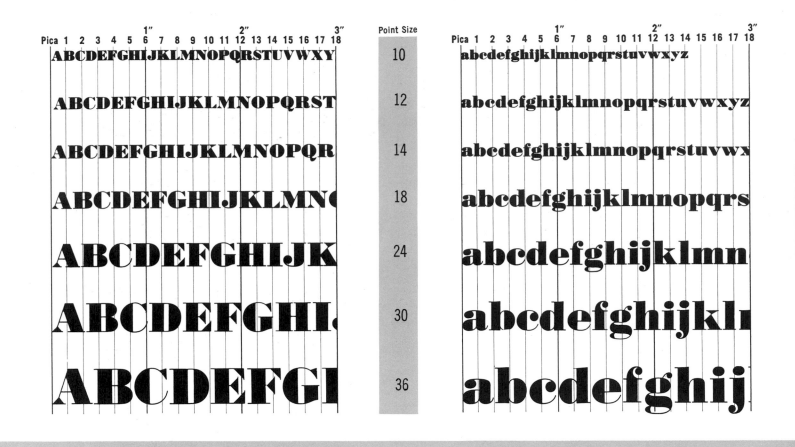

	Point Size	
ABCDEFGHIJKLMNOPQRSTUVWXY	10	abcdefghijklmnopqrstuvwxyz
ABCDEFGHIJKLMNOPQRST	12	abcdefghijklmnopqrstuvwxyz
ABCDEFGHIJKLMNOPQR	14	abcdefghijklmnopqrstuvwx
ABCDEFGHIJKLMN	18	abcdefghijklmnopqrs
ABCDEFGHIJK	24	abcdefghijklmn
ABCDEFGHI	30	abcdefghijkl
ABCDEFGI	36	abcdefghij

● VARIATIONS OF THIS TYPE:

Bodoni, Ultra Italic **Bodoni, Ultra, Extra Condensed**

ABOUT THIS TYPE FACE

This black face display type, designed by Morris Benton in 1924 for American Type Foundry is an adaptation of an early 19th century face. Structurally, Bodoni Ultra shown here is a letter form of powerful contrast, combining the two extremes, the very delicate and the very massive. Other unique features which make this an easy letter to identify and remember are the two kinds of widely different serifs; the whisp-like fine line serifs (which are the same as the hairlines in basic letter form) and the sharp triangular wedge serifs. A closer view of these wedge-like serifs will disclose a delicate hairline which extends at either end of the wedge. Look closely at the left serif of the A. Still another and most unique structural feature of Ultra Bodoni is the sharp contrast of form between the inside and outside of all bowls, exemplified adequately in the O. The outside rim of this

letter is circle-round, but the inside area is a vertical narrow channel shaped by two parallels. This structural feature is consistent in all round letters of both upper and lower cases. The ascenders and descenders are short and terminate in a hairline serif. Note the unique formation of the ball appendage of the lower part of the j reflected somewhat in the structure of the upper part of the f.

This very popular display face is available in foundry, mono and Ludlow versions in sizes which range from 6 to 120 points. The Ludlow version is known as Bodoni Black.

Good judgment would dictate that an eccentric fat display face such as this one be used sparingly. It seems to be favored for department store advertisements both for newspapers and window display cards.

ABCDEFG
HIJKLM
NOPQRST
UVWXYZ

abcdefghi
jklmnopqr
stuvwxyz

1234567890

THIS TYPE
RESEMBLES:
THOROWGOOD,
BODONI BLACK

ABCDEFGH99KLMNOPQRSTUVU **18** abcdefghijklmnopqrstuvwxyz

ABCDEFGH99KLMNOPQ **24** abcdefghijklmnopqrstuvwxyz

ABCDEFGH99KLMN **30** abcdefghijklmnopqrstuw

ABCDEFGH99KL **36** abcdefghijklmnopqr

ABCDEFGH9 **48** abcdefghijklm

ABCDEFG **60** abcdefghijkl

ABOUT THIS TYPE FACE

Brody script looks as if it were lettered with an unwashed water color brush held in an upright position. The edge of the letters are somewhat straggly as if the bristles of the brush had been partly stiffened by dried-up paint from a previous performance. The result is a very personalized thick-and-thin script which combines vigor and casualness. It is a heavy face letter form designed to make the connective links of most letters join to form unbroken words, much in the manner of handwriting. To further enhance that illusion, the letters are made not to align exactly, either on the top or bottom, thus producing a variation in height. Because this is a typeface which very closely simulates the work of the hand letterer, it is a good choice for any typographic layout where hand lettering would be appropriate as focal copy —titles of books or chapter headings, headlines, personalized signatures and logotypes, etc.

Brody is available in sizes ranging from 18 to 72 point, in one face only (the one shown in this book). The capitals do not have connecting links, yet most of the lower-case letters interlock. This is not at all out of keeping with the normal pattern of handwriting practice, where the break in words often comes between the beginning capital letter and the other letters comprising words.

Brody has no exact counterparts or "look alikes" in other typefaces. It bears a remote resemblance to Repro Script shown on page 148. Better check with your typographer before specifying Brody since it has not reached a popularity as stock in trade to make it a requisite for every typesetter's composing room.

ABCDEFGH9
JKLMNOPQR
STUVWXYZ

abcdefghijklmno
pqrstuvwxyz

1234567890

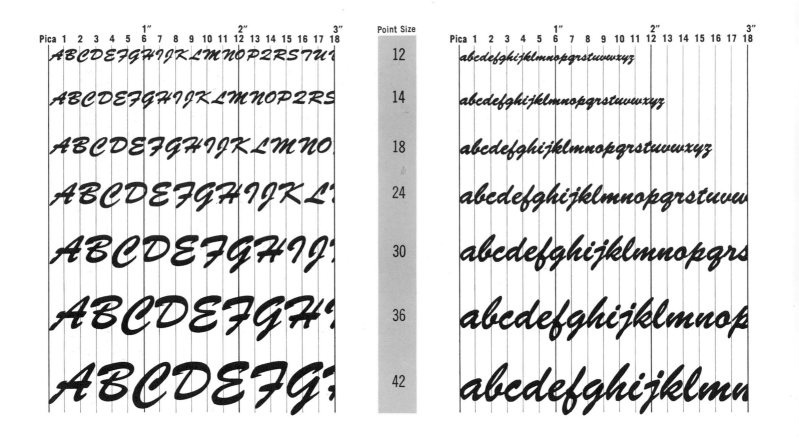

ABOUT THIS TYPE FACE

Here is a casual informal letter style which in a comparatively short time has become one of the best-recognized scripts in contemporary advertising typography. It was designed in 1942 by Robert E. Smith for the American Typefounders. A close inspection of the various letters will reveal that a consistency of construction is maintained without sacrifice of calligraphic informality. In the capitals most horizontals are strong and heavy as if produced with the broad chisel side of a lettering tool. The verticals are for the most part comparatively thin. The letter H epitomizes that structural characteristic. Brush Script is based on handwriting, but not on a specimen of the meticulous Spencerian "hand." Rather it reminds one of a quick notation dashed off with a flowmaster brush or chisel layout pencil.

The lower case called for the solution of structural problems not solely confined to design and appearance. The letters are designed to make it possible to set up type so that an almost perfect linkage of strokes is achieved in an attempt to heighten the illusion of a normal hand-lettered script. Though a close inspection will reveal tiny breaks in the connecting links, these generally tend to diminish when the type is used in smaller sizes and when there is a normal flow of ink in printing.

Although Brush Script is not a particularly aesthetic typeface, it is one of the most popular informal type scripts in use today. Its popularity can be attested to by the fact that nearly every typographer in the country carries it in stock and that it is cast both as a foundry and a monotype in a wide range of sizes.

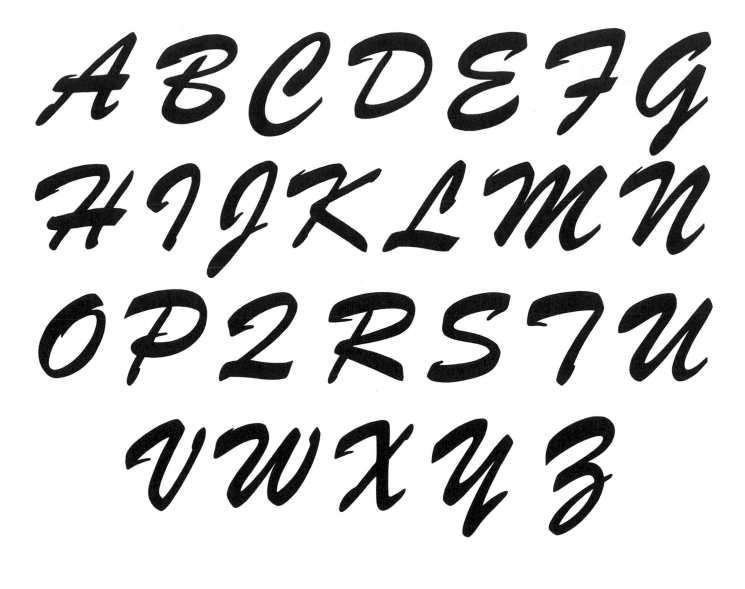

ABCDEFG
HIJKLMN
OPQRSTU
VWXYZ

abcdefghijklmno
pqrstuvwxyz

1234567890

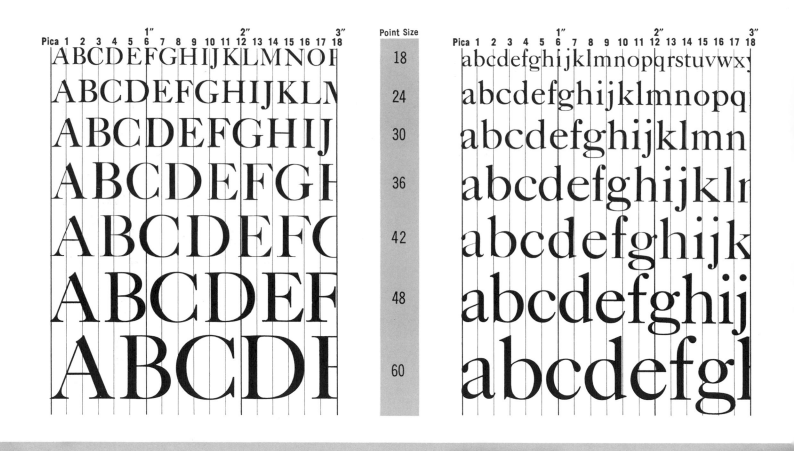

	Point Size	
ABCDEFGHIJKLMNOF	18	abcdefghijklmnopqrstuvwx
ABCDEFGHIJKL	24	abcdefghijklmnopq
ABCDEFGHIJ	30	abcdefghijklmn
ABCDEFGH	36	abcdefghijkl
ABCDEFC	42	abcdefghijk
ABCDEF	48	abcdefghij
ABCDI	60	abcdefgl

• VARIATIONS OF THIS TYPE:

Caslon Italic **Caslon Bold** ***Caslon Bold Italic*** **Caslon Bold Condensed**

Caslon Extra Condensed Caslon Old Face *Caslon Old Face Italic*

ABOUT THIS TYPE FACE

Caslon (in its multifarious variations) was once the #1 typeface, dearest to the hearts of printers all over the world. "When in doubt use Caslon" is an old maxim among typographers. Its durability is partly due to the fact that it is a typeface devoid of doodads, eccentricities or extraneous embellishments. Its pure Roman "clean" look makes for easy legibility and fitness for most any typographic task. Among its identifying structural features are the following: the apex of the A which terminates in a slightly curved and diagonal stroke extending beyond the left diagonal stroke; the pencil-thin fine strokes contrasting sharply with the clean heavy strokes; the finely bracketed serifs which end whispy-thin. Note, too, the somewhat extended form of most capitals, especially the L, N, W and the abnormally wide-set T and Z; the ball-shaped terminal of the J which dips lower than the normal alignment and the vigorous but graceful

swash terminal of the Q. In the lower case the structural characteristics which help to identify Caslon are: the triangular wedge-shaped serifs of tops of the ascenders in the b, d, h, k and l; the high crossbar of the e; the three top serifs of the w; the diagonal stress of the lower case c and e.

This alphabet is traced back to the 18th century English designer, William Caslon. It was introduced in America in 1857 under the name it now bears, but prior to that it was known as "Old Style." Every type foundry in the world has cast issues of Caslon in foundry, mono and linotype versions. As a result there are numerous variations of Caslon in a prodigious number of point sizes and faces. It is best to refer to the specimen typebook of your favorite printer in "specing" copy for a particular species of Caslon. The one shown here (Caslon No. 540) is readily available everywhere.

ABCDEFG
HIJKLMN
OPQRSTU
VWXYZ

abcdefghij
klmnopqrst
uvwxyz
1234567890

	Point Size	
ABCDEFGHIJKLMNOPQRSTU	14	*abcdefghijklmnopqrstuvwxyz*
ABCDEFGHIJKLMNOP	18	*abcdefghijklmnopqrstuvwx*
ABCDEFGHIJKLM	24	*abcdefghijklmnopqrs*
ABCDEFGHIJI	30	*abcdefghijklmnop*
ABCDEFGH	36	*abcdefghijklm*
ABCDEFG	42	*abcdefghijkl*
ABCDEF	48	*abcdefghij*

ABOUT THIS TYPE FACE

This is a variation of the parent alphabet Century Schoolbook shown on page 66. Both are credited to L. B. Benton, who was associated with the American Type Foundry for many years. Century Expanded Italic shares with its roman parent the classic beauty and the delicate balance between thick and thin strokes. The upper case of Century Expanded Italic shown here, does not differ substantially from the straight roman version of Century except of course that it has a slant. The lower cases of both alphabets, however, differ tremendously. The lower-case Century Expanded Italic is a distinct alphabet in itself and not merely roman letters tilted to an italic angle.

One of the outstanding characteristics of the lower-case Century Expanded Italic is the structure of the serifs and the unique distribution of weight of the upright stroke; the letter i will serve as an example. The head finial (starting serif) is unusually long and grace-fully twists and blends into the main stroke, to come up again just as gracefully to balance the foot finial (ending serif). Note that the main stroke of the i is not merely an accented long line, uniform in thickness from top to bottom, but that the stroke bends and turns in a sort of reverse s shape. Only the center of the stroke bears the full brunt of pressure. This exquisitely modulated stem structure is evident in the component elements of other letters, such as the right side of the h, m, n, etc.

The lower-case letters of Century Expanded Italic are used far more frequently than the upper case. In general, the upper case is employed for headline display, while the lower case is very popular as a body and text letter and is available in linotype from 6 to 18 points and foundry types which advance to 72 point. To best appreciate the identifying structure of the lower-case alphabet, enlarge in pencil-outline a letter such as the n or the u for further analytical study.

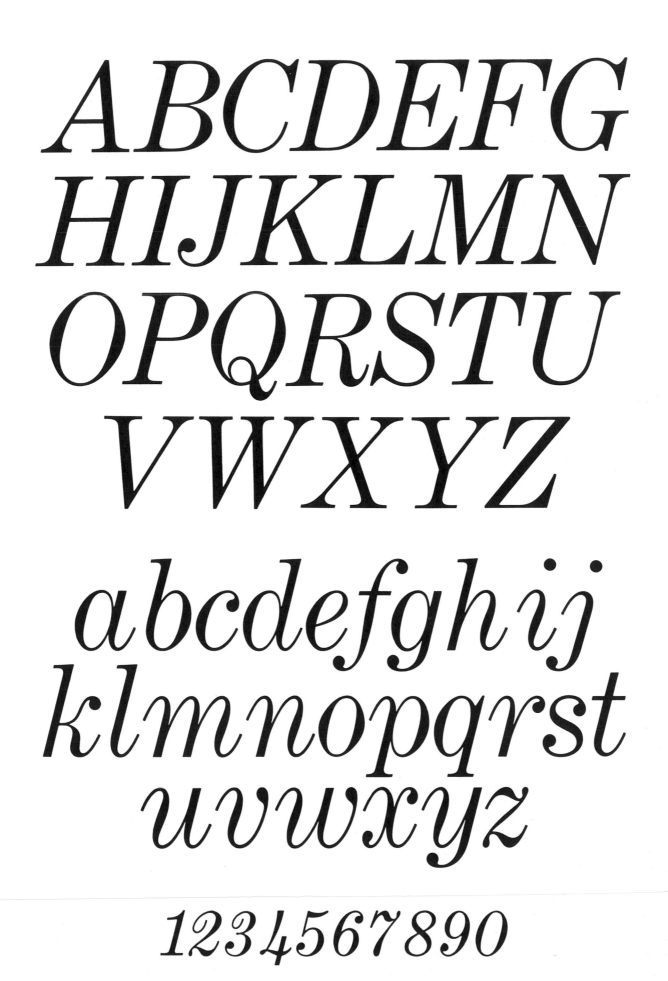

ABCDEFG
HIJKLMN
OPQRSTU
VWXYZ

abcdefghij
klmnopqrst
uvwxyz

1234567890

ABCDEFGHIJKLMNOPQRSTU

ABCDEFGHIJKLMNOPQR

ABCDEFGHIJKLMNOP

ABCDEFGHIJKLM

ABCDEFGHIJK

ABCDEFGHI

ABCDEFC

14
16
18
24
30
36
48

abcdefghijklmnopqrstuvwxyz

abcdefghijklmnopqrstuvwxy

abcdefghijklmnopqrstuvw

abcdefghijklmnopqrs

abcdefghijklmno

abcdefghijklm

abcdefghij

● VARIATIONS OF THIS TYPE:

Century Expanded **Century Bold** **Century Bold Condensed**
Century Schoolbook Italic **Century Schoolbook Bold** *Century Old Style Italic*

ABOUT THIS TYPE FACE

Century Schoolbook has proven itself through the years to be one of the most serviceable dual-purpose typefaces both as a display face in the large sizes and a body face in the smaller size range. It is easy to read, easy to space, reproduces well both in direct and reverse printing and is obtainable in a very wide assortment of sizes in foundry, mono and linotype. No respectable American printer is ever without a good supply of Century Schoolbook.

This is one of a series of faces designed way back in 1890 by L. B. Benton for the American Typefounders. It is as "modern" today as it was when it was first introduced and has been a standard face for American printers ever since. Though it was designed specifically for periodicals, its practical nature has expanded its application to diversified uses, both as a copy and text letter and a display face.

This typeface is so devoid of eccentricities or typo-graphic garnishes that it sometimes is not easy to readily tell it apart from Scotch Roman or other basic Roman faces. But Century does have a personality of its own if you care to be on familiar terms with it. Here are a few distinctive clues that help you tell it apart from the stockpile of similar Roman alphabets: the little hook-like spur of the G; the rather well-rounded ball swash which terminates the lower part of the J; the loop-shaped swash which is nestled within the counter of the Q; the tail stroke of the R which is slightly curved and flood-weighted towards the bottom as it makes its turn up-ward. Lower-case Century can be identified by its b, which has an obtuse nick in the upright stroke, a characteristic repeated in the upright of the q; the full-bodied ball terminal of the f; the 3 cross serifs of the w; and the heavy diagonal of the z. The alphabet, both upper and lower case, is of almost even set in proportion, all letters occupying about the same amount of space.

ABCDEFG
HIJKLMN
OPQRSTU
VWXYZ

abcdefghij
klmnopqrst
uvwxyz

1234567890

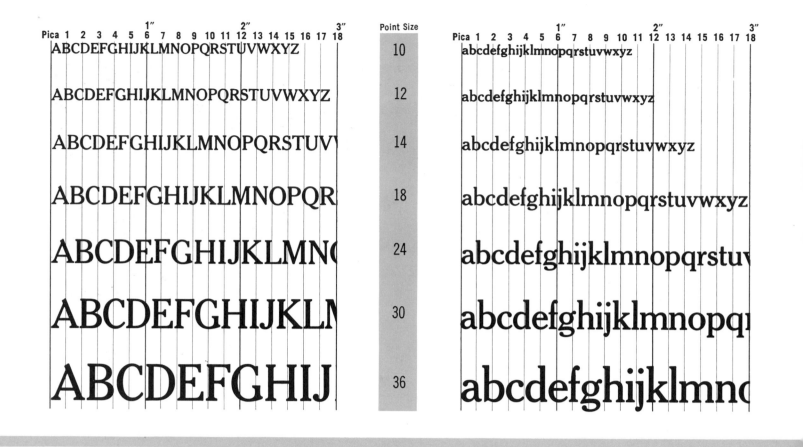

Point Size
10
12
14
18
24
30
36

• VARIATIONS OF THIS TYPE:

Cheltenham Oldstyle *Cheltenham Oldstyle Italic*

Cheltenham Medium Italic **Cheltenham Bold Italic** Cheltenham Bold Condensed Italic

CHELTENHAM BOLD **Cheltenham Bold Ext.** Cheltenham Bold Condensed

ABOUT THIS TYPE FACE

It would be a somewhat serious omission to fail to include at least one version of Cheltenham in an anthology of practical typefaces. This face is included here not because it represents the author's personal favorite but rather because Cheltenham is a traditional face among traditional printers. It is strong, reliable and can pull a load; it is a veritable workhorse in the stable of American alphabets.

Cheltenham carries some very easily identified earmarks. The serifs are flat and stubby and slope into the main stems of the letter form. Though the elements are thick and thin, they appear at first glance to be one thickness throughout. The capital A and the lower-case g are unmistakable clues as to the identity of this typeface. The heavy stroke of the A, you will notice, projects be-

yond the thin stroke, and ends in an angle cut-off. The g is unique in the formation of the lower bowl which is open, and connects to the upper element by means of a rather abrupt diagonal line. The upper-case G also is unique in the overhanging serif-like projection at the bottom of the short upright stroke.

Originally designed by Bertram G. Goodhue in 1896, the Cheltenham family of typefaces was later developed by Morris Fuller Benton and was cast by the American Type Foundry in 1902. Since then Cheltenham Type has in its very many variations remained one of the standards of American typography. It is one of the most widely-known pure American typefaces, used for heavy advertising copy in newspapers, and for handbills.

ABCDEFGHIJ
KLMNOPQRS
TUVWXYZ
abcdefghijkl
mnopqrstuv
wxyz
1234567890

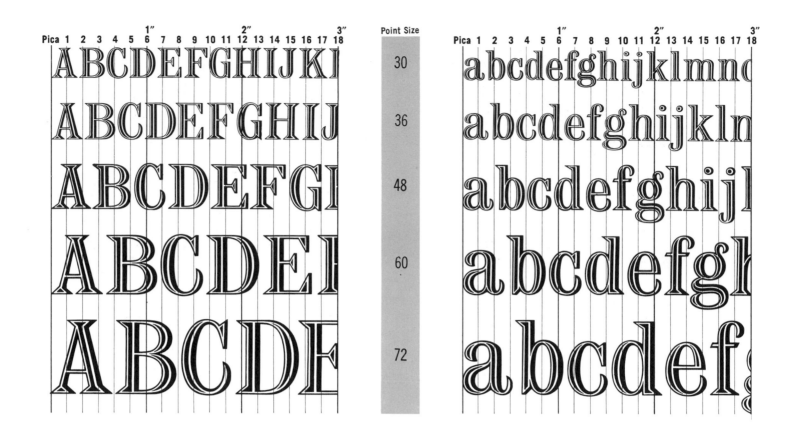

- VARIATIONS OF THIS TYPE:

Chisel Expanded

ABOUT THIS TYPE FACE

Chisel is an ornamental version of Latin Bold Condensed. It's easy to remember to associate this type with its name because its fundamental structure bears an unmistakable resemblance to the inscription on a stone incised with a chisel-edged tool. The serifs are sharp triangular shapes which project abruptly out of the main stroke without any semblance of curves, almost as if the sharp-edged cutting tool were abruptly turned at a 30° angle. Essentially this is a Roman-outline letter, darkly accented on the right side, with a similar accented stroke used as an inset within each of the main heavy strokes. This produces the illusion of a three-dimensional effect; the letter appears either sunken below or raised above the surface, depending upon a shifting point of view. Chisel is an attractive novelty display typeface which can add sparkle and interest to a typographic layout. Used with discretion this typeface can add a note of conservative elegance and classic poise to chapter headings for books, headings for ads or one-line copy for letterheads.

Because of its ornate skeleton of multiple lines, Chisel has a tendency to lose its clarity and effectiveness in the smaller sizes. It is available in point sizes 30, 36, 48, 60 and 72, in both upper and lower case. The lower case has a large x height with short ascenders and descenders. Chisel has no "look-alikes." It has remained in a distinct class by itself and cannot be mistaken for any other typeface in the printer's repertoire. The type was cut in 1939. In 1955 an expanded titling version was added.

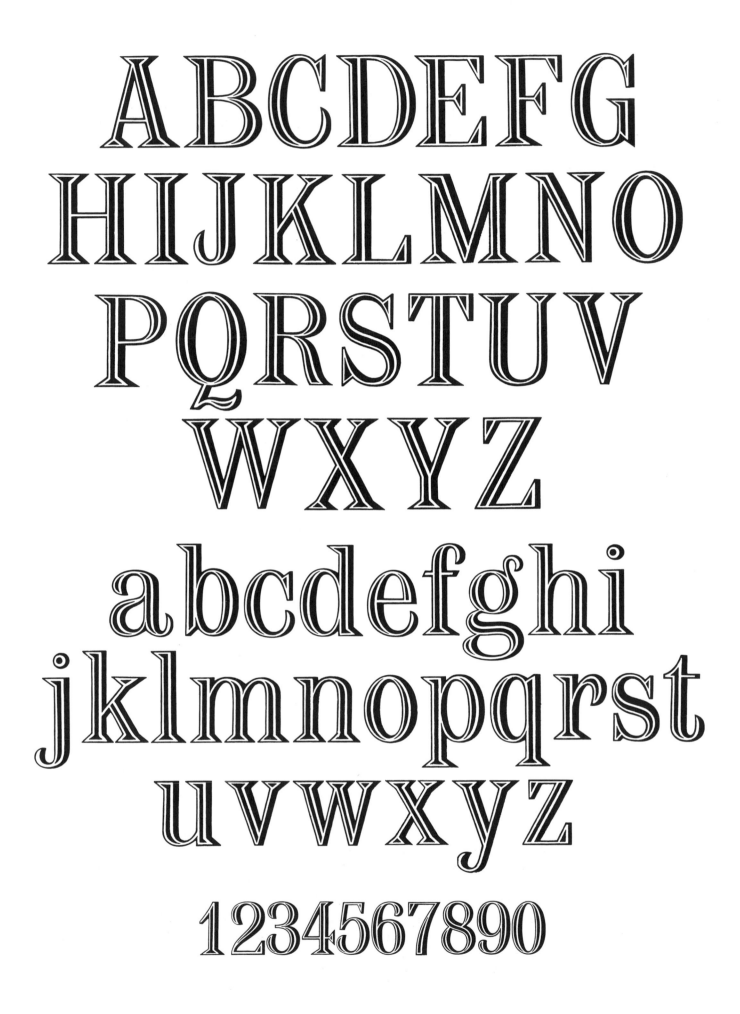

ABCDEFG
HIJKLMNO
PQRSTUV
WXYZ

abcdefghi
jklmnopqrst
uvwxyz
1234567890

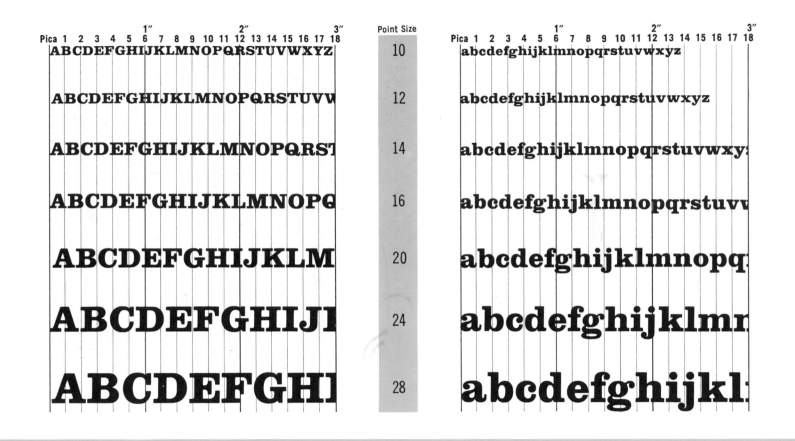

	Point Size	
ABCDEFGHIJKLMNOPQRSTUVWXYZ	10	abcdefghijklmnopqrstuvwxyz
ABCDEFGHIJKLMNOPQRSTUVW	12	abcdefghijklmnopqrstuvwxyz
ABCDEFGHIJKLMNOPQRST	14	abcdefghijklmnopqrstuvwxy
ABCDEFGHIJKLMNOPQ	16	abcdefghijklmnopqrstuvv
ABCDEFGHIJKLM	20	abcdefghijklmnopq
ABCDEFGHIJI	24	abcdefghijklmr
ABCDEFGHI	28	abcdefghijkl

● VARIATIONS OF THIS TYPE:

Clarendon **Craw Clarendon** Craw Clarendon Book

Clarendon Bold Ex.

ABOUT THIS TYPE FACE

Clarendon is a good type choice where strength, structural simplicity and legibility must be integrated. The serifs are long, slab-shaped and slightly bracketed into the main elements of the letter form. Among other recognizable features of Clarendon are the rather abbreviated arms of the E and F; the below-center stroke of the G on its tapered lower spur appendage; the compact structure of the swash of the G which nestles in the counter of the letter; and the three top serifs of the W. The structure of the capitals suggests a self-sufficient compactness which makes each letter appear to sit solidly within a square area of its own. It is a thick-and-thin letter with a well modulated contrast in thickness of its structural elements.

The lower case reflects the same compactness and square-shaped proportion of the capitals. Ascenders and descenders are short and stocky. Note the subtle variation in thickness of the lower-case letters; the swing-up foot finial of the a; the obtuse nick of the b; the flat slab serifs of the p and q; and the hook-curl descender of the y.

Clarendon is a fat-face Egyptian type design created in the midst of the 19th century industrial era and has since undergone several modern interpretations. Originally put out as a dictionary typeface because of its excellent legibility and the structural stability to accommodate itself to printing on any kind of paper, it is presently enjoying a revival as an advertising typeface.

ABCDEFGHI
JKLMNOPQR
STUVWXYZ

abcdefghij
klmnopqr
stuvwxyz

1234567890

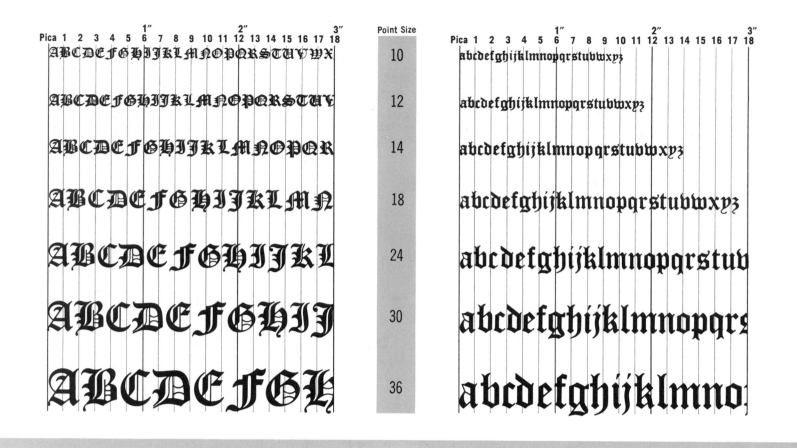

ABOUT THIS TYPE FACE

One of the more frequently used "Old English" typefaces is the one shown here and classified in the printer's specimen books as Cloister Black, or Cloister Text. The specimen shown here, inspired by a 16th century English black text letter was developed by Morris Benton in 1903 and is the favorite "Old English" on layouts for wedding announcements, testimonials, Easter and Christmas greetings, etc. There are a number of other faces which may be used as alternates without seriously affecting the tone or spirit of the layout. Principal among these are Engravers Old English, Wedding Text and Shaw Text.

There are a number of set rules to adhere to in laying out copy for Cloister Black (or any other species of Old English). First: Never use capitals to form words. Since the capital letters are considerably more ornate than the

lower case, it becomes a visual puzzle to try to read words composed solely of caps. Second: Do not letterspace Old English. The words read best when the letters are as close together as possible. Third: Use Old English faces only for appropriate occasions similar to those suggested above. It is a ridiculous misuse of the Old English for ads selling potatoes, tractors or pots and pans. Fourth: The fine hairline counters demand good paper stock—and careful make-ready in printing. Otherwise the letters fill in and the fine hairlines appear to develop breaks. Fifth: Never plan a job specifying Old English for reverse printing. The printer will have a fit and a good excuse for a sloppy or costly job.

Incidentally Cloister Black is not to be confused with Cloister Old Style or Cloister Bold. The latter faces bear no other resemblance than the name.

ABCDEFGH
IJKLMNO
PQRSTUV
WXYZ

abcdefghijklmn
opqrstuvwxyz

1234567890

THIS TYPE
RESEMBLES:
ENGRAVERS OLD ENGLISH,
SHAW TEXT,
WEDDING TEXT,
FESTIVAL TEXT,
TYPO TEXT

CLOISTER BLACK **75**

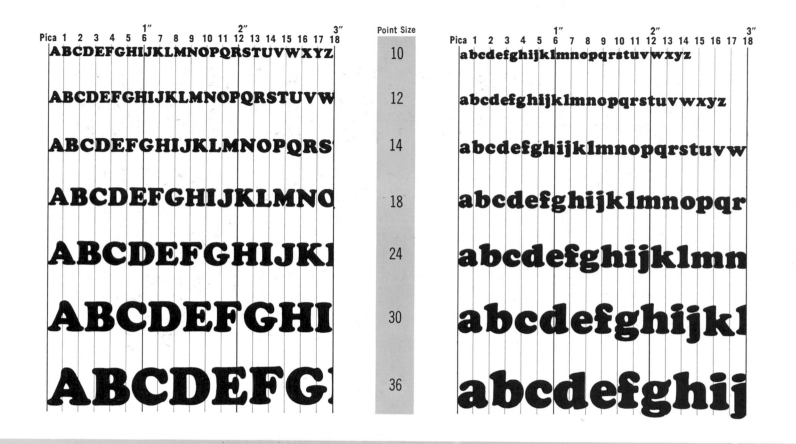

Pica 1 2 3 4 5 6 7 8 9 10 11 12 13 14 15 16 17 18	Point Size	Pica 1 2 3 4 5 6 7 8 9 10 11 12 13 14 15 16 17 18
ABCDEFGHIJKLMNOPQRSTUVWXYZ	10	abcdefghijklmnopqrstuvwxyz
ABCDEFGHIJKLMNOPQRSTUVW	12	abcdefghijklmnopqrstuvwxyz
ABCDEFGHIJKLMNOPQRS	14	abcdefghijklmnopqrstuvw
ABCDEFGHIJKLMNO	18	abcdefghijklmnopqr
ABCDEFGHIJKL	24	abcdefghijklmn
ABCDEFGHI	30	abcdefghijkl
ABCDEFG	36	abcdefghij

• VARIATIONS OF THIS TYPE:

Cooper Hi-Lite **Cooper Black Italic**

Cooper Oldstyle Italic Cooper Oldstyle

ABOUT THIS TYPE FACE

This is an all-time favorite display face which forces the attention of the viewer by its very audacity and boldness. Essentially a thick-and-thin Roman, Cooper Black was designed by Ewald Cooper in 1921. The free-flowing strokes which unite thick and thin elements blend softly into each other, almost as if the letters were formed by squeezing heavy molasses from a cake decorator's cone. There is a natural flow between one element and another. Take another look at the serifs; they are squatty, pillowy pads upon which each letter is gently cushioned. Elliptical in shape, the serifs blend softly into the main body form. Note the slanted counters in the O and Q as well as those in the C and G.

The lower case retains the structural features of the caps; note the squatty, pillowy free-flowing structure of

the stems and serifs. The elliptical dots over the i and j are very close to the letter; the top of the f swings back as if it were clearing its throat; the thin diagonal of the x is fragmented and the ascender of the y swings up. The ascenders and descenders are abnormally short. Cooper is most frequently used in its lower case with the letters spaced so close together that one letter almost touches another. Words spaced in Cooper Black are not intended to appear like a group of individual letters, but as composites and total units. There is also a shaded face called Hi-Lite, which is rarely used today.

Ludlow Black produced in 1924 is so similar in design that it can be used as an alternate to Cooper Black. Rugged Black, another similar face developed by Intertype is another "look-alike" of Cooper.

ABCDEFGH
IJKLMNOP
QRSTUVW
XYZ

abcdefghijk
lmnopqrst
uvwxyz
1234567890

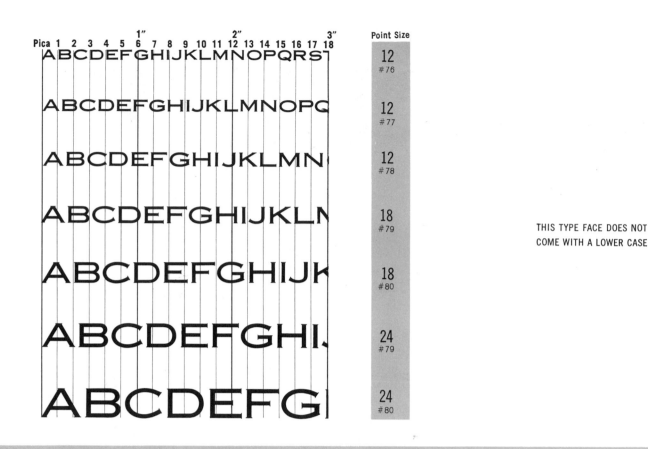

ABCDEFGHIJKLMNOPQRS

12
#76

ABCDEFGHIJKLMNOPQ

12
#77

ABCDEFGHIJKLMN

12
#78

ABCDEFGHIJKLN

18
#79

ABCDEFGHIJK

18
#80

ABCDEFGHIJ

24
#79

ABCDEFG

24
#80

THIS TYPE FACE DOES NOT
COME WITH A LOWER CASE

• VARIATIONS OF THIS TYPE:

COPPERPLATE GOTHIC LIGHT COPPERPLATE GOTHIC LIGHT CONDENSED **COPPERPLATE GOTHIC HEAVY**

COPPERPLATE GOTHIC HEAVY CONDENSED COPPERPLATE GOTHIC LIGHT EXTENDED

COPPERPLATE GOTHIC ITALIC

ABOUT THIS TYPE FACE

A business card, letterhead or invitation engraved in a Copperplate typeface reflects a conservative elegance which commands attention and respect. It is a typeface suitable for official White House stationery, professional letterheads, formal announcements and proclamations. It adds distinction to advertising typography featuring silverware, concerts and exhibitions, expensive furs, banking and insurance institutions, and the like. This face is available in a limited number of sizes but in many variations in weight and proportion; including Italic, Condensed Heavy, Light Gothic Heavy, Gothic Bold, Condensed Light, Light Expanded, etc.

The family characteristics of this specimen are common to the entire group. Some of these characteristics are: strokes are of uniform thickness; although this face (especially in its smaller sizes) seems at first glance to be sans serif, a closer inspection will reveal that there are unobtrusive feather-fine serifs terminating each stroke, producing an illusion of "flicker" sharpness and adding a note of crispness to the letter form; the short center arm of the E and the F; and the diagonal stroke of the R positioned far off into the bowl. Unlike the W, the center element of the M is pointed at the bottom and does not have a serif.

There is no lower case in Copperplate Gothic, but the effect of a lower case is achieved when two contrasting sizes of the same alphabet are used jointly and in harmony with each other.

The Copperplate shown here is not to be confused with the German "Copperplate" (Kupferplatte). The latter is a species of Roman-serifed thick-and-thin and bears no resemblance to the American type of the same family name.

ABCDEF
GHIJKL
MNOPQ
RSTUV
WXYZ
1234567890

	Point Size	
ABCDEFGHIJKLMNOPQRSTUVU	14	*abcdefghijklmnopqrstuvwxyz*
ABCDEFGHIJKLMNOPQI	18	*abcdefghijklmnopqrstuvwxyz*
ABCDEFGHIJKLM	24	*abcdefghijklmnopqrstuvwxyz*
ABCDEFGHIJ	30	*abcdefghijklmnopqrstuvwxy*
ABCDEFGH	36	*abcdefghijklmnopqrstu*
ABCDEFG	42	*abcdefghijklmnopq*
ABCDEFG	48	*abcdefghijklmnop*

• VARIATIONS OF THIS TYPE:

Coronet Light

ABOUT THIS TYPE FACE

Coronet, shown here, is a cross between an italic and script. The letters of Coronet are slanted as in a script but are not designed to actually connect. However, if the letters are set close together (as all scripts should be) a feeling of handwritten continuity can be conveyed though there are no actual physical linkages between one letter and the next.

Coronet is a typeface which is disciplined and formal, yet casual. The capitals are large in relation to the lower case and are also somewhat more free-flowing. This is a style based on handwriting, but is somewhat formalized in the degree of slant and retention of stroke relationship of thick and thin. Ascenders are exceedingly tall, and majestically stately, but the descenders are short. In imitation of natural handwriting, the f and l are looped on top. Similarly the g, q and y are constructed with looped ascenders.

Coronet, available in two faces, Bold, shown here, and Light, comes in sizes which start at 14 point and progress to 18, 24, 30, 36, 42, 48 and 60. Since this face is unfortunately not included in many typographers' listings, it would be wise to check with your composing room before committing yourself to this face in your layout.

Coronet is a logical choice for copy which reflects moods of "relaxed formality" and stately sentiment. This typeface was designed in 1937 by R. H. Middleton for Ludlow, and bears a remote resemblance to Trafton Script. And like Trafton Script, it combines well with light face composition, such as Caslon, Weiss and Bodoni Book.

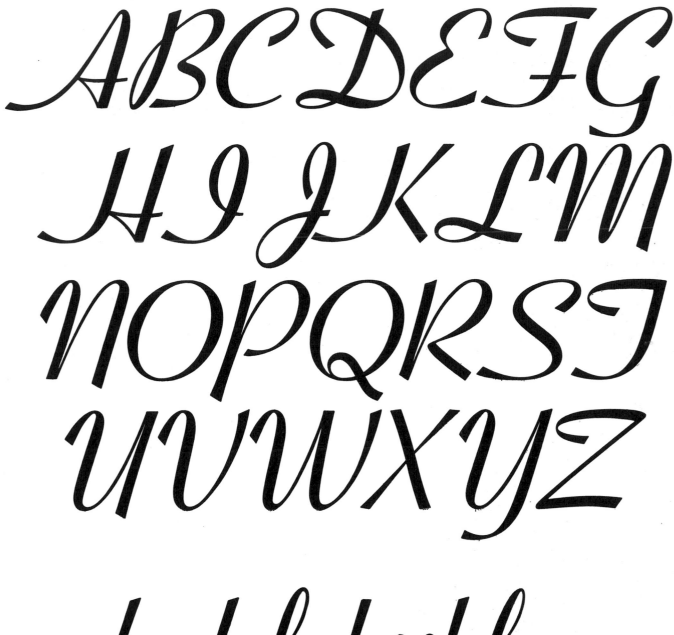

ABCDEFG
HIJKLM
NOPQRST
UVWXYZ

abcdefghijklmno
pqrstuvwxyz
1234567890

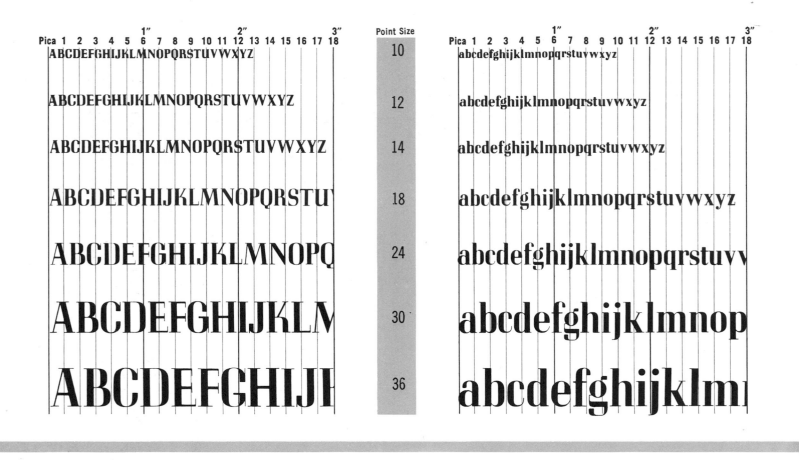

	Point Size	
ABCDEFGHIJKLMNOPQRSTUVWXYZ	10	abcdefghijklmnopqrstuvwxyz
ABCDEFGHIJKLMNOPQRSTUVWXYZ	12	abcdefghijklmnopqrstuvwxyz
ABCDEFGHIJKLMNOPQRSTUVWXYZ	14	abcdefghijklmnopqrstuvwxyz
ABCDEFGHIJKLMNOPQRSTU	18	abcdefghijklmnopqrstuvwxyz
ABCDEFGHIJKLMNOPQ	24	abcdefghijklmnopqrstuvv
ABCDEFGHIJKLM	30	abcdefghijklmnop
ABCDEFGHIJI	36	abcdefghijklm

• VARIATIONS OF THIS TYPE:

Corvinus Bold *Corvinus Medium Italic* CORVINUS Skyline

Corvinus Light *Corvinus Light Italic*

ABOUT THIS TYPE FACE

Corvinus was designed by Imre Reiner about 35 years ago. It is a style somewhat related to Ultra Bodoni Condensed. The typeface shown here is characterized by a structural combination of contrasts, the very thin and the very heavy. Another similarity this type bears to Ultra Bodoni is in the formation of the counter, the "inside space" within the letter. In both typefaces, this is formed by vertical lines running parallel to each other forming a long rectangular area. Corvinus has many distinct features of its own however, not necessarily reflected in any other face. In the main, there are three weights to the strokes: a whispy hairline stroke which forms the serif; a modulated thin line which appears in some instances as crossbars and arms; and a heavy-width stroke which forms the primary letter stroke.

Corvinus, a closer inspection will reveal, is a typeface with a number of structural inconsistencies. The crossbar of the A, for instance, is noticeably heavier than the three horizontal strokes of the B; the diagonal strokes of the splayed M depart in effect from the strong vertical aspect of the other letters; the U is of a lower-case structure. However it also contains features which make it interesting and unique. Note the serifs of the C, G, J and S which appear like hairline appendages, enhancing the typographic verticality of this face. The distinctive lower-case letters which identify Corvinus are the g and k. A very important characteristic of Corvinus is the flattened bowls which enhance the elongated effect of this condensed display face.

Its "look alike" doubles are Glamour Medium and Coronation.

ABCDEFGHIJ
KLMNOPQRS
TUVWXYZ

abcdefghi
jklmnopqrst
uvwxyz

1234567890

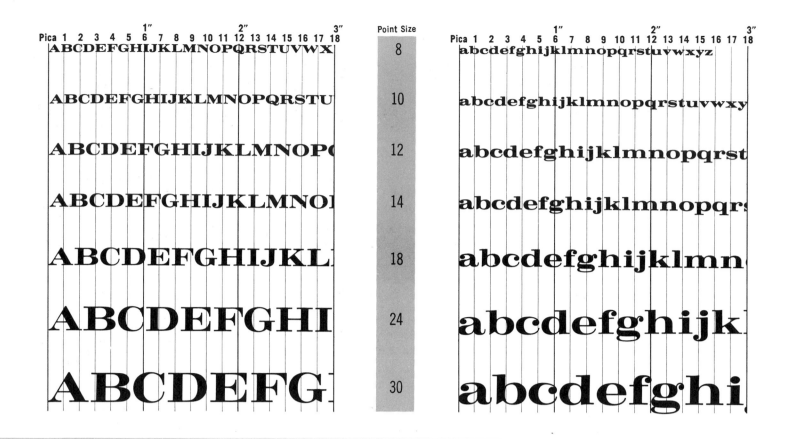

- VARIATIONS OF THIS TYPE:

Craw Modern Craw Clarendon Craw Clarendon Condensed

ABOUT THIS TYPE FACE

This is one of the recent issues by the American Type Foundry and is a display version of the lighter-face Craw Modern. Both faces share common characteristics. For example, the letters show a clean-cut contrast between thick and thin. The thin strokes are drawn exceedingly fine while the heavy elements are fat. All letters are uniformly wide-set, with very little concern for the traditional variations in proportion. The O is no wider than the E, the M takes up no more space, visually, than the N. This uniform set also describes the relationship of the lower-case letters. The serifs are square, thin slabs which add to the extended format of the letters and keep its alignment. The weight of the serif is the same as that of the thin elements of the basic letter form. The serif changes into a triangular bracket on the thin side of the A, N, S, etc., as well as in some of the lower case

letters. The counters of all letters are extremely wide and open. Note especially the counter of the lower-case e. Of special interest are the ball terminals of the a, c, f, r, etc. Maximum stress of all round letters is in the optical center of the curve.

Special letter clues: the apex of the center element of the W (upper and lower case); the curved swash tail of the R; the hairspring extension of the ball terminal of the r, rather widely removed from the main stem; the whimsical diminutive ball terminal of the upper bowl of the g.

A point of caution: Because of the extremely fine hairlines of Craw Modern Bold, only the best quality smooth paper will be "good enough." In addition, this beautiful type deserves a good selection of ink and careful make-ready.

ABCDEFG
HIJKLMN
OPQRSTU
VWXYZ

abcdefghi
jklmnopq
rstuvwxyz

1234567890

ABCDEFGHIJKLMNOPQRSTU

ABCDEFGHIJKLMNOPQF

ABCDEFGHIJKLMNO

ABCDEFGHIJKI

ABCDEFGHI

ABCDEFGI

24	abcdefghijklmnopqrstuvwxyz
30	abcdefghijklmnopqrstuvwxy
36	abcdefghijklmnopqrstu
48	abcdefghijklmnop
60	abcdefghijklm
72	abcdefghijk

● VARIATIONS OF THIS TYPE:

Dom Bold *Dom Diagonal*

ABOUT THIS TYPE FACE

Dom Casual was designed by Peter Dom in 1950 for the American Type Foundry but it was also issued by Amsterdam under the name of Polka. It is a modern typeface modelled after an informal kind of lettering, made to look as if it were brushed in by the average person doing his own sign. No attempt is made to achieve mechanical perfection; in fact, the effect produced is one which simulates the accidental stroke formation rendered either with a fluid marking pen or a brush not specifically intended for professional lettering. The stroke endings are somewhat shaggy and unfinished; the strokes vary in thickness as if the direction and position of the brush determined the fluctuation in weight, and not the controlled twist of the hand holding it. Both the direction and the sequence of strokes are clearly visible in each letter. The O, for example, looks as if it took only two deft strokes to do it—merely two semi-curves brought together in the center with a gap showing where the strokes failed to meet evenly.

Dom Casual shown here comes in upper case and lower case, as well as in a heavy-face version called Dom Bold. It is also available in an italic form which is listed as Dom Diagonal and which bears a resemblance to Monotype's Flash. Point sizes are from 18 to 72.

This is an interesting type design somewhat more free than Balloon or Cartoon. It can be used very effectively for headlines and feature display copy and looks best in the larger point sizes.

ABCDEFGHIJK
LMNOPQRSTU
VWXYZ

abcdefghijklmno
pqrstuvwxyz

1234567890

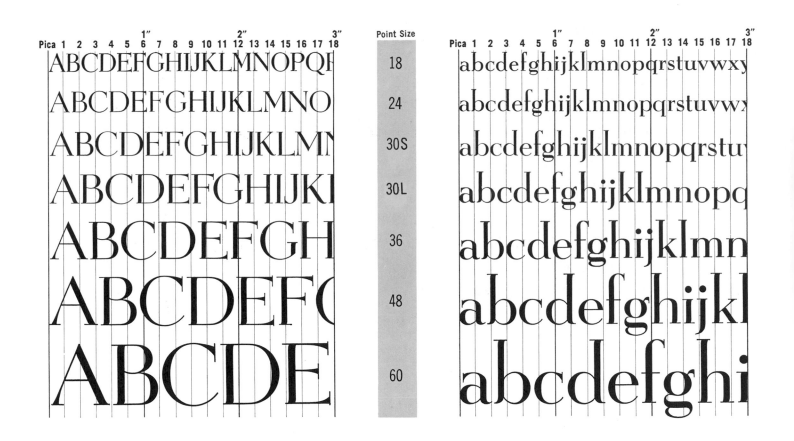

				Point Size				
ABCDEFGHIJKLMNOPQF				18	abcdefghijklmnopqrstuvwxy			
ABCDEFGHIJKLMNO				24	abcdefghijklmnopqrstuvw			
ABCDEFGHIJKLM				30S	abcdefghijklmnopqrstu			
ABCDEFGHIJKI				30L	abcdefghijklmnopq			
ABCDEFGH				36	abcdefghijklmn			
ABCDEFC				48	abcdefghijkl			
ABCDE				60	abcdefghi			

• VARIATIONS OF THIS TYPE:

Egmont Light *Egmont Light Italic* *Egmont Medium Italic* **Egmont Bold**

Egmont Bold Italic EGMONT INLINE

ABOUT THIS TYPE FACE

This light face Roman designed in 1937 by S. H. de Roos for Intertype can adequately serve both as a body and display face. In the Intertype classification, sizes range from 8 to 18 point. Foundry display sizes start at 8 point and accelerate to 10, 12, 14, 18, 24, 30, 36, 48 and 60 point.

There are several ways by which Egmont can be easily identified. For example, the serifs are thin hairlines, quite short and extending more to one side of the stroke than to the other. That the letters vary in width considerably is easily seen when you compare the W to the V. In fact the W is actually the combined width of two V's. You will note also that the M is serifed on top as well as on the bottom and has a short center element, a characteristic of many European typefaces. Most of the thin strokes terminate with accented pressure at the point where the stroke joins the serif. (In this particular Egmont is somewhat reminiscent of one of the identifying elements of Bernhard Roman, a style to which it bears some resemblance.) The upward turn of the thin center stroke in the upper bowl of the B is a structural oddity which repeats itself in the letters P and R. The crossover top serifs of the ascenders in the lower case represent a unique point of identity. The ascenders are long, while the descenders are comparatively short.

Egmont lower-case looks best in the point sizes smaller than 18. While the caps can survive enlargement to display proportion, the lower case is not as fortunate in this respect.

ABCDEFG
HIJKLMN
OPQRSTU
VWXYZ

abcdefghijklmno
pqrstuvwxyz

1234567890

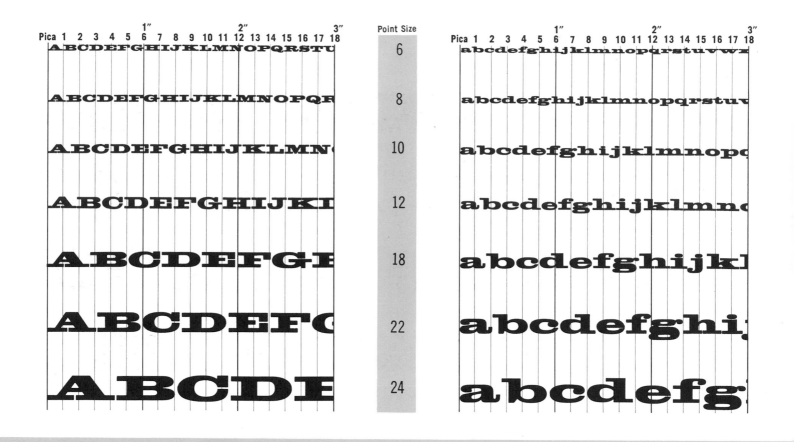

• VARIATIONS OF THIS TYPE:

Egyptian Bold Condensed **Egyptian Bold Ext.**

Egyptian Expanded Open

ABOUT THIS TYPE FACE

Egyptian Expanded shown here is a modification of an early 19th century type design and one which is currently enjoying a growing popularity as a novelty display face. If used discretely in a word or a line, Egyptian has graphic impact and can serve as an excellent device for punctuating and adding color to an otherwise neutral page of text matter.

Egyptian Expanded is an easy face to recognize. First in the list of clues to its identity is the expansiveness of its proportion. Roughly speaking, most letters are twice as wide as they are high. Another unfailing clue: square-edged slab serifs sit solidly and squarely on the line. A word or line set up in Egyptian conveys a strong horizontal pull—almost like a speckled band of black running across the page. It has another kind of serif in the form of upright blocks, as shown in the E. These are so close together that only a sliver of white space separates

them. In fact, all facing serif blocks are close enough to almost touch.

The lower case letters, constructed along the same pattern in reference to serifs and proportion, have been given low ascenders and short descenders, with the evident purpose of retaining the character of horizontal bluntness. Even the lower loop of the g has been pushed inward and flattened out. There is a marked contrast between the thick and thin element which is kept consistent through the alphabet.

The typeface shown here is a foundry type which comes in sizes from 6 to 36 points. It is a mystery to this author why it was ever cut less than 12 point since it would be most difficult to reproduce it in printing without closing in the space between the serifs. For most effective use of Egyptian, specify a size no lower than 12 point.

ABCDEFG
HIJKLMN
OPQRSTU
VWXYZ

abcdefghij
klmnopqr
stuvwxyz

1234567890

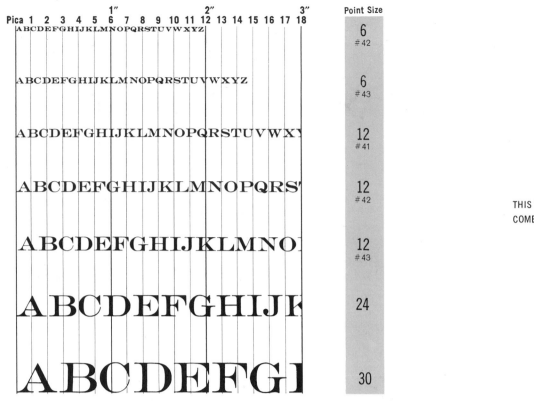

	Point Size
ABCDEFGHIJKLMNOPQRSTUVWXYZ	6 #42
ABCDEFGHIJKLM NOPQRSTUVWXYZ	6 #43
ABCDEFGHIJKLMNOPQRSTUVWXY	12 #41
ABCDEFGHIJKLMNOPQRS	12 #42
ABCDEFGHIJKLMNO	12 #43
ABCDEFGHIJK	24
ABCDEFGI	30

Pica 1 2 3 4 5 6 7 8 9 10 11 12 13 14 15 16 17 18
1" 2" 3"

THIS TYPE FACE DOES NOT
COME WITH A LOWER CASE

• VARIATIONS OF THIS TYPE:

ENGRAVERS BOLD **ENGRAVERS SHADED** **ENGRAVERS BODONI**

ABOUT THIS TYPE FACE

Engravers Roman typeface is a distinguished letter form traditionally associated with fine engravings, printed with loving care on fine paper. It is one of the time-honored favorites for banking institutions, government agencies, currency notes and professional letterheads. The fine hairline strokes and serifs offer a balanced contrast to the full-bodied main elements. The letters are extended and are almost proportionally uniform in width. For example, the M occupies no more space than the N or the E. The unique formation of the R is one of the unmistakable identifications of this Roman typeface. The diagonal tail of the R shows an abrupt hook-like, hair-thin connection to the bowl. Also note the bracketed beak on the arms of the E and R and the shortened center strokes of these letters. The following are also given-

aways of Engravers Roman: the spurred beak on the arm of the C and the closeness of the beak to the line terminal; the spur on the arm of the G; and the triangular beak terminals of the S. The serifs are of two types—pencil-thin hairlines terminating the heavy strokes, and a fillet wedge-like accent which terminates the thin strokes.

The specimen shown here is available in caps only and is produced as a foundry type in 6, 12, 14, 18, 24 and 30 point sizes. However, Engravers Roman and its variations Engravers Bold, Engravers Bodoni and Engravers Shaded can now be had in a variety of sizes in transfer-type lettering sheets as well as through photo lettering film services.

Engravers Roman is a set of capitals somewhat reminiscent of the Bodoni alphabet but in an expanded form.

ABCDEF
GHIJKL
MNOPQ
RSTUV
WXYZ

1234567890

	Point Size	
ABCDEFGHIJKLMNOPQF	14	abcdefghijklmnopqrstuvw:
ABCDEFGHIJKLMNC	16	abcdefghijklmnopqrstu
ABCDEFGHIJKLM	18	abcdefghijklmnopq
ABCDEFGHIJK	24	abcdefghijklmn
ABCDEFGHI	30	abcdefghijklr
ABCDEFGI	36	abcdefghijk
ABCDEF	42	abcdefgh

● VARIATIONS OF THIS TYPE:

Fortune Bold Italic Fortune Light **Fortune Extra Bold** FORTUNE

ABOUT THIS TYPE FACE

Though Fortune Bold is available in the diminutive sizes starting at 8 point, it is at its best in the larger sizes suitable for display copy. Maximum foundry size is 60 point, but this typeface can safely stand photographic enlargement beyond that, without loss of character or identity. Fortune is a very legible typeface of great stamina though perhaps of no personal warmth or character. It is an extended letter form requiring generous allotment of space in a layout.

Recognizable features include square stubby slab serifs with brackets which unite the serifs with the main strokes; counters which are large and open; the capital C has a head serif but has no comparable bottom terminal; the double-curve swash of the R is compact and turns up, abruptly changing into a fish-hook shape. This hook shape stroke terminal appears also in the lowercase a and t. The center arm of the E (as well as of the F) terminates in a serif and is short enough to fit snugly within the longer cross strokes above and below it. The crossbar of the G is very low and is supported on a crutch-like spur.

Fortune's stocky structure and extended proportion are retained in the several variations, which include Fortune Extra Bold, Fortune Light and Fortune Bold Italic. The Fortune Bold shown here somewhat resembles Consort Bold, which may serve as a pinch hitter if a substitution becomes necessary.

ABCDEFG
HIJKLMN
OPQRSTU
VWXYZ

abcdefghij
klmnopqr
stuvwxyz

1234567890

THIS TYPE
RESEMBLES:
CONSORT BOLD,
CLARENDON BOLD

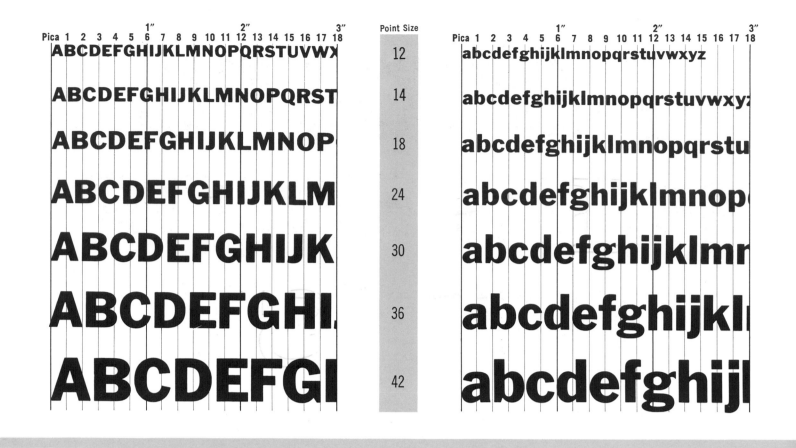

- VARIATIONS OF THIS TYPE:

Franklin Gothic Condensed **Franklin Gothic Extra Condensed** **Franklin Gothic Wide**

Franklin Gothic Italic

ABOUT THIS TYPE FACE

An almost exact facsimile of Amsterdam Continental's Standard Bold, Franklin Gothic, which is issued by American and Monotype, is one of the most widely used sans in newspaper and magazine advertisements. Because of its impact value and excellent legibility, it is also a favorite for posters, displays and billboards. Many of the Franklin Gothic and Standard type faces are so identical that one can be safely used as an alternate when the other is not available. This face (or Standard) is in stock at most composing rooms in sizes which start at 4 point and go up to 96. In addition, Franklin Gothic is to be had in photo lettering, transfer and paste-up type, as well as in cut-out wood and plastic letters used for display and exhibition panels.

Although this alphabet may appear at first glance to be a letter of single thickness, closer inspection will show it to fluctuate somewhat between thick and thin. This however is much more evident in the lower case than in the caps. In the caps, the diagonal and cross strokes and the top and bottom of the bowls are somewhat whittled down. In the lower case the appreciable fluctuation of thickness in weight of stroke is especially noticeable where a curve connects with an upright. This is also seen in the main stem or around a curve as in the a, d, etc. Additional recognizable elements of Franklin Gothic are the wedge-shaped spur extension which connects on the lower half of the G; the high-reaching lower diagonal of the K; and the double thickness of the upper joining strokes of the M. In the lower case, notice the low ascenders; the compact structure of the loop of the g; the short elbow terminal curve of the j and the square dots of the i and j.

ABCDEFG
HIJKLMNOP
QRSTUV
WXYZ

abcdefghi
jklmnopqrst
uvwxyz

1234567890

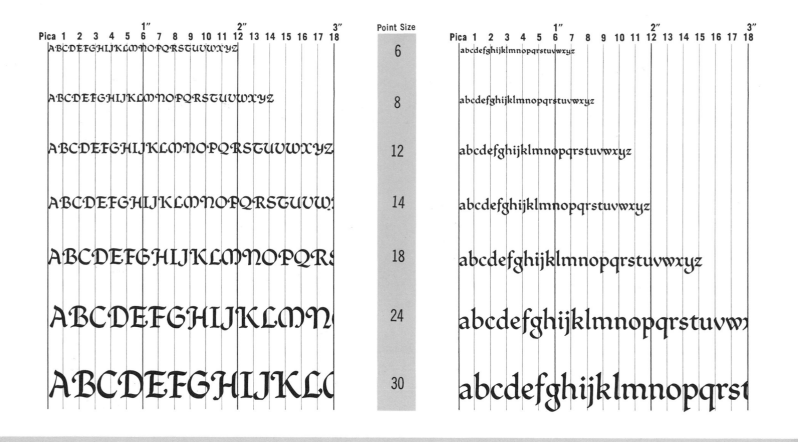

	Point Size	
ABCDEFGHIJKLMNOPQRSTUVWXYZ	6	abcdefghijklmnopqrstuvwxyz
ABCDEFGHIJKLMNOPQRSTUVWXYZ	8	abcdefghijklmnopqrstuvwxyz
ABCDEFGHIJKLMNOPQRSTUVWXYZ	12	abcdefghijklmnopqrstuvwxyz
ABCDEFGHIJKLMNOPQRSTUVW!	14	abcdefghijklmnopqrstuvwxyz
ABCDEFGHIJKLMNOPQRS	18	abcdefghijklmnopqrstuvwxyz
ABCDEFGHIJKLMN	24	abcdefghijklmnopqrstuvw
ABCDEFGHIJKL(30	abcdefghijklmnopqrst

ABOUT THIS TYPE FACE

If you are looking for a "Speedball" type of pen-lettered effect, the American Type Foundry's Freehand design should answer the purpose well. It is the kind of alphabet you find on hand lettered show cards, greeting cards, diplomas, testimonials and other documents. Freehand may be used as a practical substitute for the more archaic "Old English" and as such, it has the advantage of greater legibility and versatility.

This typeface may be classified as an upright text script. It is a concrete example of the typographic principle, "type follows the pen." In this case, Freehand seems to suggest a flat-nibbed broad lettering pen held at an oblique angle. The set angle is evident in the structure of the terminals of all strokes, straight as well as round. This characteristic is discernible more in the lower case than it is in the capital letters. The round letters show twist-ribbon turns typical of calligraphy. The O, for instance, shows the changeover of stress where

one half meets the other abruptly in true calligraphy fashion.

Actually there are no formal serifs in the accepted meaning of the term. What appears as a serif in the lower case is nothing more than the starting point and ending of the pen stroke. In the upper case, the identity of serifs is even more completely obscured.

As in all "Old English" typefaces (and other exotic or ornate typefaces) the capital letters should never be used by themselves in the formation of words. Since capitals of such alphabets are generally more heavily ornamented than lower-case letters, words composed solely of caps present difficulty in reading and comprehension.

Freehand, shown here, is cast in 6, 8, 10, 12, 14, 18, 24, 30 and 36 points in one face only. It has no variations. Heritage and Verona are other foundry types which bear some resemblance to Freehand and may serve as standby alternates.

ABCDEFGH
IJKLMNO
PQRSTUV
WXYZ

abcdefghijklmno
pqrstuvwxyz

1234567890

THIS TYPE
RESEMBLES:
HERITAGE,
VERONA

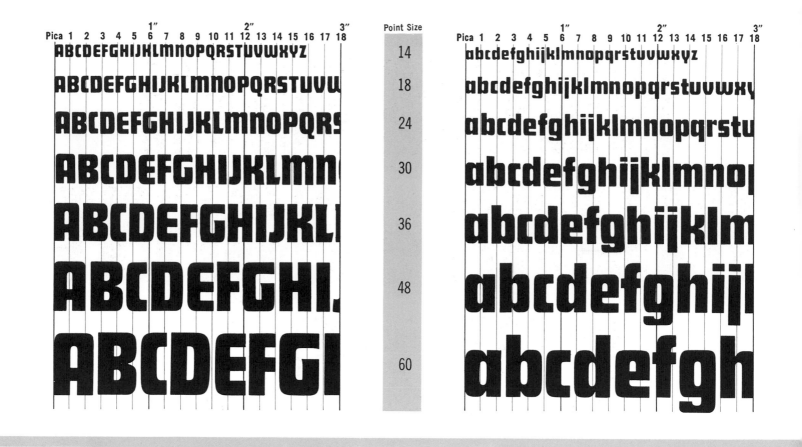

ABOUT THIS TYPE FACE

A rigid poster style (called Airport Display or Airport Tourist when issued by another foundry), Futura Display has the massive impact of a 10-ton truck hogging the road and keeping it to itself. It is a powerful black face sans serif Gothic which seems cut out of paper, shaped into condensed blocky rectangles, with small transitional curves for corners. The rectangular format is retained throughout—even in letters which traditionally have diagonals, such as in the A, K, M, N, W, V, X and Y. Round letters have been flattened, condensed and made to fit the rectangular structural format. The capital letters vary in width, sometimes without apparent reason. Compare the E and F. Logically both should be of the same proportion—but they are not. Liberties are taken in the construction of the K, V, W and X; but in spite of these apparent irregularities, Futura Display ranks high in legibility and soundness of construction. Essentially a uniform-thickness letter, Futura Display

makes structural compromises in thickness as seen in the crossbars of the A and H as well as the around-the-curve connections of the M, N and X.

The letters of the lower case retain the same rectangular format, but the strokes vary considerably more in thickness than do those of the upper-case letters. In fact, the lower case letters of Futura Display are practically thick and thin throughout and do not conform in this respect to the feeling of uniformity of the upper case.

This alphabet is available in sizes 14 to 84 points, upper and lower cases and is much in demand as a headline face on layouts for posters, window displays, twenty-four sheet billboards, as well as for newspaper and magazine advertising. The caps are more frequently used than the lower case. Though this alphabet carries the family name of Futura, it bears little resemblance to the other members of the Futura family. It is in a class by itself and is issued in only one face.

ABCDEFGHI
JKLMNOPQRST
UVWXYZ

abcdefghi
jklmnopqrstu
vwxyz

1234567890

THIS TYPE
RESEMBLES:
AIRPORT DISPLAY,
AIRPORT TOURIST

FUTURA DISPLAY **101**

ABCDEFGHIJKLMNOPQRSTUVWXYZ **14** abcdefghijklmnopqrstuvwxyz

ABCDEFGHIJKLMNOPQRSTUV **16** abcdefghijklmnopqrstuvwxyz

ABCDEFGHIJKLMNOPQRSTU **18** abcdefghijklmnopqrstuvwxyz

ABCDEFGHIJKLMNOPQ **24** abcdefghijklmnopqrstuv

ABCDEFGHIJKLMN **30** abcdefghijklmnop

ABCDEFGHIJK **36** abcdefghijklmr

ABCDEFGHI. **48** abcdefghijklr

• VARIATIONS OF THIS TYPE:

Futura Light *Futura Oblique Light* **Futura Medium Oblique**

Futura Medium Condensed **Futura Demibold** ***Futura Demibold Oblique*** **Futura Bold**

Futura Book Oblique **Futura Bold Condensed** ***Futura Bold Cond. Oblique***

ABOUT THIS TYPE FACE

This is a basic sans serif which because of its fundamental structural simplicity is likely to never become dated or obsolete. It is as typographically sound today as it was when it was designed by Paul Renner in 1928. Its basic structure is of a machine-made precision and in that it is not unlike the Kabel alphabet which may be used interchangeably without great loss of typographic effect.

The outstanding feature of identification of Futura Medium is the seeming evenness of stroke throughout every letter of the alphabet. The perfectly round circle and square terminals suggest the use of mechanical instruments with the precision of a drafting engineer. The apex of the A comes to a sharp point and extends above the cap line to balance the illusion of uniform height with the rest of the letters. The cross strokes of the E, F and H are positioned above center while the crossbar of the G is below eye-level center. The side strokes of the M are splayed and come to a point where they meet the center V element of the letter. The vertical strokes of the N come to a point at the juncture with the diagonal. This point terminal is also characteristic of the V and W. A slight inconsistency in structure exists in the stroke endings of the C and G. Those of the C are vertical and square with the base line, while the head terminal stroke of the G is at an acute angle.

The lower case is patterned after the same geometric structure and like Kabel is the product of compass and ruling pen. Futura Medium has its counterpart in Spartan Medium issued by American Type Foundry.

ABCDEFG
HIJKLMNOP
QRSTUV
WXYZ

abcdefghi
jklmnopqrstu
vwxyz
1234567890

THIS TYPE
RESEMBLES:
SPARTAN MEDIUM,
KABEL

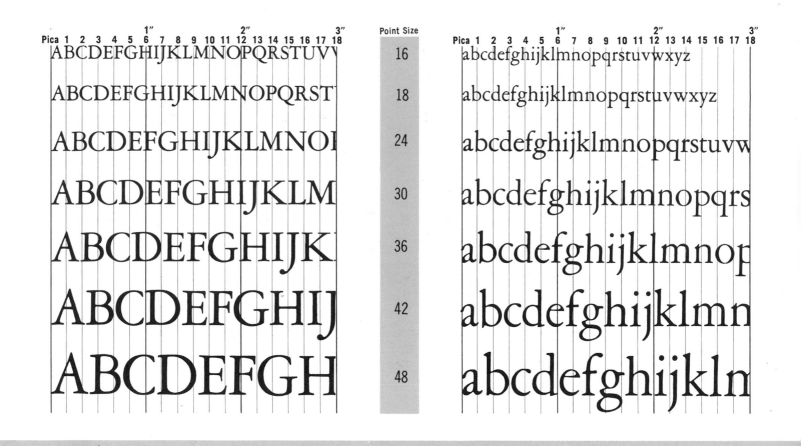

	Point Size	
ABCDEFGHIJKLMNOPQRSTUVW	16	abcdefghijklmnopqrstuvwxyz
ABCDEFGHIJKLMNOPQRST	18	abcdefghijklmnopqrstuvwxyz
ABCDEFGHIJKLMNOP	24	abcdefghijklmnopqrstuvw
ABCDEFGHIJKLM	30	abcdefghijklmnopqrs
ABCDEFGHIJK	36	abcdefghijklmnop
ABCDEFGHIJ	42	abcdefghijklmn
ABCDEFGH	48	abcdefghijkln

- VARIATIONS OF THIS TYPE FACE:

Garamond with *Italic* Garamond Bold **Garamond Bold with *Italic*** Garamont *Garamont Italic*

ABOUT THIS TYPE FACE

This elegant type face owes its name to the distinguished 16th century French type founder, Claude Garamond, although there is evidence to show that the original design was made 60 years after the death of Garamond by Jean Jannon. Since then, there have been as many variations of this type face as the type houses which have issued them. The specimen shown here is the 1917 American Type Foundry issue of Garamond, created by Morris F. Benton and modeled after the original Jannon design. Other versions of this face have been issued by Intertype and Ludlow of the United States, Monotype of England, Deberny and Peignot of France and foundries in Holland, Switzerland, Austria and Italy.

The following identifying characteristics pertain specifically to the specimens shown here, but apply equally well (with minor reservations) to all basic Garamonds, regardless of place of origin. The structure of the serifs is an unmistakable clue to Garamond: in the upper case the serifs are rather long but they appear shorter because they blend softly into the main stem. You will note that although the serifs rest flush against the cap lines (top and bottom), they join the stem by means of wedge-shaped brackets very evident in the M. The serifs in the lower case are of two distinct kinds. The serifs on top of the upright stems and all ascenders are slanted wedges, while the bottom serifs are square with the base line. In the caps the accented stress of the round letters is in the horizontal center, but this is not followed through consistently in the lower case. Indeed, one of the important clues of this type is the diagonal stress of the bowls of the c, d, e, etc. Another clue to Garamond is the high crossbar of the e and the sloped triangular two-storied bowl of the a. Other points for identification: the pointed apex of the A and the high crossbar; the elongated swash of the J which terminates in an ovular ball; the slightly splayed M; the cat's tail swash of the Q and the cross over the W.

Garamond lends grace and dignity to any page of copy. It prints well, and is a letter of high legibility.

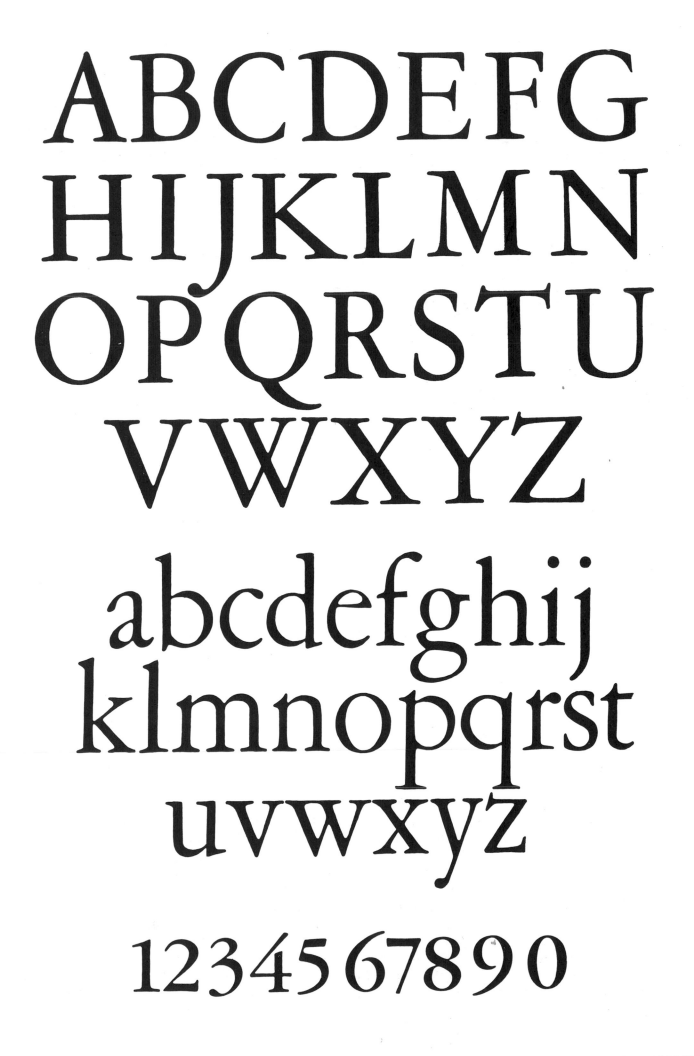

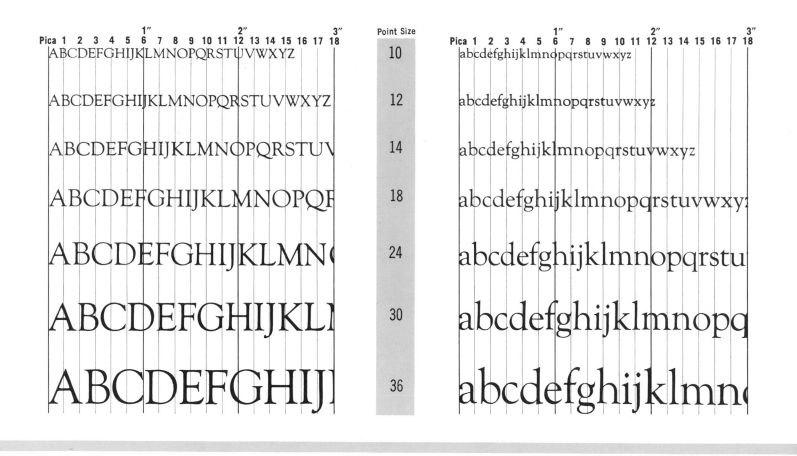

	Point Size	
ABCDEFGHIJKLMNOPQRSTUVWXYZ	10	abcdefghijklmnopqrstuvwxyz
ABCDEFGHIJKLMNOPQRSTUVWXYZ	12	abcdefghijklmnopqrstuvwxyz
ABCDEFGHIJKLMNOPQRSTU	14	abcdefghijklmnopqrstuvwxyz
ABCDEFGHIJKLMNOPQF	18	abcdefghijklmnopqrstuvwxy
ABCDEFGHIJKLMN	24	abcdefghijklmnopqrstu
ABCDEFGHIJKL	30	abcdefghijklmnopq
ABCDEFGHIJ	36	abcdefghijklmn

● VARIATIONS OF THIS TYPE:

Goudy Bold Italic *Goudy Cursive* *Goudy Old Style Italic* **Goudy Bold**

ABOUT THIS TYPE FACE

The dean of American type designers, Frederic W. Goudy, created this exquisite typeface in the late nineteen twenties. It reflects the finest elements of classic Roman design. It is one of the most beautiful alphabets in this collection.

The recognizable features of Goudy Old Style Roman are its classic restraint and majestic grace. The relationship and subtle interplay of thick and thin, the short, well-blended cupped serifs and the distribution of the accented weights combine to make this an alphabet which appears monumental and incised in granite. More specifically, most letters seem to fit the proportion of a square. The accented weights are slightly off center on an inclined axis, best shown in the letters O and Q. There is a complete absence of harshness or severity.

Every stroke seems to flow gracefully into the other. Even the uprights are not mechanically ruled strokes, but have a hand-wrought quality. This is true also of the lobes, counters and serifs. Note the graceful but virile swash of the Q, the swash of the R which combines majesty and restraint, the open bowl of the P. The lower case retains these characteristics; the slanted accented weights of the curved letters, the well-bracketed cupped serifs (which are not symmetrical), the balanced relationship between thick and thin elements.

Where is this typeface appropriate? In chapter headings and titles of fine books, programs for concerts and art exhibits, display letters for well-designed reports, certificates and proclamations, and wherever classic beauty and restraint are embodied in good typography.

ABCDEFG
HIJKLMN
OPQRSTU
VWXYZ

abcdefghij
klmnopqrst
uvwxyz

1234567890

GOUDY OLD STYLE ROMAN **107**

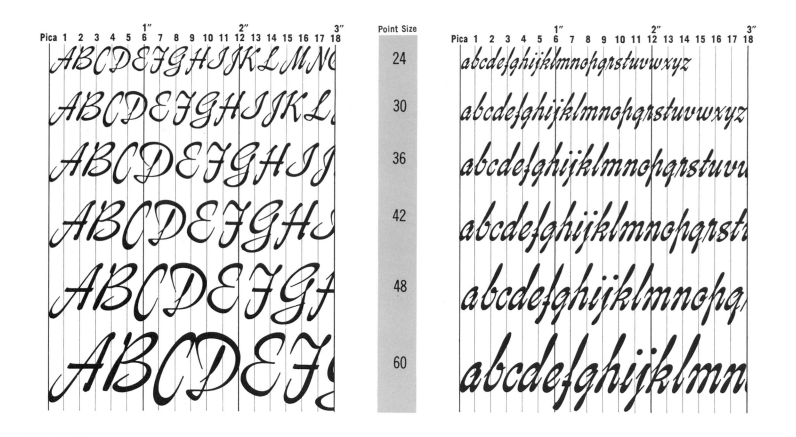

Point Size
24
30
36
42
48
60

ABOUT THIS TYPE FACE

Grayda is one of the most easily recognized scripts in use today. It is a letter rendered with a pen and held in transversal position. Designed in 1940 by Frank H. Riley, this typeface is one of the more popular script alphabets among typographic layout artists who use it as a practical display face for newspaper and magazine advertisements, brochures, book jackets, annual reports, etc. Grayda could perhaps be better classified as an italic rather than a script, since the letters are not designed to link together in the formation of words. However, though there are no links, the rhythmical structure of this alphabet conveys an impression of linkage without actual contact of one letter with the next.

The caps are free-flowing letter forms, calligraphic in structure and with a definite beat or rhythm effected by the recurring interplay of thick-and-thin strokes. Many of the swash strokes in the caps dip vigorously below the main body line, accenting the downward pressure of the lettering tool. The capitals vary in height, as well as in width. The C and U for instance, are considerably more condensed than the B or G.

The lower case is far more consistent in letter structure, but it is unusual in that the thickest parts of the letter seem to come in an unnatural way. The accented weight of the letter is top and bottom, rather than the upright and downward stroke. The ascenders are much taller than the descenders and are made to represent flooded loops. The "flooded-loop" effect is also evident in all descenders as well as the h, m and n.

Grayda does not have a high rating in legibility but it enjoys the distinction of being a typeface which has no "doubles" in the entire range of alphabets.

ABCDEFGHI
JKLMNOPQR
STUVWXYZ

abcdefghijkl
mnopqrstuvwxyz

1234567890

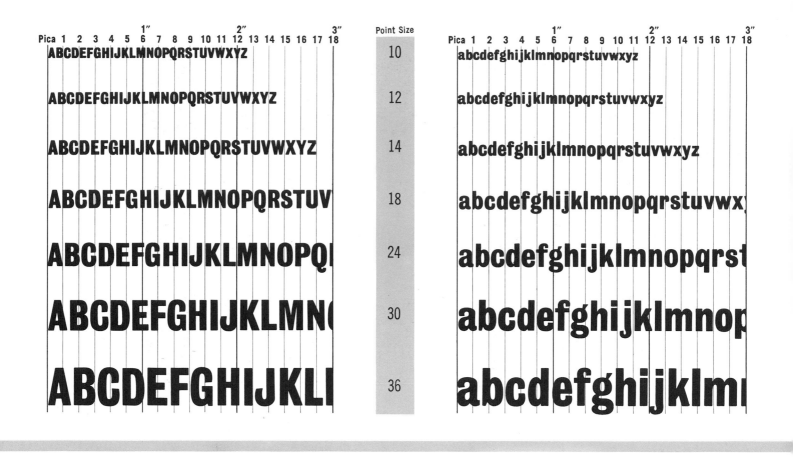

	Point Size	
ABCDEFGHIJKLMNOPQRSTUVWXYZ	10	abcdefghijklmnopqrstuvwxyz
ABCDEFGHIJKLMNOPQRSTUVWXYZ	12	abcdefghijklmnopqrstuvwxyz
ABCDEFGHIJKLMNOPQRSTUVWXYZ	14	abcdefghijklmnopqrstuvwxyz
ABCDEFGHIJKLMNOPQRSTUV	18	abcdefghijklmnopqrstuvwx
ABCDEFGHIJKLMNOPQ	24	abcdefghijklmnopqrst
ABCDEFGHIJKLMN	30	abcdefghijklmnop
ABCDEFGHIJKLI	36	abcdefghijklm

• VARIATIONS OF THIS TYPE:

Grotesque Annonce **Grotesque No. 6** *Grotesque No. 9 Italic*

Grotesque No. 18

ABOUT THIS TYPE FACE

The Grotesques comprise a very large family of sans serif typefaces most of which are based on nineteenth century models. The letters appear as one thickness, but they really are not, as we will point out more specifically later. Most of the caps are of the same width, which make letters like the E and F seem wider than the traditional proportions. The G has a spur at the bottom of the straight stroke and the R is unique because of its subtle double-curve tail.

The sample of Grotesque shown here (Grotesque #9) is condensed in proportion, simple in design and strong in legibility. The bowls of the letters are not completely flattened as they are in Railroad Gothic to which they bear some resemblance. However while the bowls are not pressed flat, they are not round either. Some of the curvature has been retained in all "round" elements. Grotesque seems more the design of a hand lettering artist rather than the work of a drafting engineer. There are other subtleties which are not immediately apparent but which nevertheless reflect the spirit of the hand letterer. The letter thickness differs somewhat in varying degrees. The H is obviously thick and thin, while the X is practically uniform in thickness. These fluctuations in thickness are more easily discernible in the lower case where the variation in this respect is greater than in the upper case. Compare the thick-and-thin e to the one-thickness w or x. Unusual letter formations are seen in the hook-like head of the f, and its counterpart of the lower portion of the j and the fish-hook formation of the y, the droop-tail appendage of the r. Dots over the i and j are square and very low over the body of the letter. Ascenders and descenders are low and squatty. Grotesque #9 is available in various sizes up to 72 point. The description of this version of Grotesque, while it characterizes some of the distinguishing elements of all Grotesques, cannot be applied to each of the faces which are united by the common name. The faces differ widely.

ABCDEFG
HIJKLMN
OPQRSTU
VWXYZ

abcdefghij
klmnopqrst
uvwxyz

1234567890

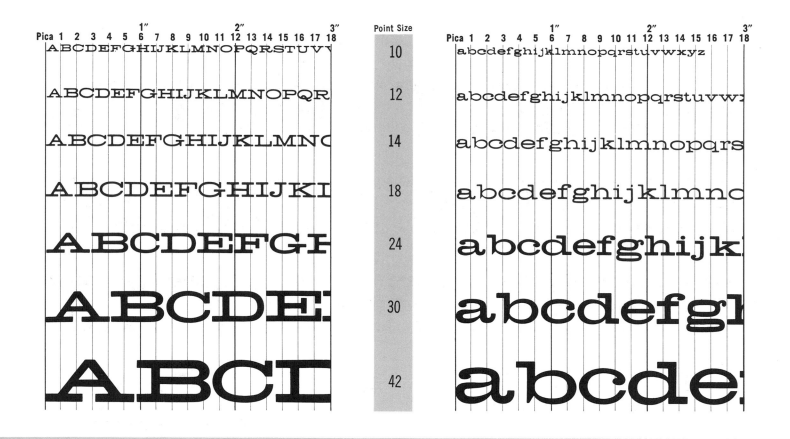

ABOUT THIS TYPE FACE

This modern version of an antique square serif is enjoying a re-born popularity as a display face. Reminiscent of the hand-painted wood signs over general stores and of the gilded inscriptions decorating early railroad cars, this typeface offers dramatic possibilities in contemporary advertising. Its very expansiveness reminds one of the wide plains of the Old West. Hellenic, in its modern version, is a very legible display type and is easily identified. It is a one-thickness, very widely extended Gothic letter to which long serifs have been added to provide a well balanced firm base for the letter form. The slab-type serifs are of the same thickness as the main strokes, and are elongated and rigid, like solid steel girders. Note the center arm of the E and F, foreshortened to make it possible to carry the middle serifs dovetailed within the others. The illusion of expansiveness is dramatized in the very wide W which has an additional serif across the center element as well as at the two ends.

The lower case departs somewhat from the single-thickness characteristic. A close inspection will reveal slight variations in thickness evident in the bowls of the a, b, d and in the round elements of most of the other letters. Note the extremely short ascenders and descenders, and the square-looking g with its tucked-under structure.

Hellenic is best as a one-line lettering style for several reasons. Being a novelty display face it serves its purpose most dramatically if not too much is shown on the page. Another, and more practical reason, for limiting the use of Hellenic is simply that it demands a lot of space for copy.

There are no variations of this face.

ABCDEFG
HIJKLMN
OPQRSTU
VWXYZ

abcdefghij
klmnopqrs
tuvwxyz

1234567890

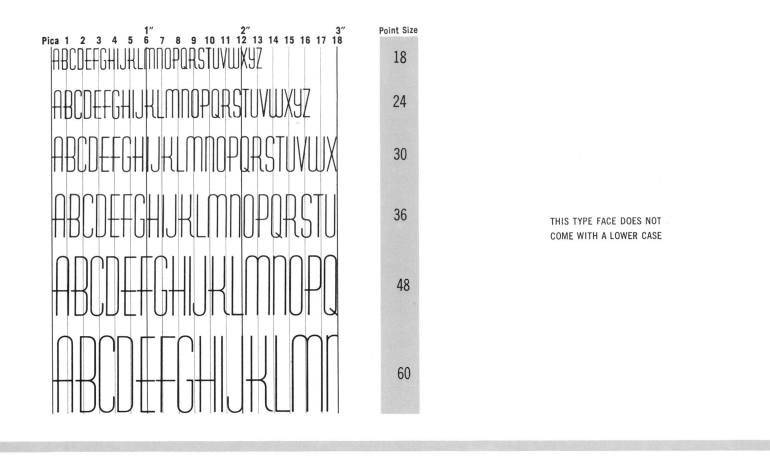

THIS TYPE FACE DOES NOT
COME WITH A LOWER CASE

ABOUT THIS TYPE FACE

Huxley Vertical has been included here as a relief and departure from the heavier display faces which have priority in this collection of alphabets. Huxley answers the need for a typographic effect calling for a "long lean look." It is appropriate for feminine appeal, the aesthetic and the formal. Because Huxley may produce an astigmatic visual reaction on the part of the beholder, it is advisable to limit its use to one line, letterspaced generously so that the repeating verticals are not too close to one another.

If rendered by hand, Huxley would be produced with a ruling pen adjusted to one width of stroke. The letters are narrow in proportion to height, and with few exceptions are mechanically the same width. The crossbars are below center and cut through the left side upright stroke. All bowls of this condensed sans serif letter are flattened to run straight up and down, parallel to the main vertical stem. There are very few diagonals in this typeface. The extended horizontals help in a measure to check and balance the strong vertical effect and act as counterparts to the rhythmic vertical beat.

Huxley was created by Walter Huxley for the American Type Foundry. It comes only in upper case. Two years later the same foundry developed Phenix, a vertical type similar to Huxley, but somewhat heavier in weight which has an upper as well as a lower case. Advice: Don't use Huxley (or Phenix) for reverse printing. It's difficult to read—and difficult to keep open in printing.

ABCDEFGHIJ

KLMNOPQRS

TUVWXYZ

1234567890

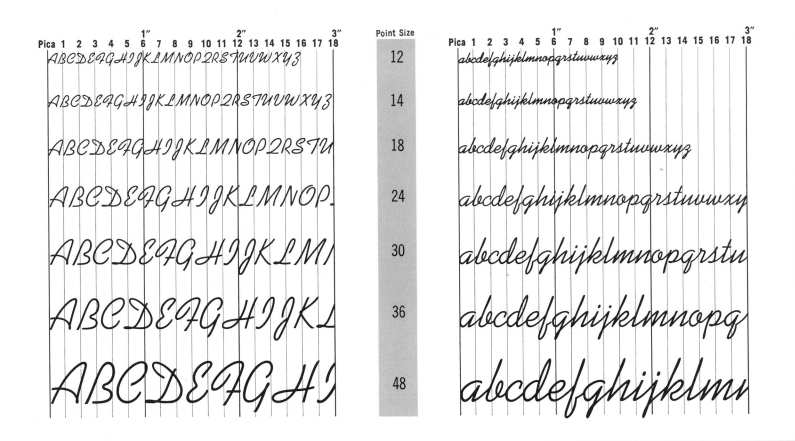

Pica	Point Size
	12
	14
	18
	24
	30
	36
	48

- VARIATIONS OF THIS TYPE:

Kaufmann Bold

ABOUT THIS TYPE FACE

Kaufmann Script, designed by Max Kaufmann for American Type Foundry in 1936, is one of the "standards" of contemporary connecting scripts and was among the first commercial scripts to feature connecting links. The capitals, however, which are used as initial letters, are not meant to link to the subsequent letters. It is the perfect alignment of links built into the lower case which creates the complete illusion of continued writing, simulating natural penmanship. Only close examination of the structure of the lower case will in some letters disclose the point of joining, principally in the lobes of the round letters. Upon a closer examination the a, c, g, o and q will show a slight angularity in the curvature of the lobe, but these become invisible to the casual observer.

The capitals are characterized by greater freedom of flourishes than are the letters of the lower case. Note the structure of the D, the free-flowing lines of the S, the flourish of the Y. The lower case shows a more deliberate consistency in slant and structure, creating an even rhythmic zig zag pattern of line and motion. The chief characteristics of the lower case are the uniform thickness of all strokes, the consistent angle of slope of the main strokes and the connecting links.

Kaufmann Script comes in a bold face which does not reflect the more delicate grace of its lighter version. Both faces are available in a wide range of point sizes, the range extending from 10 to 72 points. Kaufmann Script is also known as Swing Bold (Mono 217).

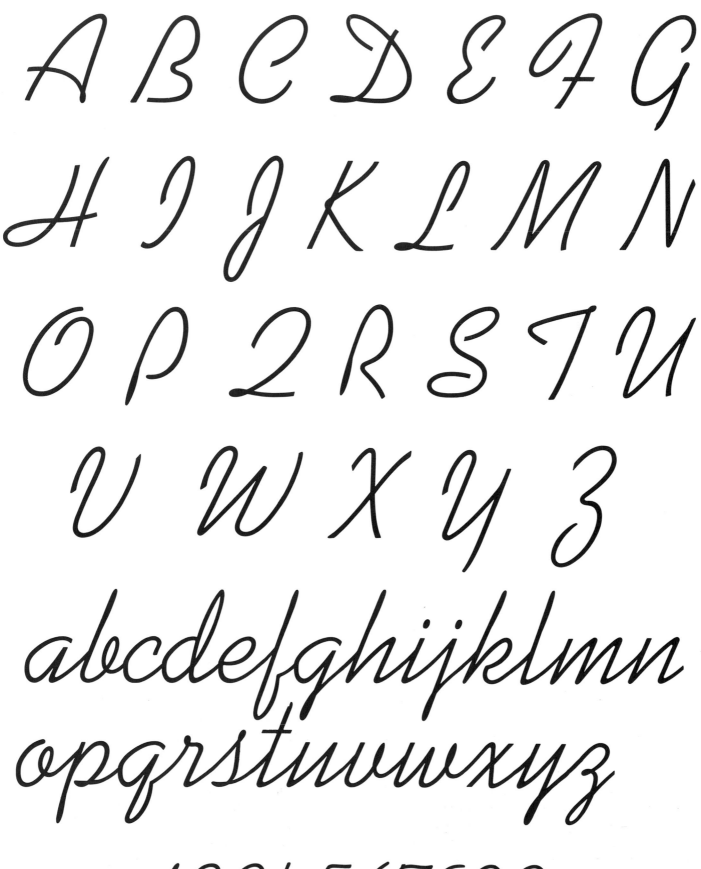

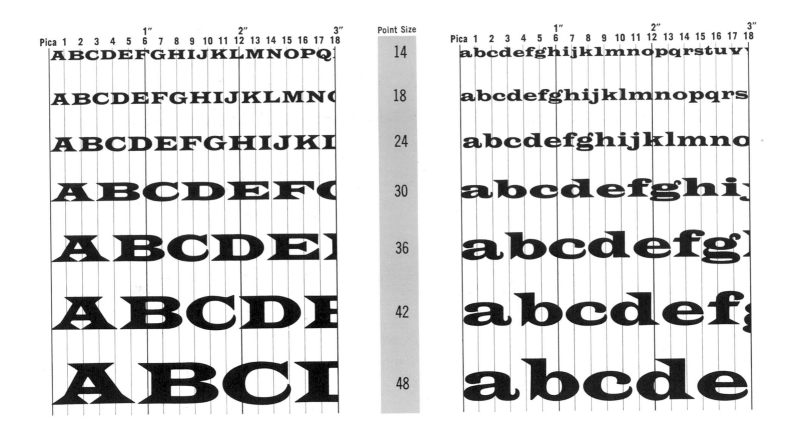

Pica 1 2 3 4 5 6 7 8 9 10 11 12 13 14 15 16 17 18	Point Size	Pica 1 2 3 4 5 6 7 8 9 10 11 12 13 14 15 16 17 18
ABCDEFGHIJKLMNOPQ	14	abcdefghijklmnopqrstuv
ABCDEFGHIJKLMNO	18	abcdefghijklmnoqrs
ABCDEFGHIJKI	24	abcdefghijklmno
ABCDEFG	30	abcdefghi
ABCDEI	36	abcdefg
ABCDI	42	abcdef;
ABCI	48	abcde

- VARIATIONS OF THIS TYPE:

Latin Bold Latin Wide Open LATIN COND. Latin Elongated

Latin Bold Condensed

ABOUT THIS TYPE FACE

A display face with positive character, Latin Wide meets the needs for a dramatic extended face for contemporary display use. In its extended form, shown here, Latin Wide is bold and brash, yet it is not devoid of a certain "good old days" charm. The outstanding clue to this Latin family of display faces, is the presence of the very conspicuous serifs. These serifs which align strongly horizontally, are sharply cut and connect to the main stroke by a distinct wide-based triangle. There are a number of variations within the Latin family of faces which include Latin Bold, Latin Bold Expanded, Latin Wide Open, Latin Elongated, Latin Condensed, Latin Bold Condensed, etc. While the triangular serifs undergo modification with each face, the general characteristics remain identifiable.

The version of Latin shown here has the special identification of expansiveness. The letters are massive and extremely squatty. Each letter seems to want to occupy more than its rightful share of allotted space and does

so by sheer weight and force. This expansiveness poses a problem of space allocation in the layout, a factor which requires planning both in the writing of copy and in the actual layout. Though Latin Wide is cut in point size as small as 6 point, it would be folly to select this face for small copy which is intended to be legible. The best use of Latin is made in the larger sizes, 14 and up. (It comes to 48 points).

Another characteristic of Latin Wide is the sharp contrast between thick and thin elements in both upper and lower cases, in which the serifs are not only unusual, as we mentioned before, but are also abundant. A closer inspection of the V and W will bear out this observation. In fact, sometimes they get in the way of legibility and letter identification, as you will agree when you regard the K or Y. But then not all typefaces serve the same purpose. Latin Wide is reserved for copy which is to convey an effect rather than a vital message.

ABCDEF
GHIJKLM
NOPQRS
TUVYWXYZ

abcdefghij
klmnopqr
stuvwxyz

1234567890

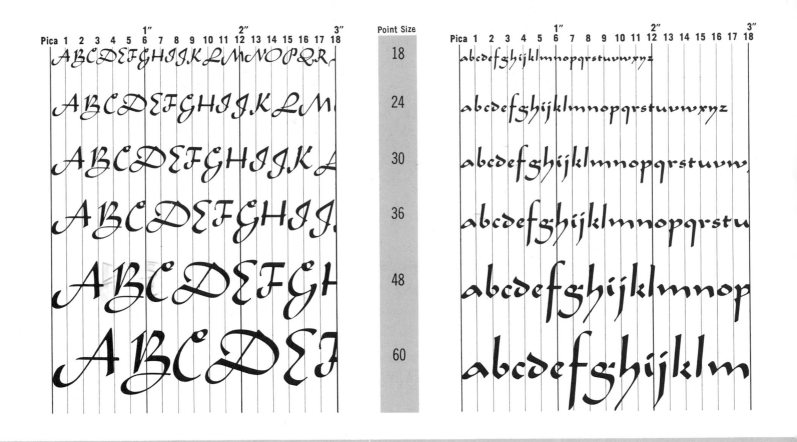

	Point Size	
	18	
	24	
	30	
	36	
	48	
	60	

ABOUT THIS TYPE FACE

This is a typeface hard to describe, yet easy to identify once you see it. In essence, Legend conveys an exotic, oriental feeling. Calligraphically, it is reminiscent of Arabic, Persian or Hebrew; of the art of medieval scribes of antiquity. Very much in evidence is the mark of the broad-nibbed lettering pen which is its natural tool. There is a noticeable angularity in most of the letters; even the flourishes show an abruptness and almost spasmodic sudden change in direction and angle. Legend, especially in the upper case, defies any format of discipline and consistency. However, a general tendency towards a forward slant makes Legend appear as a script or italic. The lower case is subject to somewhat greater restraint and consistency. The angularity is still evident and so is the extreme contrast between thick and thin

strokes. Ascenders are long, compared to the rather short squatty main body of the letter form, and the descenders are wildly inconsistent.

Legend type looks best when it is kept to a small size. It seems to lose its identity in large format where its eccentricity of structure becomes all the more erratic. It is very appropriate as a display face for copy relating to the exotic, biblical and esoteric themes.

Legend is definitely a novelty typeface but one which has lasted through the years since 1937 when it was designed by F. H. E. Schneidler for the Bauer Type Foundry. Great discretion must be exercised in its use as it does not rank high in legibility. It comes in sizes 18 to 72 but only in one face. Though it has no variants in its own family it bears a remote resemblance to Ondine.

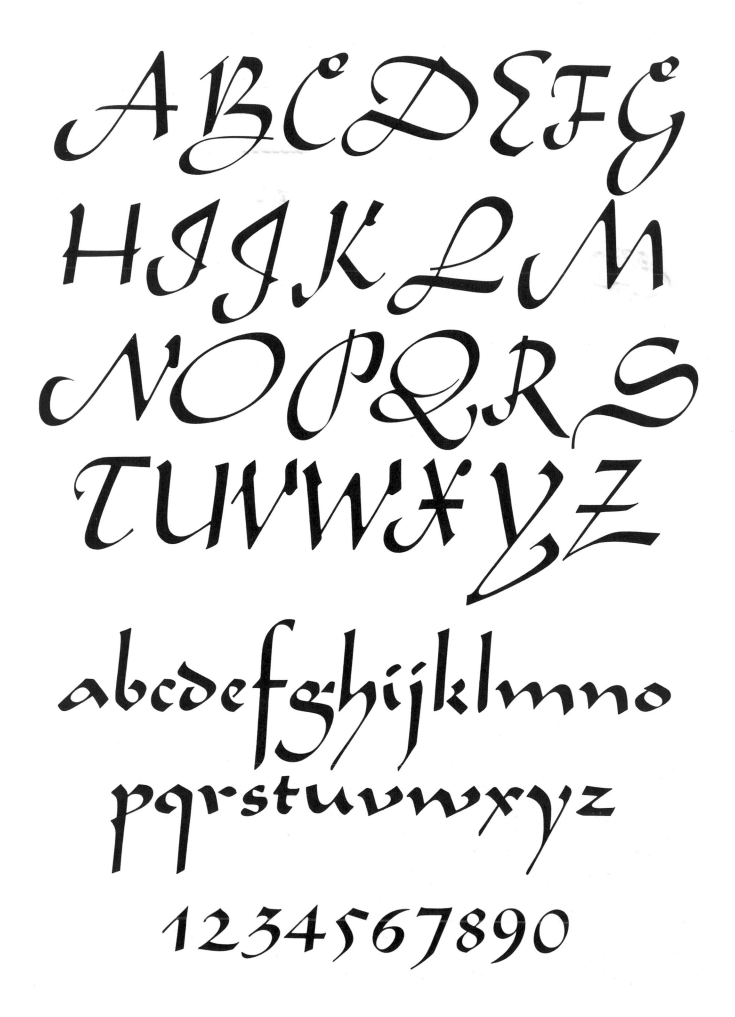

aBcoefGhijklmnopqRstuvwxyz — **12**

aBcoefGhijklmnopqRstuvwxyz — **18S**

aBcoefGhijklmnopqRstuv — **18L**

aBcoefGhijklmnopqR — **24**

aBcoefGhijklmnop — **30S**

aBcoefGhijklm — **30L**

aBcoefGhijk — **36**

THIS TYPE FACE DOES NOT
COME WITH A LOWER CASE

● VARIATIONS OF THIS TYPE:

libRa light

ABOUT THIS TYPE FACE

Designed for the Amsterdam Continental Typefoundry by Sjoerd Hendrik deRoos, Holland's leading type designer, Libra follows the pattern of uncial scripts. This alphabet represents a cross between an ecclesiastical calligraphy and formal lettering. Each letter in itself cannot be judged on its own merit. The letters of the alphabet in Libra have a strong interdependence in a collective sense which is best revealed in word formation. Judged independently, the letters seem to lack a basic consistency. They vary in height, for example, some letters such as the D, K and L are not above the guide line, while others like the G, J, P and Q extend below the line. They also vary in basic construction. Although Libra is classified as an upper-case letter (there is no companion lower case) the letters vary so much in structure and size that the alphabet can be said to be both upper and lower case all at the same time. For instance, the A, F, M, N and T exhibit distinctive lower-case features, while the B, R and G are formed along more conventional upper-case lines. Libra is a pen-lettered type creation, which reflects the nature of the tool. No attempt is made to soften the curves or introduce transitional smoothness in the change of a direction of stroke. The O, for instance, is easily identified as the product of two strokes joining somewhat abruptly with no attempt made to conceal or correct the ill-matched meeting of the two strokes. This is a typical characteristic of this extremely provocative and unique type. Libra is available in two faces, the one featured on the facing page plus a lighter face called Libra Light. Range of sizes is from 8 to 60 points.

ABCDEFG

hijklmno

pqrstuv

wxyz

1234567890

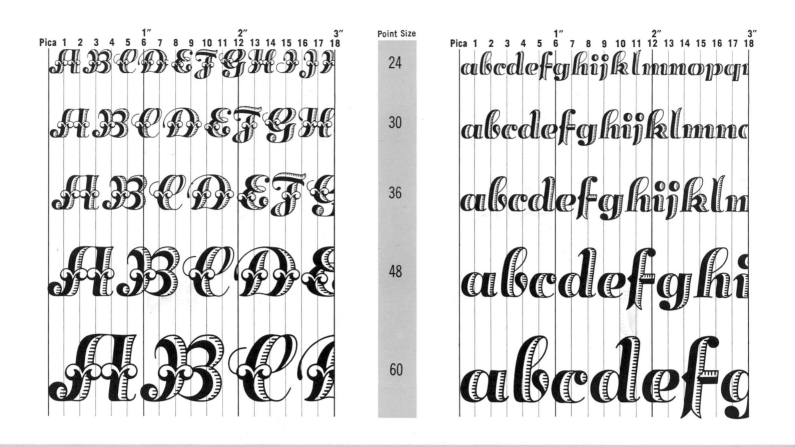

ABOUT THIS TYPE FACE

A letter face with a jewel-like quality, Lilith's highly ornamental design makes it a unique typeface to be reserved for special occasions. Suggested uses are printed matter dealing with art, music, classic literature, flowers, milady's fashions, and the like. Because of its comparatively limited use, Lilith is available only at the best-equipped composing rooms and type houses. Where the need warrants it, however, it may be well worth the special effort (and cost) it takes to get it.

Essentially, Lilith is an extended form, barely qualifying as an italic because it veers only slightly from the upright. The capitals are ornamental, with a plumed floral design motif and are shaded to the right. There are fine hairline serifs, but they are hardly noticeable. The structure of the letter form is a contrasting thick-and-

thin, flanked by a thin outline producing a kind of open face effect. It is textured with horizontal pen strokes which stop just short of the main black accented strokes.

Because of its extended form, Lilith demands a generous allotment of space in any layout. It also demands (and deserves) special care in the choice of paper, ink and make-ready, to avoid blurry closing up of the fine decorative lines within the letter form.

Lilith is a creation by the dean of contemporary American type designers, Lucian Bernhard, who drew up this face in 1938 for the Bauer Foundry. It is available in five hand set sizes only: 24, 30, 36, 48 and 60. There are no variants and there exists no other type which looks like it. It is truly in a distinguished class by itself.

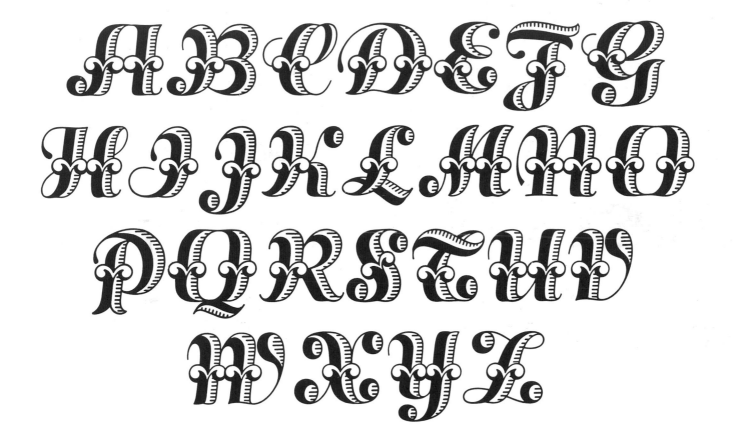

ABCDEFG
HIJKLMNO
PQRSTUV
WXYZ

abcdefghijk
lmnopq
rstuvwxyz

1234567890

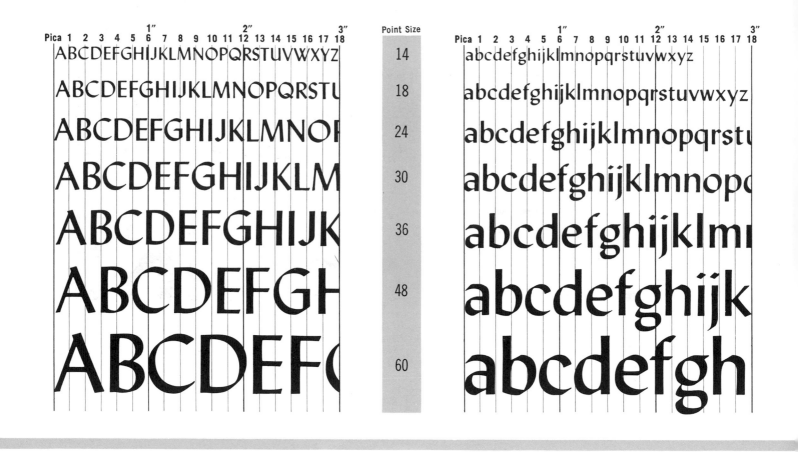

Point Size
14
18
24
30
36
48
60

● VARIATIONS OF THIS TYPE:

Lydian Italic **Lydian Bold** *Lydian Bold Italic* **Lydian Bold Condensed** *Lydian Bold Condensed Italic*

ABOUT THIS TYPE FACE

This clean, lovely sans serif typeface was designed by Warren Chappell for American Type Foundry in 1938, the same sensitive calligraphic artist who created Lydian Cursive and Lydian Italic. Lydian is an excellent type for all printing processes and demands little in terms of special handling in production. The pen-drawn character is best revealed by the calligraphic twist-and-turn structure of all bowls and round elements. Note that the maximum stress is on an inclined axis either below or above the center, but never in the center. The D is typical. Observe too the abrupt turn of the round letters resulting in a twisted ribbon effect. This is strongly evident in the O, P, Q, etc. The capital A has two variations, both of which are distinctive. The little projection of the right side stroke extends beyond the thin stroke. Where the alternate A is used, Lydian can always be identified by the broad line serif which runs across the top. A closer examination of the terminal of the strokes of the caps will disclose an angular, rather than square-cut ending. This is very much in evidence in letters such as the G, but is also characteristic of the arms of the E, F, L, etc. Observe the lower-case type of U in the caps and also that the M is slightly splayed. The diagonal of the N extends beyond the left vertical stroke and the W is cross-stroked in the center.

The lower case reflects the angular pen-drawn quality even to a more marked degree, almost as if the letters were chiselled with a flat inflexible nibbed pen using a minimum of strokes. Ascenders and descenders are short.

ABCDEFGHIJ
KLMNOPQRS
TUVWXYZ

abcdefghi
jklmnopqrs
tuvwxyz

1234567890

ABCDEFGHIJKLMNOPQRS — 24 S — abcdefghijklmnopqrstuvwxyz

ABCDEFGHIJKLMN — 24 L — abcdefghijklmnopqrstuvwx

ABCDEFGHIJKL — 30 — abcdefghijklmnopqrstu

ABCDEFGHIJK — 36 — abcdefghijklmnopq

ABCDEFGHI — 42 — abcdefghijklmn

ABCDEFGI — 48 — abcdefghijklm

ABOUT THIS TYPE FACE

Strongly calligraphic in design, this Warren Chappell alphabet, designed in 1940, has become a standard listing in all typographers' specimen books. It is easy to see why. It has a high degree of legibility in any point size and is extremely versatile, appropriate for almost any occasion. In addition, the fine balance between thick and thin elements gives a pleasing tonal value to this typeface whether it appears as a single word, a line or as a paragraph. As a foundry type it is available in sizes ranging from 18 to 72 point, and it also is to be had in intermediate sizes in photo lettering form and in the several varieties of "instant" paste-up and transfer type varieties. It is an easy typeface to identify, though the points of identification vary somewhat from letter to letter.

Lydian Cursive is classified as an italic rather than a script because the terminal hairlines are not designed to connect in word grouping. The caps do not all align at the bottom. Some letters, like the A, G, J, M, etc., dip below the line, in free swash form. The letters seem to be produced with a chisel-edged pencil or a broad-nibbed lettering pen, a supposition which would tend to explain the angular terminals and upswing slant of the serifs. This calligraphic influence is also evident in the below-or-above-center distribution of weight in the round strokes in all letters, especially in the O. A feeling of angularity and abrupt change in direction and weight of stroke is one of the outstanding characteristics of this beautifully designed calligraphic typeface. There is no "double" or "look alike" for Lydian Cursive, a rare distinction when one considers the hundreds of alphabets listed in type specimen books.

ABCDEFG
HIJKLM
NOPQRST
UVWXYZ

abcdefghijkl
mnopqrstuvwxyz

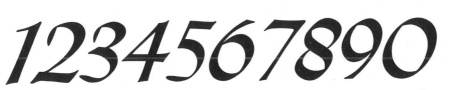

1234567890

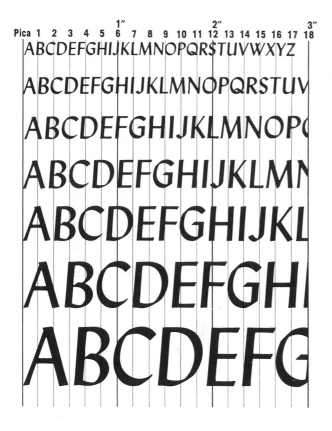

Point Size
14
18
24
30
36
48
60

- VARIATIONS OF THIS TYPE:

Lydian Bold Italic *Lydian Bold Condensed Italic*

ABOUT THIS TYPE FACE

Lydian Italic is easily one of the most popular italics in any typographer's handbook. It has many features which make it distinctive and recognizable.

First, it is strongly calligraphic. The letters are composed of free-hand strokes rendered with a boldness, directness and economy of movement. There are no artful refinements either in the stems or curves. Each stroke is set down as if with a flat pen, layout pencil or well-paletted brush. Once a stroke is down, it is final and isn't doctored up. The stroke endings are slightly angular, both in the uprights and the horizontals. The curves show, without attempt at concealment, the joinings of the strokes. The result is a twist-ribbon effect which is one of the strongly recognizable design features of all Lydian faces.

The lower case shows the same calligraphic characteristics. The direction and the sequence of the strokes are evident in all letters. The dots over the i and j are slanted and unfinished. The shapes of the letters throughout the alphabet are determined by the chisel of the lettering tool, the angle at which it is held and the directness of the movement which has guided it.

Most printers carry varied sizes of Lydian Italic in stock. The range is from 10 to 96 point and is in three faces, Lydian Italic as shown here and two heavier-faced versions called Lydian Bold Italic and Lydian Bold Condensed Italic. The Lydian Italic and Lydian Cursive should not be confused. Both were designed by Warren Chappell, but each has a distinct character of its own.

ABCDEFGHIJ
KLMNOPQRST
UVWXYZ

abcdefgh
ijklmnopqrs
tuvwxyz

1234567890

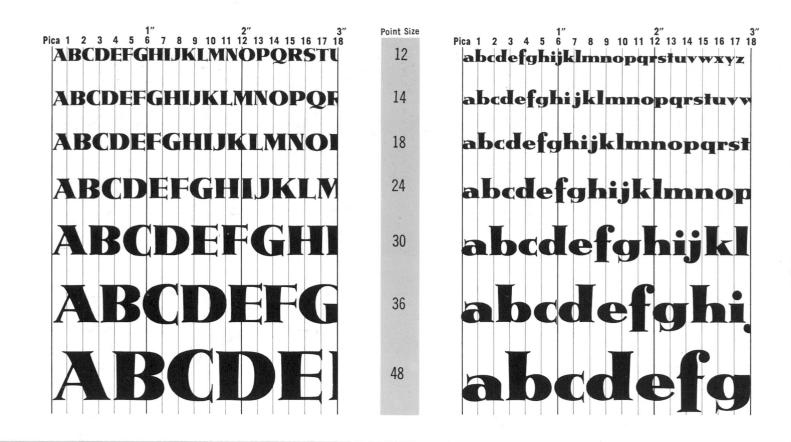

	Point Size	
ABCDEFGHIJKLMNOPQRSTU	12	abcdefghijklmnopqrstuvwxyz
ABCDEFGHIJKLMNOPQR	14	abcdefghijklmnopqrstuvw
ABCDEFGHIJKLMNOI	18	abcdefghijklmnopqrst
ABCDEFGHIJKLM	24	abcdefghijklmnop
ABCDEFGHI	30	abcdefghijkl
ABCDEFG	36	abcdefghi
ABCDEI	48	abcdefg

- VARIATIONS OF THIS TYPE:

Metropolis Light **METROPOLIS**

ABOUT THIS TYPE FACE

The effectiveness of this type design stems from its boldness and strong contrast between thick and thin. It is a fat typeface and can be used effectively to introduce a point of emphasis and color to a typographic layout. It shows up best when employed with a light and simple sans serif face.

An important characteristic of Metropolis Bold is its rather abbreviated serif structure. The serifs serve as whispy flick terminals for the heavy stems of the letters, but have no distinct character of their own to compete for attention with the parent stems. Many of the main strokes in both upper- and lower-case letters are made more interesting by being tapered, heavy on top and narrow at the bottom. The ascenders are high in relation to the x height of the letter, while the descenders are comparatively short and stocky. This is a typeface with an extended set, in relation to its point sizes. It is well to remember in laying out copy for Metropolis to allow ample space in the layout.

Metropolis Bold is carried by most of the better composing rooms in a generous assortment of upper case and lower case sizes, and in several variants, which include Metropolis Light and Metropolis Shaded.

Metropolis Bold shown here is of German origin designed in 1932 by W. Schwerdtner, and is widely distributed in America where it is available as a hand set foundry type in sizes ranging from 8 to 96 points.

ABCDEFG
HIJKLMN
OPQRST
UVWXYZ

abcdefghij
klmnopqrs
tuvwxyz

1234567890

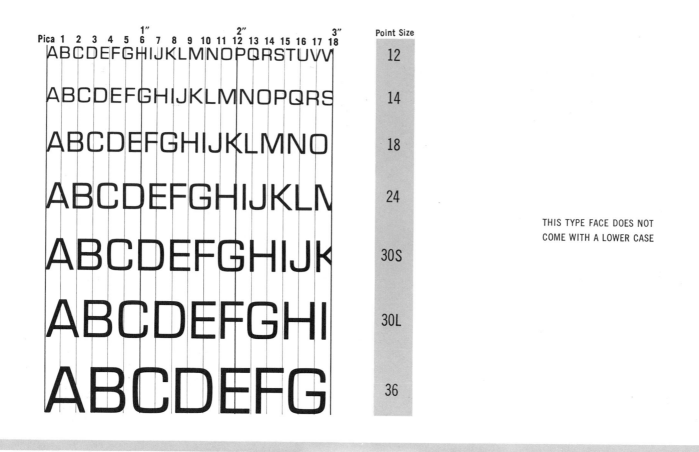

Point Size

12

14

18

24

30S

30L

36

THIS TYPE FACE DOES NOT
COME WITH A LOWER CASE

• VARIATIONS OF THIS TYPE:

MICROGRAMMA CONDENSED MICROGRAMMA EXTENDED

MICROGRAMMA BOLD EXTENDED MICROGRAMMA BOLD

ABOUT THIS TYPE FACE

This is an Italian sans serif, designed by A. Butti in 1939 and cut by the Nebiolo Foundry. The Microgramma family of typefaces includes a number of various modifications in weight and proportion. The specimen shown on the facing page is called Microgramma Normal.

This is a Gothic type sans serif alphabet, seemingly mechanistic in structure, but yet not devoid of the human touch. The O is not round, but at the same time it is not completely flat either. Note the slight suggestion of a bulge of the four sides which comprise the rectangle. The same effect is achieved in the other letters of the alphabet where a bowl of a letter has been flattened. The B, C, D, G, etc. are examples. A noteworthy feature of Microgramma is the rather unusual structure of the K, M, N, V and W. Let us examine the K more closely. You will note that the two diagonal arms do not

actually meet the upright stem directly. Instead they are held away from the stem by a small horizontal cross stroke. Now look at the construction of the M. The sides of the center V-shaped elements do not blend or coincide with the thickness of the two main uprights; instead, they keep their distance, retaining their original thickness and creating a double-thick weight at the points of meeting. This double-thick stroke juncture is also evident in the apex of the A and the N. Also observe the rather low-strung and somewhat thinned crossbar of the A, the vertical tail stroke of the R, the diagonal cross stroke of the Q, the major portion of which is nestled within the counter.

Microgramma is essentially an extended letter form, elemental and pristine in structure and as modern as tomorrow.

ABCDEF
GHIJKL
MNOPQ
RSTUV
WXYZ

1234567890

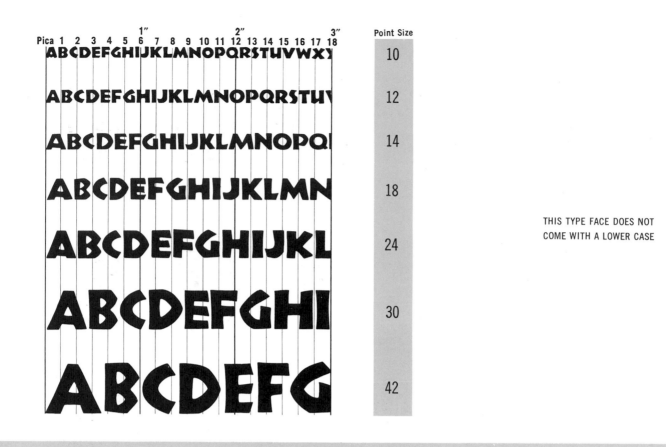

Point Size
10
12
14
18
24
30
42

THIS TYPE FACE DOES NOT
COME WITH A LOWER CASE

• VARIATIONS OF THIS TYPE:

NEULAND INLINE

ABOUT THIS TYPE FACE

An old favorite among novelty display faces, Neuland, designed by Rudolph Koch, has been used since 1922, subject to a fluctuating popularity.

Neuland is used where rough-hewn stability and ruggedness are needed. It has an angular woodblock letter appearance, as if the letter form were chiseled with blunt strokes of a penknife on tough-fibred wood. Neuland may be classified as a Gothic letter since it has no serifs and it makes an attempt to be uniform in thickness. The strokes seem as if they were possibly intended to be all alike in weight, but did not quite succeed. The result is an alphabet which varies in structure and thickness of weight but which nonetheless holds together in color when letters are grouped to form words.

Neuland is a suitable letter for copy which appeals to the virility and stamina of men. It is a letter of field, stream and the great rugged outdoors. Yet despite all its masculinity, Neuland possesses a certain artistic, though primitive, sensitivity which makes it not at all inappropriate for copy relating to art exhibits, lectures, concerts and other occasions where virile good taste is in demand.

This typeface is available in sizes which range from 10 points to 72 points, in caps and figures only. It has its counterpart in Newtown which resembles it in form as well as in name.

THIS TYPE
RESEMBLES:
NEWTOWN,
MONOTYPE OTHELLO

	Point Size	
ABCDEFGHIJKLMNOPQRSTUVWX	14	abcdefghijklmnopqrstuvwxyz
ABCDEFGHIJKLMNOPQRST	18	abcdefghijklmnopqrstuvwxy
ABCDEFGHIJKLMNOF	24	abcdefghijklmnopqrst
ABCDEFGHIJKLM	30	abcdefghijklmnop
ABCDEFGHIJK	36	abcdefghijklmr
ABCDEFGHIJ	42	abcdefghijklr
ABCDEFGH	48	abcdefghijk

• VARIATIONS OF THIS TYPE:

News Gothic Bold Lightline Gothic News Gothic Condensed News Gothic Extra Condensed

ABOUT THIS TYPE FACE

This is a light clean-faced Gothic alphabet which is one of the staples of every printer's job case. Nearly all one thickness in the capital letters, the lower case fluctuates somewhat in thickness of stroke in such letters as the b, d, h, m, n and u where the stroke thins out as it makes a turn to join the main stem. The O is symmetrically oval, as is the C, G and Q, all of which are optically of the same proportion. The o oval in the lower case also fixes the shape of the c and e. The same principle with some modification applies to the b, d, p and q. For other recognizable characteristics note the following: the lower spur extension stroke of the G; the double-weight strokes which unite the V element to the two upright stems atop the M; the double-thick juncture of the left apex of the N; and the hook of the Q. The ascenders and descenders in the lower case are short; the dots over the i and j are square.

News Gothic's widespread and versatile applications can be established by the fact that it is issued as a foundry type in a prodigious variety of sizes, as well as in Intertype, photo lettering and a series of mechanically applied lettering systems. The News Gothic family of typefaces includes in addition to the specimen shown here a bolder version called News Gothic Bold, an extended version, an extra condensed species and a fine face variety of Gothic called Lightline Gothic.

ABCDEFGHI
JKLMNOPQR
STUVWXYZ

abcdefghi
jklmnopqrst
uvwxyz
1234567890

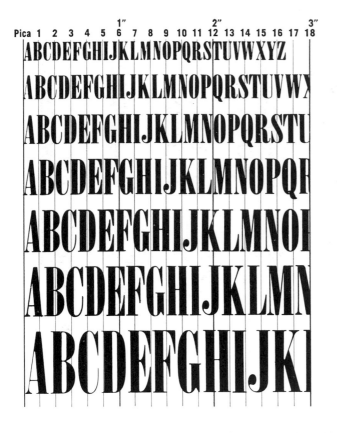

Pica 1 2 3 4 5 6 7 8 9 10 11 12 13 14 15 16 17 18

ABCDEFGHIJKLMNOPQRSTUVWXYZ

ABCDEFGHIJKLMNOPQRSTUVWX

ABCDEFGHIJKLMNOPQRSTU

ABCDEFGHIJKLMNOPQR

ABCDEFGHIJKLMNOI

ABCDEFGHIJKLMN

ABCDEFGHIJKI

Pica 1 2 3 4 5 6 7 8 9 10 11 12 13 14 15 16 17 18

abcdefghijklmnopqrstuvwxyz

abcdefghijklmnopqrstuvwxyz

abcdefghijklmnopqrstuvwxy

abcdefghijklmnopqrstuv

abcdefghijklmnopqrs

abcdefghijklmnop

abcdefghijklmr

● VARIATIONS OF THIS TYPE:

Onyx Italic

ABOUT THIS TYPE FACE

This typeface resembles a Bodoni or a Modern Roman Extra Condensed stretched out lengthwise. The most recognizable features are the enormous contrasts between the primary and secondary strokes and the extremely condensed and elongated form of each letter. Onyx has two types of serifs, both of which are present in most letters. The A can be used to illustrate this. The serif on the left is triangular in shape and blends softly into the thin diagonal stroke. The right serif is merely a whispy hairline running straight across the bottom of the stem. Note too the extremely narrow rectangular counters. The outside bowls, as in the B, C, etc. are round, the areas within are flat and long, resembling pillars. Actually there is a third kind of serif as will be noted by a close inspection of the terminals of the three arms of the E. All three serifs are triangular and spearlike. This is a characteristic of the head serif of the C, E, F, G, L, S, T and Z.

The lower case follows the set pattern of the capitals. There is the same shocking contrast between thick and thin elements as well as the several kinds of serif treatments. The a is somewhat of a maverick, in that the outside as well as the inside of the bowl is flattened, and also in that it has a ball-shaped terminal. The ball terminal in a modified form is seen also in the j and r. The Onyx is a beautiful letter style but it cannot be used too copiously in paragraph form. The strong black and white contrasts produce an astigmatism and make reading tiresome. There is also an italic form which retains the characteristics of the parent alphabet.

Onyx was issued by American Typefounders in 1937 from a design by Gerry Powell. Since then it has joined the family of display faces with some assurance of permanency. It has its counterpart in Slimblack as produced by another foundry the same year.

A B C D E F G H I J
K L M N O P Q R S T
U V W X Y Z

abcdefghijklmno
pqrstuvwxyz
1234567890

THIS TYPE
RESEMBLES:
SLIMBLACK,
SPIRE NO. 377,
OLYMPIC

ONYX **141**

Pica 1 2 3 4 5 6 7 8 9 10 11 12 13 14 15 16 17 18	Point Size	Pica 1 2 3 4 5 6 7 8 9 10 11 12 13 14 15 16 17 18
ABCDEFGHIJKLMNOPQRSTUVW	14	abcdefghijklmnopqrstuvwxyz
ABCDEFGHIJKLMNOPQRSTU	18	abcdefghijklmnopqrstuvwxyz
ABCDEFGHIJKLMNOPQ	20	abcdefghijklmnopqrstuv
ABCDEFGHIJKLMN	24	abcdefghijklmnopqrs
ABCDEFGHIJKL	30	abcdefghijklmnop
ABCDEFGHIJ	42	abcdefghijklm
ABCDEFG	54	abcdefghijl

• VARIATIONS OF THIS TYPE:

Palatino Italic **Palatino Semi-Bold** *PALATINO SWASHES*

ABOUT THIS TYPE FACE

Palatino, shown here, was created by Hermann Zapf who is considered by many to be one of Europe's greatest contemporary type designers. This typeface was first produced in 1950 by Germany's Stempel Foundry but it has recently been brought to America where it is available at the better composing rooms and type houses. Palatino is named after a historically famous penman of the 16th century, but Zapf in creating this typeface drew his inspiration from the Venetian Romans.

Palatino has a strong calligraphic flavor. The stress of curved strokes is somewhat diagonal and the general tone shows evidence of the pen, rather than the engraver's tool. The strange thing about this face (and other faces of calligraphic origin) is that each letter viewed by itself never looks as good as letters combined in words, or words held together in mass copy. The D, for example, seen in isolation seems somewhat lopsided with too much stress on the upper portion of the lobe. The E and F have no serifs on the center arms, the G has a very low upright, the S seems to be leaning backward, and the W lacks mechanical symmetry. This apparent lack of consistency or mechanical precision is also quite evident in the lower case. Observe closely the last six letters of the alphabet. The structure of the u is conventional, but the v, w, x, y and z are all independent forms showing very little family relationship. Yet in spite of these apparent inconsistencies, there are very few contemporary faces which match Palatino in freshness, originality and in unity of total impression.

ABCDEFG
HIJKLMN
OPQRSTU
VWXYZ

abcdefghij
klmnopqrst
uvwyxz

1234567890

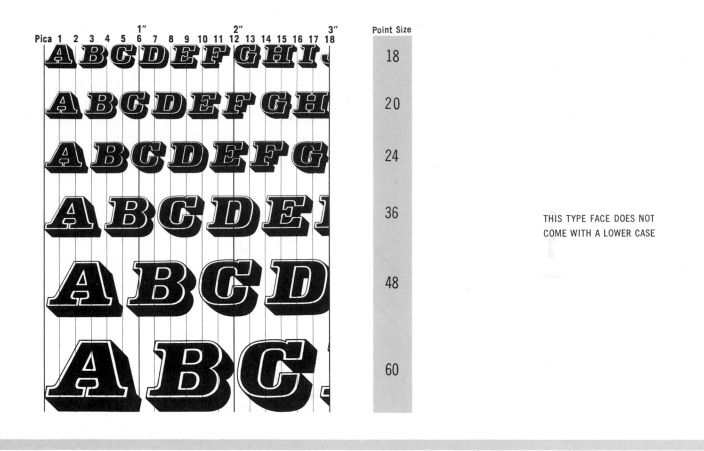

ABOUT THIS TYPE FACE

This contemporary Egyptian display type designed by Eugene and Max Lenz in 1943 shares some of the same characteristics of Beton Bold in the slab structure of the serifs, extended proportion and relationship of massive thick and thin elements. It has, however, many unique features which make it a type very easy to distinguish from Beton or the myriads of other typefaces in use today.

At first glance, Profil seems like a photograph negative of a sloped square serif letter drawn in white on black paper. This is due to the predominance of the black in both face and shadow, relying chiefly on the thin white outline to give form and definition to the letter structure. The heavy drop-shadow supports the white outline to the right and below, producing an effective three-dimensional illusion. The bowls of most letters are somewhat flattened, but that is not a consistent pattern throughout the alphabet. You will note that the bowls of such letters as the B, P, R and S are full-blown, while those of the D and O etc., are compressed.

Excellent as an eye catcher, Profil is appropriate for advertising purposes, as well as for book jackets, decorative initials, etc. It is issued in only one face, in sizes which range from 18 to 72 points. There is no lower case. Profil is now obtainable also in patented transfer lettering sheets as well as in assorted sizes in photo lettering systems.

To keep the thin inline clear and open, especially in the smaller type sizes, a good glossy calendered stock is needed, as well as personal attention to careful makeready in terms of ink, printing contact and other production controls.

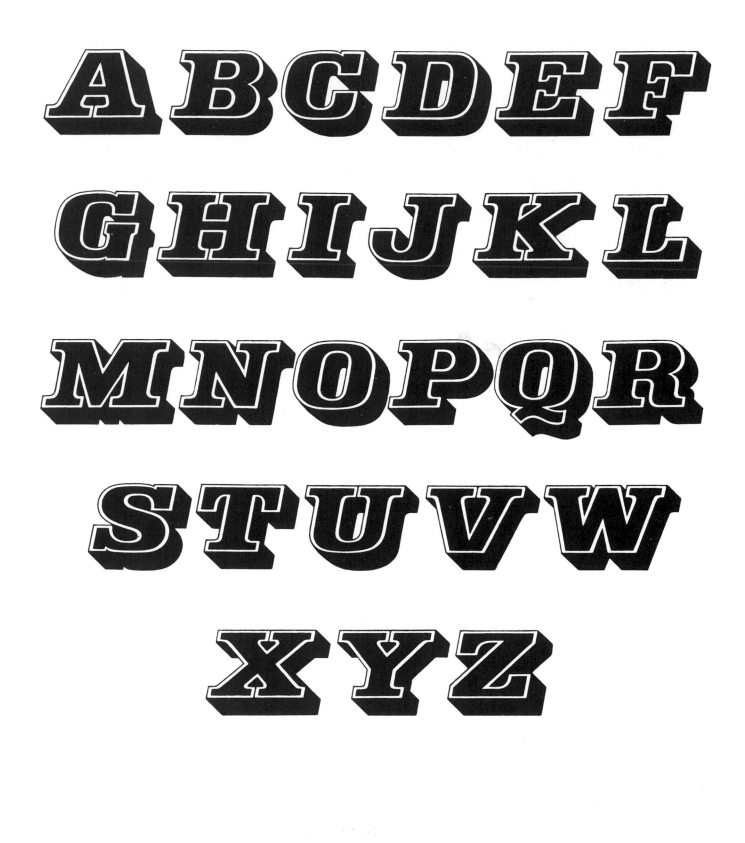

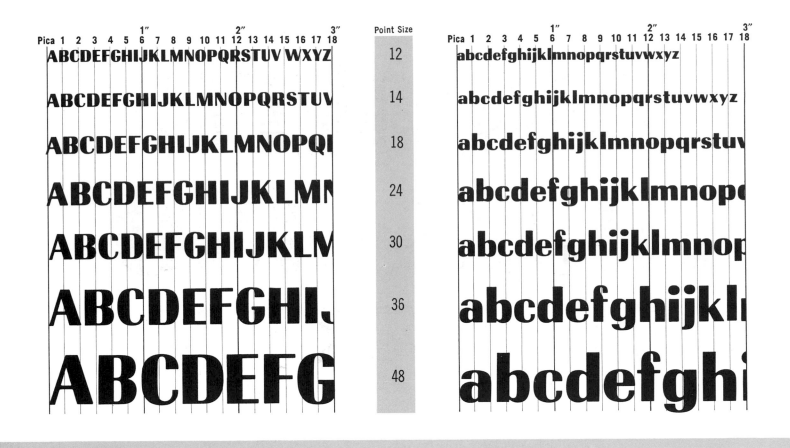

- VARIATIONS OF THIS TYPE:

Radiant Medium **Radiant Bold** **Radiant Bold Condensed** **Radiant Bold Extra Condensed**

ABOUT THIS TYPE FACE

Radiant Heavy, designed for Ludlow in 1940 by Robert Middleton is not a particularly beautiful letter style, but it has proven itself to be serviceable as one of the standard fat face display types.

This is a sans serif thick-and-thin typeface whose chief personality lies in its contrast between thick and thin. The heavy elements are so dominant that the thin lines seem incidental, almost appearing like the gaps in the Stencil typeface. There are a number of members of the Radiant family of typefaces; Radiant Medium, Radiant Heavy, Radiant Bold Condensed and Radiant Bold Extra Condensed. All of these are condensed to a lesser or greater degree; in none of them for instance, is the C or O fully circular. In the specimen shown here, all the round letters are flattened to some extent, as best exemplified in the D, O, P, etc. Note that in the round letters or elements, the counters do not follow the same broad curve of the outer rim. The sides of the counters of the letters are practically upright and vertically parallel to the upright stems. The lower case exhibits the same strong contrasts between thick and thin; the ascenders and descenders are short and stocky. Radiant can be effectively used as a display face for commercial printing in newspapers, booklets, direct mail, brochures, etc. Radiant Heavy bears a resemblance to Britannic and Rothbury, two faces issued by the English foundry, Stephenson Blake.

ABCDEFG
HIJKLMNO
PQRSTUV
WXYZ

abcdefghij
klmnopqrst
uvwxyz
1234567890

THIS TYPE
RESEMBLES:
BRITANNIC,
ROTHBURY

ABCDEFGHIJKLMNOPQRSTU — 18 — *abcdefghijklmnopqrstuvwxyz*

ABCDEFGHIJKLMNOPQ — 24 — *abcdefghijklmnopqrstuvwxyz*

ABCDEFGHIJKLM — 30 — *abcdefghijklmnopqrstuvwxyz*

ABCDEFGHIJKL — 36 — *abcdefghijklmnopqrstuvwxy*

ABCDEFGHI — 48 — *abcdefghijklmnopqrst*

ABCDEFG — 60 — *abcdefghijklmn*

ABOUT THIS TYPE FACE

This is a connected script which closely simulates a personal style of handwriting. The capitals and such letters as the e, g, p, w and y have no connecting link extensions; nonetheless when letters are grouped to form words, they seem to link together very well. The occasional break in linkage simulates the character found in personalized handscript. The letters in Repro Script are proportionally tall compared to the width. Although there are variations in the weight and accent of strokes, the total effect is one of even tone and color. The variations in thickness are more discernible in the capitals than they are in the lower case. The slight fluctuations in weight seem to diminish in the smaller point sizes.

Repro Script is a practical typographic substitute for hand lettering. It can be effectually used as captions in advertising layouts, book jackets and chapter headings, titles for magazine stories, packaging, etc. Repro Script is an American Foundry type cast only in 18, 24, 30, 36, 48 and 60 points. It is obtainable however in a number of patented photo lettering and transfer sheets in varied sizes.

As a typeface, Repro Script has no variants and there is no other standard typeface which can be quite mistaken for it. There are other informal type scripts such as Rimer Script, Maxine, Hauser Script, Flair, Charme, Charcoal, Bravo, Brody, etc., but none strike the perfect balance between the formal and informal character which typifies Repro Script. Perhaps Brody comes closest in the listing of alternates.

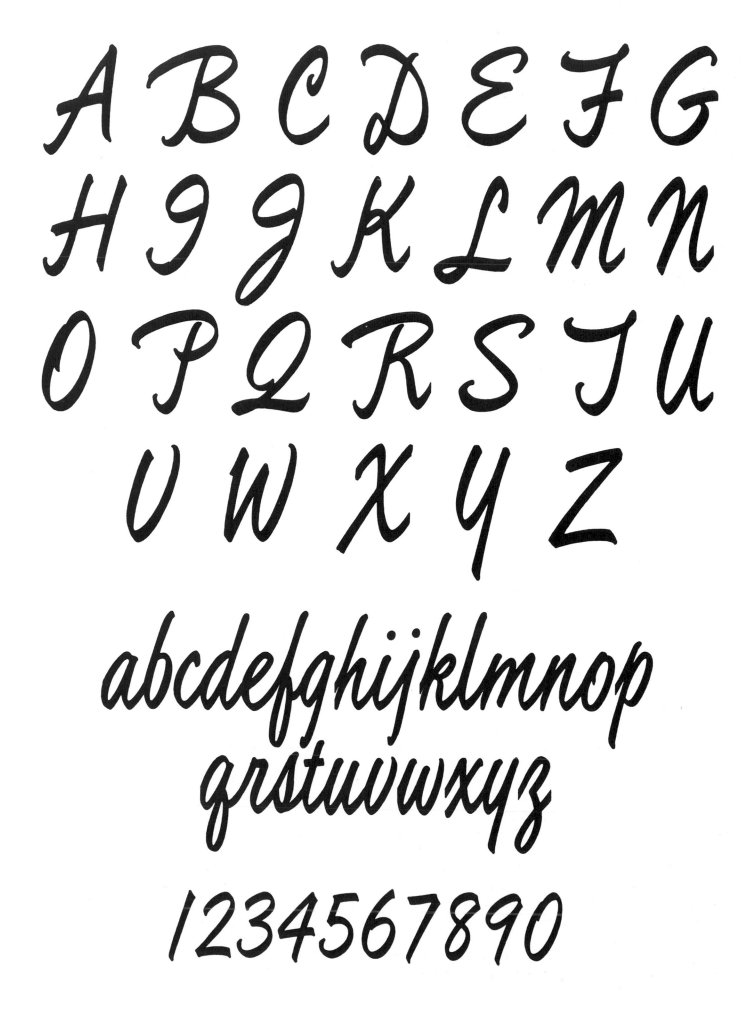

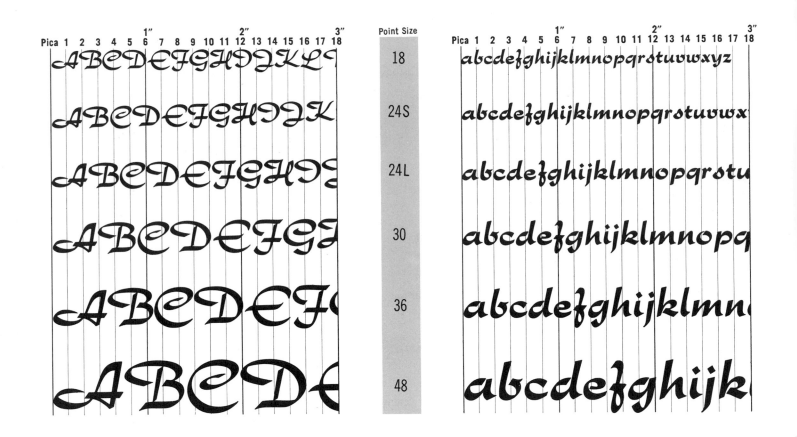

	Point Size
	18
	24S
	24L
	30
	36
	48

- VARIATIONS OF THIS TYPE:

Rondo

ABOUT THIS TYPE FACE

This free-flowing calligraphic typeface was created by two Dutch designers, Stefan Schlesinger and Dick Dooijes for the Amsterdam Continental Typefoundry in 1948. The letters give the appearance of having been done with an obliquely cut, chisel-edged felt marking pen or broad layout pencil. The letters of the upper case are handled somewhat differently from those of the lower case. The capitals are more vigorous, less restrained and somewhat less consistent than the lowercase letters. The upright strokes of the capitals are thin, indicative of having been produced with a sweeping movement of the obliquely held tool. The horizontal strokes and curves show the full force and width of the

tool as evidenced by the weight of the stroke.

The lower-case letters show a heavy upright stroke consistently through the alphabet with the exception of the f. The accented stress of the round letters is at an angle. The ascenders and descenders are short and stubby.

Rondo is not a bread-and-butter script like Kaufmann or Grayda, but we don't live by bread alone. Rondo has admittedly limited use but where a calligraphic or exotic motif will help convey the mood expressed in the copy, it may be just the typeface you are looking for. It comes in two variations, Rondo and a bolder version (which is shown here). Point sizes range from 12 to 72.

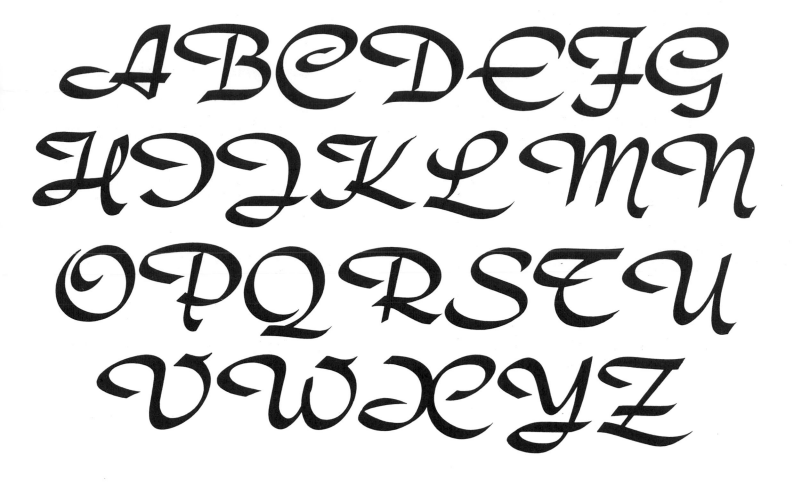

ABCDEFG
HIJKLMN
OPQRSTU
VWXYZ

abcdefghijklmno
pqrstuvwxyz

1234567890

ABCDEFGHIJKLMNOPQRSTUVWXYZ **12**

ABCDEFGHIJKLMNOPQRSTUVWX **14**

ABCDEFGHIJKLMNOPQRS **18**

ABCDEFGHIJKLMNO **24S**

ABCDEFGHIJKLM **24 L**

ABCDEFGHIJK **30**

ABCDEFGH **42**

abcdefghijklmnopqrstuvwxyz

abcdefghijklmnopqrstuvwxyz

abcdefghijklmnopqrstuvw

abcdefghijklmnopqr

abcdefghijklmnop

abcdefghijklm

abcdefghijk

• VARIATIONS OF THIS TYPE:

Standard Extra Light Ext Standard Light Ext Standard Light Standard Light Cond

Standard *Standard Italic* Standard Ext Standard Cond ***Standard***

Med. Italic Standard Medium Cond **Standard Bold** **Standard Extrabold**

ABOUT THIS TYPE FACE

Closely resembling Franklin Gothic, the specimen of Standard Medium shown here is a clean-looking continental sans serif Gothic, almost mechanically even in thickness. The round letters are somewhat condensed to an oval form in the upper case, but are more full and naturally curved in the lower case. By turning to page 96 which displays the Franklin Gothic you will see the basic identity between these two alphabet families. Note the structure of the M, with its double weights where the V-shaped element meets the two side strokes, the high juncture of the two arms of the K, the appendage which drops down on the side of the crossbar of the G. In the lower case, the g's are radically different; they have an open loop. The y has a horizontal flat tail in the lower case, but does not carry it in the upper. Both alphabets carry square dots over the i and j.

The Standard Medium of the facing page bears a very close resemblance to Akzidenz-Grotesk Medium, which is in fact a lighter version of Standard.

The family of Standard typefaces is very extensive and includes Light, Condensed, Extra Bold Condensed, Extra Bold Extended, Light Extended, Extra Light Extended, Italic Extended, etc. Sizes range from 6 to 72 points.

Standard Medium is an extremely versatile typeface, completely devoid of eccentricities or typographic configurations. It prints well on any type of paper stock and reproduces nicely by letterpress, offset, silk screen, photogelatine, etc. This typeface (in all its variations) represents an excellent addition to any typographer's choice list of practical typefaces.

ABCDEFG HIJKLMNOP QRSTUV WXYZ

abcdefghi jklmnopqrstu vwxyz

1234567890

THIS TYPE
RESEMBLES:
FRANKLIN GOTHIC,
AKZIDENZ-GROTESK MEDIUM

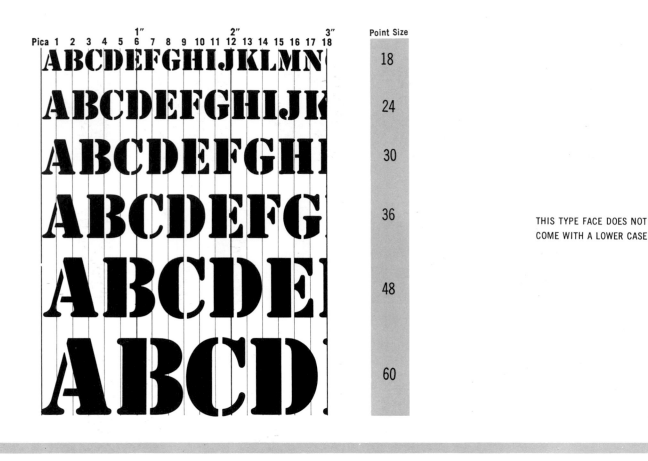

THIS TYPE FACE DOES NOT
COME WITH A LOWER CASE

ABOUT THIS TYPE FACE

This easy-to-recognize display face, cut by Ludlow in 1936 is based on the type of lettering traditionally used for identification markings on shipping containers, burlap bags and wooden packing crates. Such lettering is usually rough and bold because the marking is achieved by rubbing ink through the openings of a cut stencil. The little unprinted gaps within the letter form are due to ties or bridges needed to keep the counters from dropping out. It is these gaps which give character and identity to the Stencil typeface.

Essentially this is a fat Roman typeface with inconspicuous but stubby little serifs. The counters are elongated and have flat walls which do not conform to the round shell of the traditionally round letters and lobes.

The integral parts of the letter form are separated by the gaps which create an interesting pattern of breaks in the continuity of the letter structure. There is no standard lower case available but for the hand letterer this becomes a challenge in design, for if need be, a compatible lower case can surely be devised to match the general pattern. Another typeface called Tea Chest, produced in England and designed in 1939 by the Stephenson Blake Foundry, is somewhat similar in structure to the Stencil type, but it is a condensed modification of it. Either is appropriate for things rustic and masculine and the dramatic, and there would be no great loss in effect in using them as alternates. Stencil is available as a foundry type in 18, 24, 30, 36, 48 and 60 points.

A B C D E F
G H I J K L
M N O P Q
R S T U V
W X Y Z
1234567890

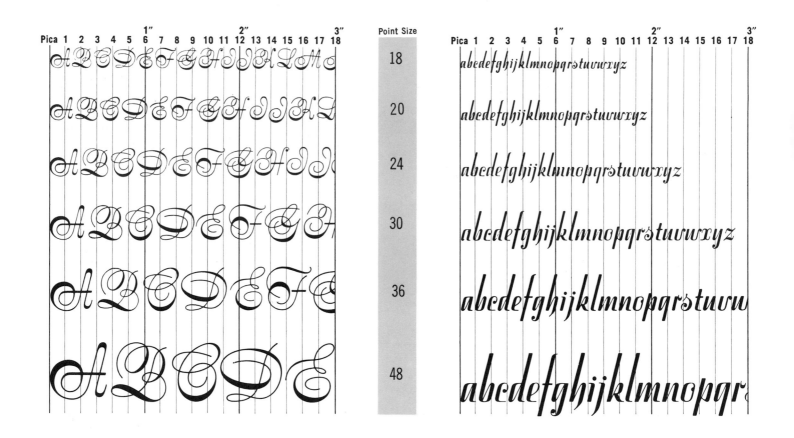

	Point Size	
	18	
	20	
	24	
	30	
	36	
	48	

ABOUT THIS TYPE FACE

The graceful swirl of the musical clef is reflected in the modulated flourishes of this delicately graceful typeface, designed by Imre Reiner in 1945 for Bauer Type Foundry. Stradivarius is distantly related to the round hand of Spencerian writing and the decorative initials that one occasionally comes across on faded inscriptions in pages of a prized family book. Although at first glance Stradivarius gives one the impression that it is an evenly-distributed thick-and-thin alphabet of letters, it would be better to describe it as being comprised of essentially fine hairline letters with delicately accented weights. All the capitals share that characteristic; the L for example shows the structure of the letter form to be a fine hairline, with the exception of the downstroke of the lower loop which embodies the accented stress. This is true of all other caps, although some letters such as the H, K,

and M carry in addition a little disconnected ball-shaped bullet, either at a terminal or at the sharp turn in the direction of the strokes.

The lower case does not reflect these recognizable characteristics at all. Absent are the full-bodied round swirls and flourishes. The ascenders are long, the descenders short and constant in weight. The letters of the lower case are very rectangular and condensed, and seem compressed. Perhaps the only lower-case letters which carry the family identifications of the upper case are the full-bodied s and the flourish z. The others are patterned after a different structural treatment. The lower case has a rigidity which is produced by compressing the normally round letters into a rectangle. This alphabet is also known as Sinfonia.

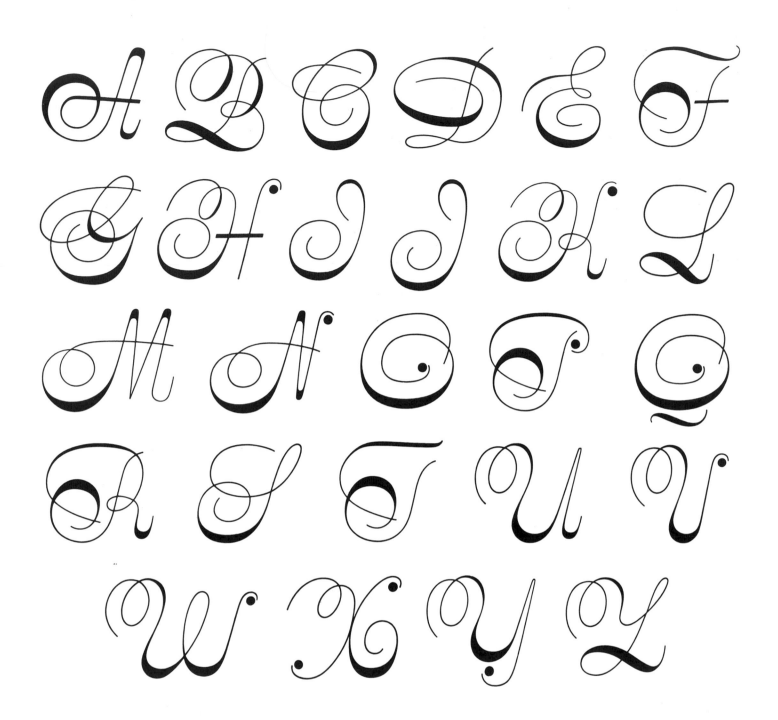

abcdefghijklmnopqrstuvwxyz

1234567890

ABCDEFGHIJKLMNOPQRSTUVWXYZ 12 abcdefghijklmnopqrstuvwxyz

ABCDEFGHIJKLMNOPQRST 18 abcdefghijklmnopqrstuvwx

ABCDEFGHIJKLMNOP 24S abcdefghijklmnopqrst

ABCDEFGHIJKLMN 24L abcdefghijklmnop

ABCDEFGHIJKL 30 abcdefghijklmn

ABCDEFGHIJ 36 abcdefghijklr

ABCDEFG 48 abcdefghi

Point Size

● VARIATIONS OF THIS TYPE:

Studio Bold

ABOUT THIS TYPE FACE

Although Studio is available in sizes up to 72 points, it is at its best as a small-point alphabet. Its inherent free-drawn charm is best manifested in the 8, 10 and 12 point sizes. What is more, Studio is among those typefaces which take on character in word groupings and in long lines of copy. For those, however, who use this book as a specimen reference for hand lettering, this alphabet, like all others in this collection, is shown in individual letters and enlarged to present a clear and unobstructed close-up view of the fundamental structure of each letter.

The Studio alphabet, designed by A. Overbeck in 1949, reminds one of Oriental calligraphy. The letters look as if they were shaped with a Chinese brush held upright, in the manner of Chinese calligraphic writing. Observe the three distinct stab-like strokes of the A, each stroke set down with a direct boldness, and crossing vigorously beyond the intersection. This is typical of most of the letters in this alphabet. The basic letter form is for the most part, thick-and-thin, but the interrelationship of thin and thick strokes do not follow the traditional pattern. The A shows distinct variation in thickness of stroke, but this does not hold true of the H, the N, etc. The lower case exhibits a somewhat greater consistency in the thick-and-thin pattern, but it is quite innocently inconsistent in the uniformity of letter shapes. Some letters are upright, others lean forward, still others end with a backhand stroke. However, all these inconsistencies are obscured and quite charming when the letters are spaced to form words and hold on to each other as word groups.

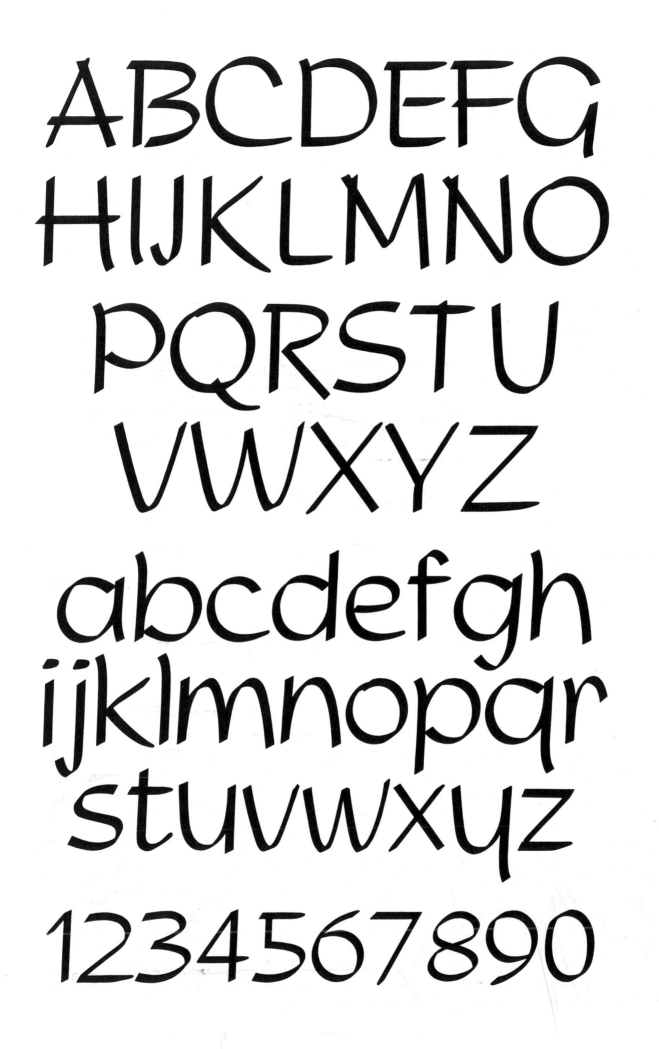

ABCDEFG
HIJKLMNO
PQRSTU
VWXYZ

abcdefgh
ijklmnopqr
stuvwxyz
1234567890

Point Size		
ABCDEFGHIJKLMNOPQRSTUVWX	12	abcdefghijklmnopqrstuvwxyz
ABCDEFGHIJKLMNOPQRST	14	abcdefghijklmnopqrstuvwxyz
ABCDEFGHIJKLMNOP	18	abcdefghijklmnopqrstuv
ABCDEFGHIJKLM	24	abcdefghijklmnopq
ABCDEFGHIJK	30	abcdefghijklmno
ABCDEFGH	36	abcdefghijklr
ABCDEFG	42	abcdefghijl

• VARIATIONS OF THIS TYPE:

Stymie Light *Stymie Light Italic* Stymie Medium *Stymie Medium Italic*

Stymie Medium Condensed ***Stymie Bold Italic*** **Stymie Bold Condensed**

ABOUT THIS TYPE FACE

Stymie Bold, created by Morris Benton in 1931, can be said almost to have "a thousand faces." The variations that come under the general name "Stymie" are so extensive that only the name itself remains when the family characteristics of the type all but disappear. It is often difficult to see any marked resemblance between them. Stymie Bold varies greatly with Stymie Bold Condensed, which in turn differs considerably from Stymie Black, etc. To compound the confusion, a version of the Stymie family of typefaces is represented by names coined by different type foundries. It takes an expert with a keen eye to tell unerringly the difference between Girder, Stymie, Memphis and Rockwell. However the broad recognizable features of Stymie Bold apply for the most part to its equivalents in most of the others as well.

The particular version of Stymie selected here has a distinct machine-made quality as if it were designed by a lettering robot who was handed drafting tools and India ink. This is no frilly type. The type has the appearance of being constructed from sheet metal hammered to take on the shape of the letter form. More particularly stated, Stymie Bold's recognizable features are as follows: an almost unvarying monotone throughout the twenty-six letters of the alphabet; the slab serifs are cut square and long, and are of the same thickness as the main strokes; the broad serif bar running across the apex of the A; the absence of serifs on the center arm of the E and F; the almost perfectly round C, G, O and Q; and the bar serif stroke over the middle element of the W. The lower case retains nearly all the same weight of stroke, the uniform slab serifs and the machine-like structure. Note the inconsistency in the treatment of the descenders of the p and q.

ABCDEFG
HIJKLMN
OPQRSTU
VWXYZ

abcdefghi
jklmnopqrs
tuvwxyyz

1234567890

THIS TYPE
RESEMBLES:
GIRDER,
MEMPHIS,
ROCKWELL

STYMIE BOLD **161**

	Point Size	
ABCDEFGHIJKLMNOPQRSTUVWXY	12	abcdefghijklmnopqrstuvwxyz
ABCDEFGHIJKLMNOPQRSTUVW	14	abcdefghijklmnopqrstuvwxyz
ABCDEFGHIJKLM	24	abcdefghijklmnopqrst
ABCDEFGHIJK	30	abcdefghijklmnop
ABCDEFGH	36	abcdefghijklm
ABCDEFG	42	abcdefghijkl
ABCDEFC	48	abcdefghij

● VARIATIONS OF THIS TYPE:

Times Roman *Times Roman Ital.* **Times Roman Semi Bold**

ABOUT THIS TYPE FACE

Times Roman, attributed to Stanley Morrison, is considered by some to rank among the most practical typeface designs of our day. It gets its name from the London Times for which it had been specifically created when that newspaper underwent a complete typographic restyling in 1931.

Times Bold, a derivative of Times Roman, is basically an "old face" style since it has many of the earmarks of this category. The point of maximum stress in the lower case is at an angle; the A has a pointed apex; the upper serif of the C is barbed, while the lower part of the letter ends with a point. A Roman by family lineage, it is a good bread-and-butter alphabet, one which can handle a dual job; that of a display letter and that of a body and text face. It cannot be too easily recognized because it simply does not make any pretension to achieve structural whimsies which would set it apart from many other alphabets in the spreading family tree of Roman typefaces.

Times New Roman Bold is a fine-serifed letter, somewhat extended and considerably contrasty in the relationship of thick and thin. The serifs connect to the main stem by means of fillets which terminate as hairlines. The thin elements of the letters as well as the arms and diagonals are rather mechanically even in thickness. The bowls of the capitals are smooth and round, weighted in the center and symmetrical. The swash of the Q does not extend into the counter and resembles a dog's clipped tail. The W is wide enough for two V's and is indeed constructed in the manner of two V's overlapping in the center. While only the Bold version is shown here, Times Roman is made in italic forms, as well as in a lighter and more basic face called Times Roman. It is also available in an extended version called Times Roman Titling Extended. Being a favorite newspaper type, its range of sizes starts at a low 6 points and goes up to 72.

ABCDEFG
HIJKLMN
OPQRSTU
VWXYZ

abcdefghij
klmnopqrst
uvwxyz

1234567890

	Point Size	
ABCDEFGHIJKLMNOPQRSTUVWX	14	abcdefghijklmnopqrstuvwxyz
ABCDEFGHIJKLMNOPQRSTU	18	abcdefghijklmnopqrstuvwxyz
ABCDEFGHIJKLMNOP	24S	abcdefghijklmnopqrstuv
ABCDEFGHIJKLMN	24L	abcdefghijklmnopqrs
ABCDEFGHIJKLM	30	abcdefghijklmnop
ABCDEFGHI	36	abcdefghijklm
ABCDEFG	48	abcdefghijk

● VARIATIONS OF THIS TYPE:

Torino Italic

ABOUT THIS TYPE FACE

Here is a very clean-looking typeface which is not used nearly as much as it deserves to be. It has a pristine elegance in both line and form; reads easily as a text face as well as a display face and possesses the fresh modern look which would brighten up any page of copy.

Structurally, Torino owes its heritage to Bodoni which it resembles in many ways, but it has a distinct personality all its own. Foremost among its characteristic features are the serifs, which are needle thin, long and extremely well-balanced. The weight of the serif matches exactly the weight of the hairline of the letter itself, so that the general tone of the letter is reduced to two weights—the thick main elements, and the serif-hairline element. A closer analysis will reveal two other kinds of serifs but those seem to carry the same weight as the main elements of the letter form. The triangular serif of the left side of the A blends gracefully into the diagonal strokes and ends up on the base as a hairline. It makes its appearance again in the M, N, U, etc. The other kind of serif, the spurred beak is exemplified in the C and G and in a modified form, in the E, F, etc.

Another strong (and favorable) characteristic of Torino is the well-balanced distribution of the accents of the round letters. There is perfect symmetry in the O and Q as well as in the lobes of the B, P, R, etc.

Torino is a condensed letter form; all letters are of practically the same width. Visually, the O is no wider than the E or the L. Even the traditionally wide letters such as the M and W have been slimmed down to stay within the condensed proportion.

The lower case reflects the same simple elegance and classic balance of the caps. The letters are condensed, carry the same needle-fine serifs and measured weight of the main stems. Ball terminals of the a, c, f, r and y add a note of sparkle. The only oddity (we almost said gimmick) to the lower case is the open lower loop of the g which turns into itself like a cat sitting on its tail.

ABCDEFG
HIJKLMN
OPQRSTU
VWXYZ
abcdefghij
klmnopqrst
uvwxyz
1234567890

ABCDEFGHIJKLMNOPQRSTUVWXYZ — 12 — abcdefghijklmnopqrstuvwxyz

ABCDEFGHIJKLMNOPQRSTUVWXYZ — 14 — abcdefghijklmnopqrstuvwxyz

ABCDEFGHIJKLMNOPQRSTUVWXYZ — 18 — abcdefghijklmnopqrstuvwxyz

ABCDEFGHIJKLMNOPQRSTU — 24 — abcdefghijklmnopqrstuvwxyz

ABCDEFGHIJKLMNOPQR — 30 — abcdefghijklmnopqrstuvw

ABCDEFGHIJKLMN — 36 — abcdefghijklmnopqrst

ABCDEFGHIJKL — 48 — abcdefghijklmn

ABOUT THIS TYPE FACE

To best remember this typeface, picture in your mind an elongated Gothic condensed letter form to which has been added square serifs of the same thickness as the main letter strokes. This in essence is the basic structure of the Tower typeface shown here. This type design does not boast of calligraphic inventiveness or Old World charm, but it does have the power and legibility which make it a serviceable typeface where an effect of height and simple strength are desired. Tower reproduces well on any kind of printing stock and is therefore used frequently in newspaper ads, department store merchandising, throwaways and handbills, window signs, posters and displays. The flattened bowls add to the effect of verticality. The only roundness evident in this face are the

upper and lower elements of the letters which have retained their curvature. Even these are flattened somewhat so that the letters do not extend beyond the normal alignment and stay visually within the x height.

For the hand letterer working for reproduction, Tower is an ideal model to follow. The weight can be measured off mechanically, the major portion of the elements lend themselves for ruling pen and the spacing offers no particular problem.

Tower was cut in 1934 by American Type Foundry from a design by Morris Benton and is now available in sizes from 12 to 72 points. In a sense, this typeface resembles a condensed version of Stymie.

ABCDEFGHIJ
KLMNOPQRST
UVWXYZ

abcdefghijklmn
opqrstuvwxyz

1234567890

Point Size
14
18
24
30
36
48
60

ABOUT THIS TYPE FACE

Trafton Script has become one of the basic type scripts in use today. Designed by Howard Trafton in 1933 for Bauer Type Foundry, this type which bears his name is based on handwriting. The script style is especially noticeable in the capitals. Trafton exhibits a spirit of spontaneous calligraphic improvisation in the swash and flourish elements in the capitals. You will note that the format of the flourishes is not consistently fixed throughout the upper case but varies considerably from letter to letter. Compare the flourish and swash of the D with its unrestrained loops and sweeps, with the fundamentally simple C or the unadorned K. The B dips well below the base line in an exuberant loop. Some semblance of consistency however is achieved by the fixed relationship between thick and thin strokes and the italic slant. The lower case conforms more to a fixed pattern of a typeface than to the spontaneous character of hand lettering. The lower-case letters have elongated ascenders which terminate with an oblique cut. The descenders are looped as in normal handwriting. The bullet-sized dots over the i and j are unique.

This is an unconnected script, so that letters must be set solid to give the effect of unity to word formation. The capitals are too ornate to be used as individual letter forms for complete words. Trafton has a free-drawn pen-lettered quality, and when used appropriately adds a personal touch to a well-designed typographic layout.

It is available in foundry sizes 14 to 84 points, in one face only.

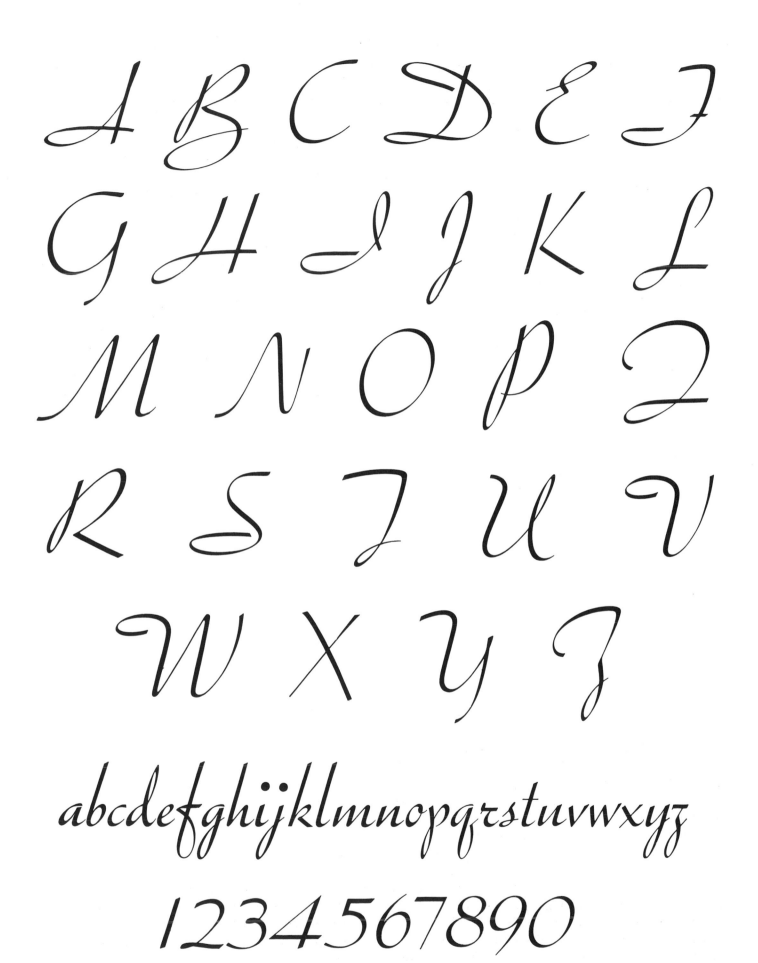

ABCDEF
GHIJKL
MNOP2
RSTUV
WXY3

abcdefghijklmnopqrstuvwxyz

1234567890

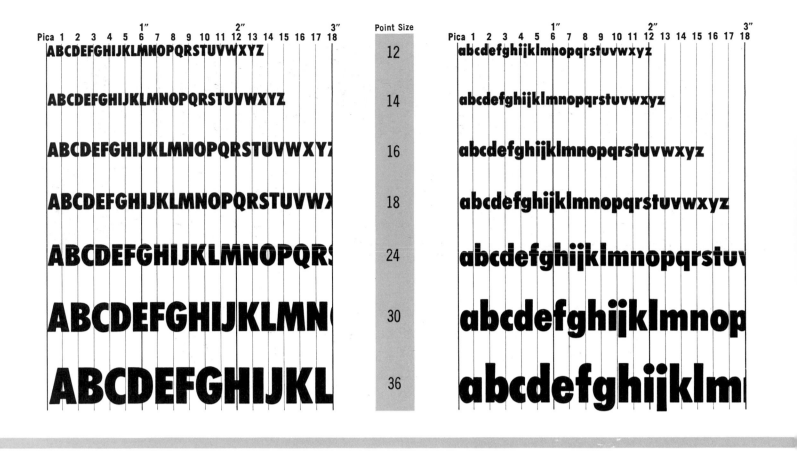

		Point Size		
ABCDEFGHIJKLMNOPQRSTUVWXYZ		12		abcdefghijklmnopqrstuvwxyz
ABCDEFGHIJKLMNOPQRSTUVWXYZ		14		abcdefghijklmnopqrstuvwxyz
ABCDEFGHIJKLMNOPQRSTUVWXYZ		16		abcdefghijklmnopqrstuvwxyz
ABCDEFGHIJKLMNOPQRSTUVW		18		abcdefghijklmnopqrstuvwxyz
ABCDEFGHIJKLMNOPQR		24		abcdefghijklmnopqrstu
ABCDEFGHIJKLMN		30		abcdefghijklmnop
ABCDEFGHIJKL		36		abcdefghijklm

• VARIATIONS OF THIS TYPE:

Twentieth Century Medium *Twentieth Century Medium Ital.*

Twentieth Century Bold **Twentieth Century Ultra Bold**

Twentieth Century Ultra Bold Cond. Ital.

ABOUT THIS TYPE FACE

In the bedeviled dictionary of type there are often several typefaces almost identical in every respect but the name. One such instance is shown here and variously referred to as Twentieth Century Ultrabold Condensed in one series, Futura Ultrabold Condensed in another and Airport Black Condensed Title in still another. The one bearing the name Twentieth Century Ultrabold Condensed is of the Monotype 610 series.

This typeface (whether it be called one name or the other) is one of the most widely-used typefaces today. It is appropriate as a display face for nearly any type of advertising layout. It is a pure Gothic form of integrity and strength. The strokes are nearly all of the same thickness, but not quite. The horizontal bar in the A is thinned down considerably to avoid a blotchy area at the point of crossing. For the same reason subtle compromises in thickness are made in the center elements of the M, N, V, and W. Even the round elements of the C, D, O, etc. are slightly thinned top and bottom to avoid crowding the area within the letter form. The letters in the lower case show an even greater structural compromise in width of stroke. This is most obvious in the crossbar of the e and runs quite consistently in all letters with round elements.

This very popular type is available in sizes 8 to 72 points and in variations which include Medium, Medium Italic, Medium Condensed, Bold, Condensed and many others.

ABCDEFGHIJ
KLMNOPQRST
UVWXYZ

abcdefgh
ijklmnopqrst
uvwxyz

1234567890

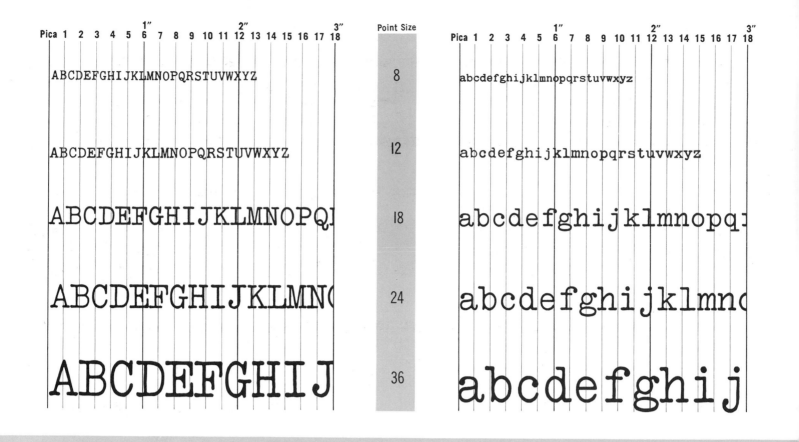

- VARIATIONS OF THIS TYPE:

Typewriter Underwood **Typewriter Remington** Typewriter Reproducing

TYPEWRITER JUMBO

ABOUT THIS TYPE FACE

There are occasional uses for a typeface which simulates the characteristics of typewritten copy. To meet these needs, Typewriter Bulletin and its several variations such as Typewriter Remington and Typewriter Underwood are available in sizes which range from 8, 10 and 12 points in linotype, and from 6 to 48 points in foundry type. There is also a 6-point foundry type for another variation called Reproducing Typewriter.

The typefaces based on the typewriter alphabet are so faithfully simulated in printer's type, that even the poor spacing which is an unfortunate characteristic of typewritten copy is left uncorrected. To attempt to correct this traditional tell-tale sign of the typewriter letter structure would be like squaring up a photograph of the leaning tower of Pisa, to "improve" its appearance. To retain this eccentricity in typewriter spacing, nearly all letters are of uniform set so that even a normally wide letter such as the w is put on a type block no wider than

an n or a t. This produces an unevenness to the individual letter structure making some letters seem pushed in, some stretched. Narrow letters such as the i and l are made to fill up the allotted space by an extension of the serifs, as you will see when you compare the serif of the i and n or the l and w.

Although the 48 point is the largest typeface cast, the copy can be blown up to most any size without loss of effect or identity. A great enlargement will magnify the natural unevenness and feathery edges, but this can be used to dramatic advantage. A line or word of greatly enlarged "typewriter" typeface, shaky and fuzzy as it may appear, can serve as an interesting headline or foil for sharp smaller copy set up in Caslon, Bodoni or some other conventional typeface. There is also a variant to this typeface, called Typewriter Jumbo which comes only in 24 point size.

ABCDEFGHI
JKLMNOPQR
STUVWXYZ

abcdefghij
klmnopqrst
uvwxyz
1234567890

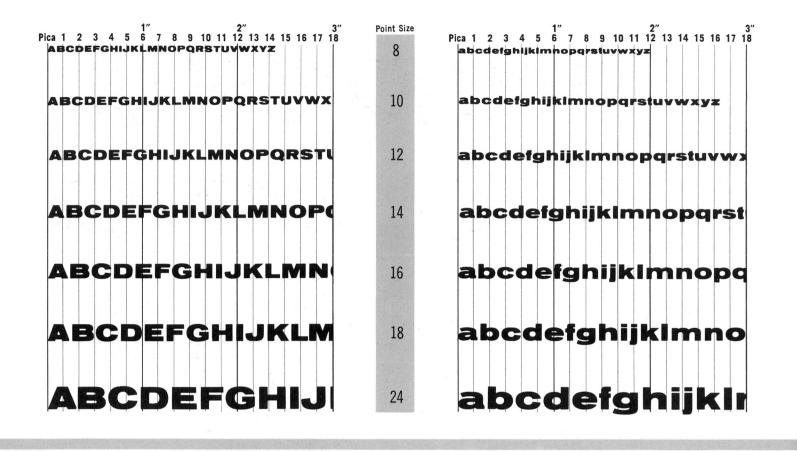

	Point Size
ABCDEFGHIJKLMNOPQRSTUVWXYZ / abcdefghijklmnopqrstuvwxyz	8
ABCDEFGHIJKLMNOPQRSTUVWX / abcdefghijklmnopqrstuvwxyz	10
ABCDEFGHIJKLMNOPQRSTU / abcdefghijklmnopqrstuvwx	12
ABCDEFGHIJKLMNOPQ / abcdefghijklmnopqrst	14
ABCDEFGHIJKLMN / abcdefghijklmnopq	16
ABCDEFGHIJKLM / abcdefghijklmno	18
ABCDEFGHIJ / abcdefghijklr	24

• VARIATIONS OF THIS TYPE:

Venus Medium Venus Medium Extended **Venus Bold** **Venus Extrabold Condensed**

Venus Bold Extended ***Venus Bold Italic*** Venus Light Extended

Venus Light Condensed *Venus Light Italic*

ABOUT THIS TYPE FACE

Venus is one of the more popular nineteenth century revivals, very much in favor today as a display face. Although this sans serif fat typeface is loosely classified as a one-thickness alphabet, the specimen shown here will, upon closer inspection reveal definite variations in thickness in most letters, both upper and lower case. The thinning of the stroke is in evidence in most crossbars and arms, as well as in the curved parts of the letter form. A sampling of the first three letters of the alphabet will suffice to reveal this characteristic. The crossbar of the A is thin, to conserve the space of the counter so that this part of the letterform will not tend to close in. The three horizontal bars which lead into the lobes of the B are thinned for the same reason. The C is thinned top and bottom to keep the letter from becoming too black. Other letters of the alphabet, both capitals and lower case, show the same tendency to thin around curves and

to keep counters open as wide as possible.

The Venus Extrabold Extended, shown here, requires a lot of space on the layout. It is massive, bold and demands attention. That is why it is a good choice for posters and newspaper display heads. It adds color to a well designed letterhead, especially if it is used as a powerful graphic counterbalance to a lighter typeface.

Noticeable clues to Venus Extrabold Extended are: the square appearance of most capitals; the wide arms of the E, F and L; the double-thickness strokes of the top of the M; the sliver-like counters of the B, P and R. In the lower case some outstanding recognizable features are: the two-storeyed structure of the a; the open tail of the g; the oblique cut top terminal of the t; the low oblong dots over the i and j. The ascenders and descenders are extremely short and stocky and add to the effect of squatty compactness so typical of this alphabet.

ABCDEFG
HIJKLMNO
PQRSTUV
WXYZ

abcdefghi
jklmnopqr
stuvwxyz

1234567890

VENUS EXTRABOLD EXTENDED **175**

ABCDEFGHIJKLMNOPQRSTU — 14

ABCDEFGHIJKLMNOPQRS — 18

ABCDEFGHIJKLMNC — 24

ABCDEFGHIJKLM — 30S

ABCDEFGHIJK — 30L

ABCDEFGH — 42

ABCDEFG — 48

THIS TYPE FACE DOES NOT
COME WITH A LOWER CASE

● VARIATIONS OF THIS TYPE:

WEISS INITIALS NO. 2 WEISS INITIALS NO. 3

ABOUT THIS TYPE FACE

Here is a distinguished and individually styled design which puts Weiss Initials, shown here, in a class by itself. Each letter is styled with the loving care of the aesthetic calligraphic artist, E. R. Weiss, who created this face in 1931.

The letters of the alphabet are unique in many ways. The crossbars of the A, E, F, L, T and Z are as heavy as the main stems, although this is a Roman letter form whose traditional structure calls for thin crossbars. The C and G appear unbalanced, as isolated letters, a structural oddity which strangely enough produces a very pleasing effect when the letters unite to form a word. The serifs of Weiss Initials are hair-thin and possess majestic grace. The thin elements of the M, N, etc., are tapered

at the point of meeting the serifs. Some of the heavy lines are curved somewhat as in the A, the wide-open arms of the T, and the right side of the lower-case type of u. The letters vary quite noticeably in proportion; for instance, the B is narrow when compared to the D or Z. But it is not in spite of, but rather because of, these irregularities in structure and proportion that the Weiss Initial alphabet has the individual calligraphic charm and elegance necessary to reflect "the finer things in life."

The Weiss Initial alphabet shown here is a specimen of Series No. 1. Series No. 2 is a monotone variation and suffers considerably in the transition. No. 3 in the series is thick-and-thin but of a heavier face.

ABCDEF
GHIJKL
MNOPQ
RSTUV
WXYZ
1234567890

SUPPLEMENTARY TYPE FACES

ABCDEEFGHIJKL
MNNOOPQRRS
STTUVWXYZ

aabccdeeffggh
ijkllmmnoopqrss
ttuvwxyz

1234567890 0

ABCDEFGHIJKL
MNOPQRSTUV
WXYZ

abcdefghijklmno
pqrstuvwxyz

1234567890

Foundry • 10 12 14 18 20 24 30 36 42 48 60 72 84 96
Lino • 8 10 12

ABCDEFGHIJK
LMNOPQRST
UVWXYZ

abcdefghijklmno
pqrstuvwxyz

1234567890

ABCDEFGHIJ
KLMNOPQRS
TUVWXYZ

abcdefghijk
lmnopqrstuv
wxyz

1234567890

ABCDEFGH
IJKLMNOP
QRSTUVW
XYZ

abcdefghijk
lmnopqrst
uvwxyz

1234567890

ABCDEFG
HIJKLMN
OPQRSTU
VWXYZ
abcdefghijk
lmnopqrs
tuvwxyz
12345
67890

AaBCDEe
FGHIJKLMm
NnOPQRr
STUVWXYZ

abcdefghijklmn
opqrstuvwxyz

1234567890

ABCDEFGHIJ
KLMNOPQR
STUVWXYZ

abcdefghijklm
nopqrstuvwxyz

1234567890

Foundry • 6 8 9 10 11 12 16 18 24 30 36 42 60 72
Mono • 6 7 8 9 10 11 12 14 18 24 30 36 42 48 60 72
Ludlow • 10 12 14 18 24 30 36 42 48 60 72
Intertype • 6 7 8 9 10 11 14 18
Mergenthaler • 6 8 10 12 14 18

ABCDEFGHIJ
KLMNOPQR
STUVWXYZ

abcdefghijkl
mnopqrstu
vwxyz

1234567890

ABCDEFGHIJ
KLMNOPQRS
TUVWXYZ

abcdefghi
jklm nopqrs
tuvwxyz

1234567890

ABCDEFGHIJKLMN
OPQRSTUVWXYZ

abcdefghijklmn
opqrstuvwxyz

1234567890

ABCDEFGHIJKL
MNOPQRSTU
VWXYZ

abcdefghijklmn
opqrstuvwxyz
1234567890

Foundry • 6 8S 8L 10 12S 12L 14 18 24S 24L 30 36 48 60
Lino • 6 7 8 9 10 12

ABCDEFGHIJKL
MNOPQRSTU
VWXYZ

abcdefghijklmno
pqrstuvwxyz

1234567890

ABCDEFGHIJKL
MNOPQRS
TUVWXYZ

abcdefghijklm
nopqrstuvwxyz
1234567890

ABCDEFGHI JKLMNOPQR STUVWXYZ

abcdefgh ijklmnopq rstuvwxyz

1234567890

ABCDEFGHIJKLMNO
PQRSTUVWXYZ

abcdefghijklmno
pqrstuvwxyz

1234567890

SUPPLEMENT OF PHOTO-LETTERING

BASE PRICE INFORMATION

9307n

THE PRESIDENT'S CONFERENCE

9354n

Mad Plaids For Messy Moppets.

8789n
SPECIAL EFFECTS

energy Regulation week

5199n

TT5494N

8417n

8849n

5477n

VOTER'S CHOICE PROMOTION

4591n

DESIGN MODERN CIRCUITS

5963n

27 BILLION STARS SHINING BRIGHTLY

8780n

CIRCUS DAYS with CLOWNS BALLOONS

3687n

BREAKTHROUGH

5083n

A SUMMER FESTIVAL OF STARS

TT5584s
SPECIAL EFFECTS

Turnabout

9302s
SPECIAL EFFECTS

Turnabout

NEW SANGRIA NEW SANGRIA

6127B PHOTO EFFECTS

NAUSEA
AND
VOMITING

4523B
SPECIAL EFFECTS WITH ANY STYLE

QUEENS
COLLEGE

6156N

LIVE IN CONCERT

5494n

LAST MINUTE SAVINGS

5785s

GHOSTS & HAUNTINGS

5471c

INSTANT NOSTALGIA

6021n

ARTHUR KOESTLER

THE CASE OF THE

6022n

MIDWIFE TOAD THAT WAS

MONEYVIEWS

TT6291s

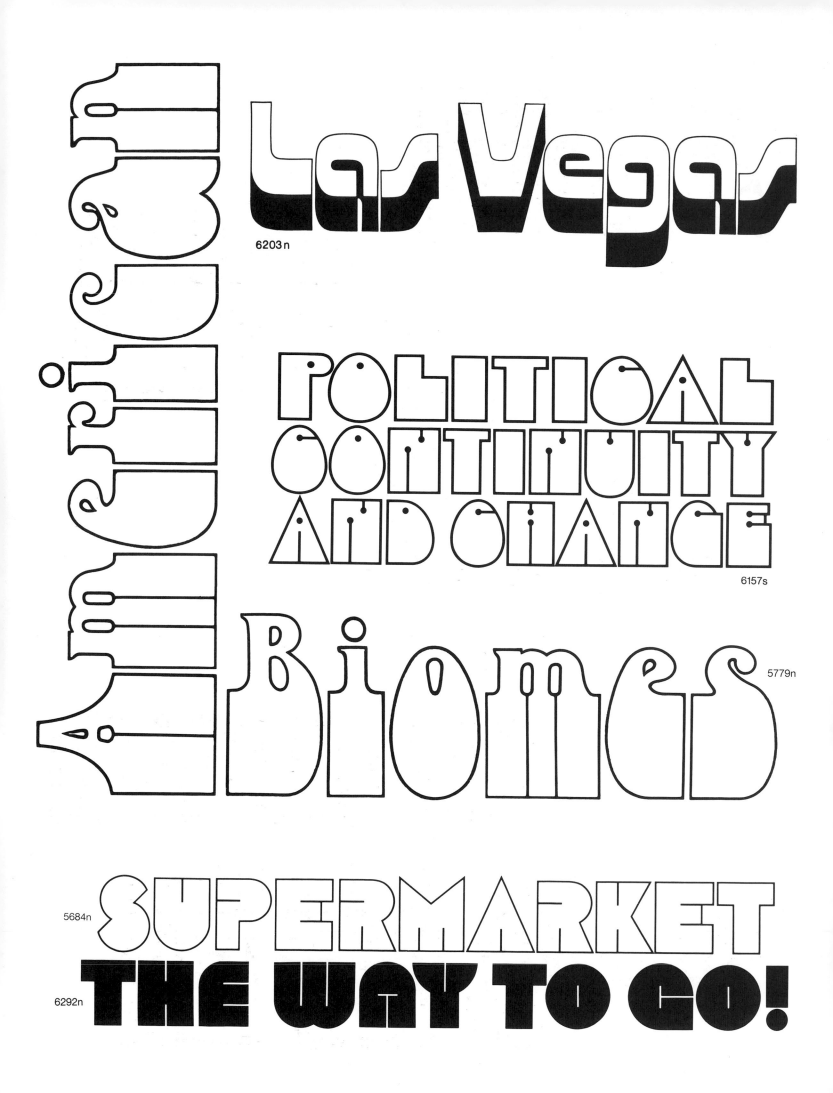

American

Las Vegas
6203n

POLITICAL
CONTINUITY
AND CHANGE
6157s

Biomes
5779n

SUPERMARKET
5684n

THE WAY TO GO!
6292n

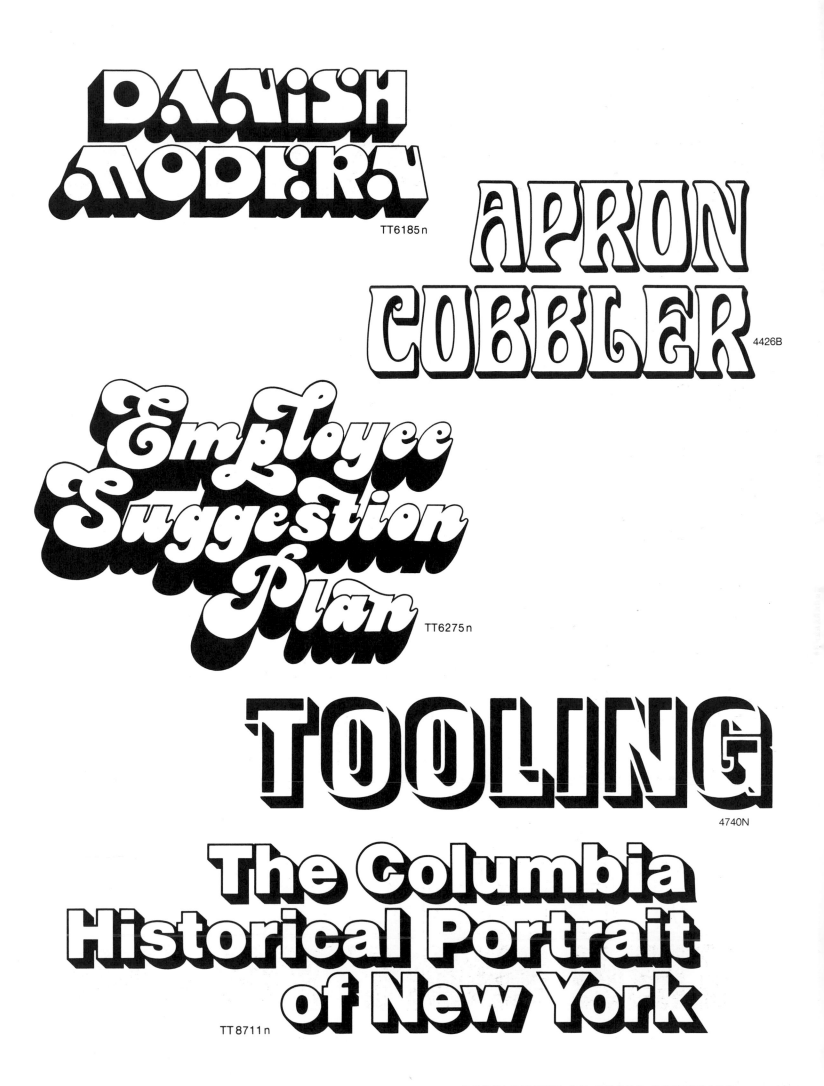

DANISH MODERN
TT6185n

APRON COBBLER
4426B

Employee Suggestion Plan
TT6275n

TOOLING
4740N

The Columbia Historical Portrait of New York
TT8711n

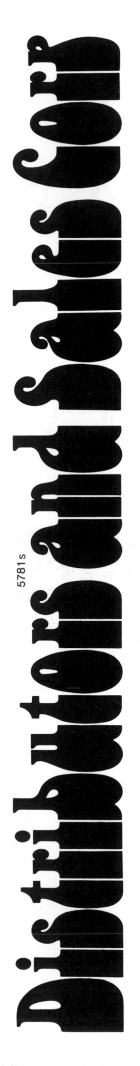

Distributors and Sales Corp 5781s

RULES 3461N

ISLAND OF OAHU

MAUI

MAUAI

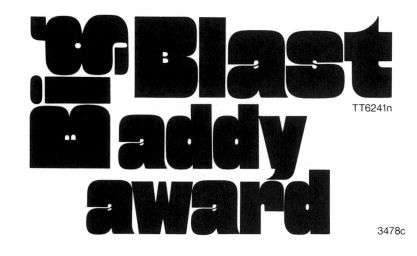

Big '86 Blast TT6241n

Maddy

award 3478c

WEST

PALM

BEACH North

Floridian 6532n

MUSIC
MAKES
THE
CHARTS
9319n

STACK
THE
DECK
3612n
2731s
3612n

CAESARS
PALACE
THE VERY
BEST THERE IS.
6547n

HOME
PERM
8703n

FM106
WEZI
9321n

SPAIN'S resort hotels luxury at low cost

5202N

WEST INDIAN LINE Calcutta express

6533n

Free and Female

3482C

LIFE
HEALTH
GROUP
SPECTRUM
VARIABLE ANNUITY

TT6184n

"THE LONG GOODBYE"

TT8431n

The
SHOCK that
sent WORLD
VIBRATIONS

3846n

Gun
Rich

9362N

MAY
IS A
BETTER
MONTH

4766n

a new
Photo Lettering
style

8931n

BODY MECHANICS 5681N

OXFORD

TT3747B OUTLINED

TT8808N Merchandising Support

Pick your reason to do business with 5982N

a screwball comedy

4749 3n

COOK BOOK

4703s

THE ILLUSTRATED HASSLE-FREE MAKE YOUR OWN CLOTHES BOOK

TT8045n

CHALLENGE CHAMPIONS

9312n

LOOK WHAT WE'RE GIVING YOU NOW

TT5683n

ENGELHARD

TT3291n

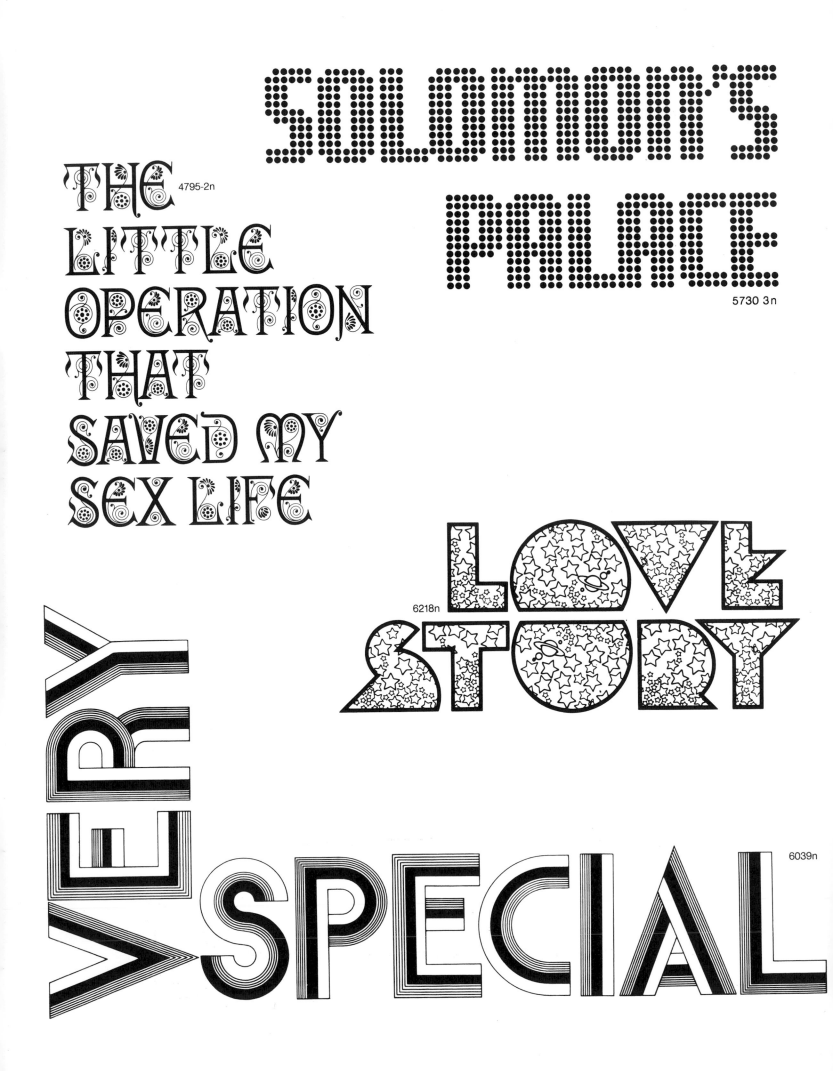

SOLOMON'S PALACE
5730 3n

THE LITTLE OPERATION THAT SAVED MY SEX LIFE
4795-2n

LOVE STORY
6218n

VERY SPECIAL
6039n

DIRECTORY OF STANDARD TYPE FACES

To compile this Directory of Standard Type Faces, the type specimen listing of The Composing Room, Inc., was alphabetically integrated and supplemented by the selected specimens featured in the brochures of a number of other major type houses. The complete collection of type specimens as shown here, therefore, represents a rather broad overview of the most important body and display faces commercially available today.

For an industry-wide encyclopedia of standard type faces showing size availability and source of supply refer to the latest official Type Face Directory issued by your regional Typographers Association. Many of these type faces (or modifications thereof) are available as photo-lettering styles. Check with your photo-lettering service.

AD Lib

AGENCY OPEN

Aigrette

★ **Airport Black** **AIRPORT**

AIRPORT BLACK COND.

Airport Extra Bold Condensed

Airport Display

Akzidenz-Grotesk Regular AKZIDENZ

Akzidenz-Grotesk Medium **AKZIDENZ**

Albertus ALBERTUS

ALBERTUS TITLING

ALBERTUS BOLD TITL.

★ *Allegro*

Alternate Gothic No. 1 ALTERNATE GOTHIC

★ Alternate Gothic No. 2 ALTERNATE GOTHIC

Alternate Gothic No. 2 Italic GOTHIC

Alternate Gothic No. 3 GOTHIC

Alternate Gothic No. 20

Annonce Grotesque

Antique No. 1 ANTIQUE

Antique Italic No. 1 *ANTIQUE*

Anzeigen Grotesk Bold

Ariston Light

Ariston Medium

Astoria ASTORIA

AUGUSTEA SOLID

AUGUSTEA INLINE

AURORA Grotesk 8

BALLOON LIGHT

BALLOON BOLD

★ ***BALLOON EXTRA BOLD***

Balzac Brush

BANCO

BANK GOTHIC

BANK GOTHIC

BANK GOTHIC LIGHT CONDENSED

★ *featured in this book*

BANK GOTHIC MEDIUM

BANK GOTHIC COND. MEDIUM

BANK GOTHIC COND. BOLD

★ *Bank Script*

★ Barnum BARNUM

★ Baskerville BASKERVILLE

Baskerville Italic *BASKERVILLE*

Baskerville Bold **BASKERVILLE**

Baskerville Bold Italic *BASKERVILLE*

BAUER TEXT INITIALS

Bembo

Bembo Italic

Benedictine Book

Benedictine Book WITH S.C. BENEDI

Benedictine Book Italic *BENEDICT*

★ *Bernhard Cursive Bold*

Bernhard Gothic Light BERNHARD

Bernhard Gothic Light Ital. *BERNHARD*

Bernhard Gothic Medium BERNHARD

Bernhard Gothic Medium Italic *BERNHARD*

Bernhard Gothic Medium Condensed

Bernhard Gothic Heavy **BERNHARD**

Bernhard Gothic Ex. Hvy.

★ Bernhard Modern Roman BERNHARD

Bernhard Modern Italic *BERNHARD*

Bernhard Modern Bold **BERNHARD**

Bernhard Modern Bold Ital. *BERNHARD*

★ *Bernhard Tango*

BETON Light

Beton Medium

Beton Medium Condensed

Beton Bold

Beton Bold Condensed

★ **Beton Extra Bold**

★ **BETON OPEN**

BINDER Style

Binney Old Style

Binney Old Style Italic

★ Bodoni BODONI

★ *Bodoni Italic* *BODONI*

Bodoni Bold **BODONI**

Bodoni Bold Italic

Bodoni Extrabold Italic

Bodoni Bold Condensed **BODONI**

Bodoni, Bauer Roman BODONI

★ *featured in this book*

Bodoni, Bauer Italic	*BODONI*
Bodoni, Bauer Bold	**BODONI**
Bodoni, Bauer Bold Italic	***BODONI***
Bodoni, Bauer Extra Bold	**BODONI**

Bodoni Book BODONI

Bodoni Book Italic

Bodoni Campanile

BODONI, ENGRAVERS

Bodoni Modern **BODONI**

Bodoni Modern Italic ***BODONI***

Bodoni, Open BODONI

★ **Bodoni, Ultra** **BODONI**

Bodoni, Ultra Italic ***BODONI***

Bodoni, Ultra Condensed

Bodoni, Ultra, Extra Cond. **BODONI**

BOLD FACE NO. 4

Bon Aire

Bond Script

Bookman BOOKMAN

Bookman Italic BOOK

Bookman Old Style

Bookman Old Style Italic

Boulevard

BRANDON

BROADWAY

★ **Brody**

★ *Brush*

Bulmer

Bulmer Italic	*BULMER*
Caledonia	CALEDONIA
Caledonia Italic	*CALEDONIA*
Caledonia Bold	**CALEDONIA**
Caledonia Bold Italic	*CALEDONIA*

CARD LIGHT LITHO

CARD MERCANTILE

CARTOON LIGHT

CARTOON BOLD

Caslon	CASLON
Caslon Italic	*CASLON*
Caslon No. 3	CASLON
Caslon No. 3 Italic	*CASLON*

Caslon No. 4 CASLON

Caslon No. 137 CASLON

Caslon Italic No. 137 CASLON

Caslon No 471

Caslon No. 471 Italic

Caslon No. 471 Italic Swash

★ Caslon No. 540 CASLON

★ Caslon Italic No. 540

Caslon Bold CASLON

Caslon Bold Italic CASLON

Caslon Bold Condensed CASLON

Caslon Extra Condensed

Caslon Antique CASLON ANTIQUE

Caslon Heavy CASLON HEAVY

Caslon Heavy Compressed

Caslon, New CASLON

Caslon, New Italic

Caslon Old Face CASLON

Caslon Old Face Italic CASLON

Caslon Oldstyle No. 471

Caslon Old Style Italic

Caslon Openface CASLON

Caslon, Tru-Cut

Caslon, Tru-Cut, Italic

Century Bold CENTURY

Century Bold Italic CENTURY

Century Bold Condensed CENTURY BOLD COND.

Century Expanded CENTURY

★ Century Expanded Italic CENTURY

★ Century Nova

Century Old Style

Century Old Style Italic

★ Century Schoolbook CENTURY

Century Schoolbook Italic CENTURY

Century Schoolbook Bold

Champion

Charme

Cheltenham CHELTENHAM

Cheltenham Condensed CHELTENHAM

Cheltenham Italic CHELTENHAM

★ Cheltenham Medium

Cheltenham Medium Italic

★ *featured in this book*

Cheltenham Bold CHELTENHAM BOLD

Cheltenham Bold Italic ***CHELTENHAM***

Cheltenham Bold Condensed

Cheltenham Bold Condensed Italic

Cheltenham Bold Extra Condensed

Cheltenham Bold Ext.

CHELTENHAM
CHELTENHAM BOLD OPEN

Chelt. Inline

Cheltenham Old Style

Cheltenham Old Style Italic

Cheltenham Wide CHELTENHAM

Cheltenham Wide Italic

CHICAGO

★ Chisel

Chisel E
CHISEL EXPANDED

Cigno

City Light CITY LIGHT

City Medium **CITY MEDIUM**

City Bold **CITY BOLD**

Civilite

Clarendon CLARENDON

★ **Clarendon Bold** **CLARENDON**

Clarendon Bold Ex.

Clarendon Haas

Clarendon Bold Haas

Claudius

Cloister WITH SMALL CAPS CLOISTER

Cloister Italic *CLOISTER*

Cloister Bold **CLOISTER BOLD**

Cloister Bold Italic ***CLOISTER BOLD***

Cloister Bold Condensed

Cloister Old Style

Cloister Old Style Italic

★ Cloister Black

Cochin, Nicolas, No.1 COCHIN

Cochin, Nicolas, No. 2 COCHIN

Cochin, Nicolas, No. 2 Italic *COCHIN*

Cochin, Nicolas Bold **COCHIN**

★ *featured in this book*

Columbia COLUMBIA

Columbia Italic

Columbia Bold

Columbia Bold Italic

A B D G I J K
COLUMBIA ITALIC SWASH

COLUMNA

COMMERCIAL Grotesk

Commercial Script

COMSTOCK

Consort

Consort Italic

Consort Bold

Consort Condensed CONSORT COND.

Consort Bold Condensed **CONSORT**

Consort Light

Consort Light Condensed

Constanze

Contact Bold Condensed **CONTACT**

Contact Bold Condensed Italic

CONTOUR

★ **Cooper Black** **COOPER BLACK**

★ ***Cooper Black Italic*** ***COOPER BLACK***

COPPERPLATE GOTHIC BOLD

COPPERPLATE GOTHIC ITALIC

COPPERPLATE GOTHIC LIGHT

COPPERPLATE GOTHIC COND. LIGHT

COPPERPLATE LIGHT EXT.

COPPERPLATE GOTHIC HEAVY

(COPPERPLATE) LINING GOTH. HEAVY

COPPERPLATE GOTHIC CONDENSED HEAVY

★ COPPERPLATE GOTH. HVY. EXT.

CORINTHIAN

Coronet Light

★ *Coronet Bold*

Corvinus Light CORVINUS LIGHT

Corvinus Light Italic *CORVINUS*

★ **Corvinus Medium** **CORVINUS MEDIUM**

Corvinus Medium Italic ***CORVINUS***

Corvinus Bold **CORVINUS**

Corvinus Skyline

Craw Clarendon **CRAW**

★ *featured in this book*

Craw Clarendon Condensed

★ Craw Clarendon Book CRAW

★ Craw Modern CRAW

★ **Craw Modern Bold**

Crayonette

CRISTAL

Cursiva Rusina

CURSIVA RUSINOL

Deepdene

Deepdene Italic

Della Robbia

DELPHIAN

Delphin I

Delphin II

DEMETER

Derby

De Roos Roman

De Roos Italic

De Roos Semi Bold

DE ROOS INL

De Vinne DE VINNE

De Vinne Italic *DE VINNE*

DIAMOND JIM

Discus

Discus Semibold

Dom Bold

★ Dom Casual DOM CASUAL

Dom Diagonal *DOM DIAGONAL*

DORIC NO. 1 1234567890

Doric No. 1 Italic

DRESDEN

DUO OUTLIN

DUO OUTLINE

DUO SOLID

Dutch Initials

Dynamic

Eden Light EDEN LIGHT

Eden Bold **EDEN BOLD**

Egizio Medium EGIZIO

Egizio Medium Condensed EGIZIO

Egizio Medium Italic *EGIZIO*

★ *featured in this book*

Egizio Bold

Egmont Light	EGMONT LIGHT
Egmont Light Italic	EGMONT LIGHT
★ Egmont Medium	EGMONT
Egmont Medium Italic	EGMONT
Egmont Bold	EGMONT BOLD
Egmont Bold Italic	EGMONT BOLD

EGMONT INL
EGMONT INLINE

★ ## Egyptian Exp.

EGYPTIAN BOLD CONDENSED

Egyptian Open

Electra

Electra Italic

Electra Bold

Electra Cursive

Electra Bold Cursive

Elizabeth

Elizabeth Italic

EMPIRE

★ ## ENGRAVERS ROMAN

ENGRAVERS BODONI

ENGRAVERS BOLD

Engravers Old English

ENGRAVERS SHADED

Engravers Text

ERAS

ERASMUS SERIES 2

ERBAR

★ ## Eurostile Bold E
EUROSTILE BOLD EXTENDED

Eve

Eve Italic

Eve Light Italic

Eve Heavy

Eve Heavy Italic

EVE DECORATOR

Eve Special b d f h k ffl
EVE SPECIAL CAPS AND ASCENDERS

Excelsior Script

Excelsior Script Semi Bold

Fairfield

Fairfield Italic

Fairfield Medium

Fairfield Medium Italic

★ *featured in this book*

Figaro

Firmin Didot Roman

Firmin Didot Italic

Firmin Didot Bold

Flash *FLASH*

Flash Bold *FLASH BOLD*

Flex

FLORADORA

★ Folio Medium Extended FOLIO

Folio Medium Extended Italic

FONTANESI

Fortune Light FORTUNE

★ **Fortune Bold** **FORTUNE**

Fortune Extra Bold

Fortune Bold Italic

FORUM (GOUDY)

FORUM I

FORUM II

FOURNIER, CAPS

★ **Franklin Gothic** **FRANKLIN**

Franklin Gothic Italic *FRANKLIN*

Franklin Gothic Condensed

Franklin Gothic Condensed Italic

Franklin Gothic Extra Condensed

FRANKLIN COND
FRANKLIN GOTHIC CONDENSED OUTLINE

Franklin Gothic Wide

FRENCH

★ Freehand FREEHAND

Futura Book FUTURA BOOK

Futura Book Italic FUTURA BOOK

Futura Light FUTURA LIGHT

Futura Light Oblique *FUTURA*

★ Futura Medium FUTURA

Futura Medium Oblique

Futura Medium Condensed FUTURA MED. COND.

Futura Medium Condensed Oblique

Futura Black

Futura Broad
AIRPORT BROAD

Futura Bold **FUTURA**

★ *featured in this book*

Futura Bold Oblique **FUTURA**

Futura Bold Condensed **FUTURA BOLD COND.**

Futura Bold Condensed Oblique

Futura Demibold **FUTURA**

Futura Demibold Oblique

Futura Extra Bold

Futura Extra Bold Oblique

Futura Extra Bold Condensed

Futura Extra Bold Condensed Italic

FUT. XBOLD COND TITLE

Futura Ultra Bold
TWENTIETH CENTURY ULTRABOLD

Futura Ultra Bold Italic
TWENTIETH CENTURY ULTRABOLD

★ **Futura Display** **FUTURA DISPLAY**

FUTURA INLINE CAPS
GALLIA

★ Garamond GARAMOND

Garamond Italic GARAMOND

Garamond Light

Garamond Light Italic

Garamond Light Swash

Garamond Bold

★ *Garamond Bold Italic*

Garamond Bold Swash

GARAMOND OPEN

Gavotte

Gillies Gothic Light

Gillies Gothic Bold

Girder Light

Girder Heavy

Gloria

GOLD RUSH

GOTHIC NO. 15

GOTHIC NO. 25

GOTHIC NO. 26

GOTHIC NO. 520

Gothic No. 544 GOTHIC

Gothic No. 545 **GOTHIC**

Gothic Condensed **GOTHIC**

Gothic Condensed No. 2 GOTHIC CONDENSED NO. 2

GOTHIC CONDENSED NO. 521

Gothic Condensed No. 529 GOTHIC CONDENSED NO. 529

★ *featured in this book*

Gothic, Modern Condensed No. 140

GOTHIC OUTLINE TITLE NO. 61

GOTHIC TITLE CONDENSED

GOTHIC CONDENSED TITLE NO. 117

GOTHIC TITLE EXTRA CONDENSED

Gothic, Tourist

Goudy

Goudy Italic

Goudy Bold GOUDY

Goudy Bold Italic GOUDY

Goudy Cursive

Goudy Handtooled

★ Goudy Oldstyle

Goudy Light Old Style

Goudy Light Old Style Italic

Goudy Open GOUDY

Goudy Open Italic GOUDY

Goudy Text

Gracia

Granjon GRANJON

Granjon Italic GRANJON

Graphic Light

Graphic Bold GRAPHIC BOLD

GRAPHIQUE

Gravure Open

GRAVURE DECOR
GRAVURE DECORATIVE OPEN

★ *Grayda*

GREAT PRIMER NO. 8
GREAT PRIMER ORNAMENTED No. 8

GRECO ADORNADO

Greco Bold

Greco Bold Italic

★ Grotesque No. 9 GROTESQUE

Grotesque No. 9 Italic GROTESQUE

Grotesque No. 18

HADRIANO
HADRIANO STONECUT

Hallo
HALLO ITALIC

Hauser Script

HEADLINE GOTHIC

★ Hellenic Wide

★ **Helvetica Medium**

HIDALGO

★ *featured in this book*

Holla

HOMEWOOD

Horizon Light

Horizon Light Italic

Horizon Medium

Horizon Bold

★ HUXLEY VERTICAL

Ideal IDEAL

Ideal Italic *IDEAL*

★ **Informat**

★ **INSERAT Grotesk**

Invitation Shaded

Janson JANSON

Janson Italic *JANSON*

JIM CROW CAPS

Juliet

Kabel Light

Kabel Medium

Kabel Bold

Kabel Bold Italic

Kabel Extra Bold

Karnak Light KARNAK

Karnak Medium

Karnak Black Condensed Italic

★ *Kaufmann Script*

Kaufmann Bold

Kennerley

Kennerley Italic

Kennerley Bold

Kennerley Bold Italic

Kenntonian KENNTONIAN

Kenntonian Italic *KENNTONIAN*

Keynote

LARGO OPEN

★ **Latin Wide** **LATIN**

Latin Bold

Latin Bold Condensed

Latin Elongated

Laureate

★ *featured in this book*

★ *Legend*

Le Mercure

LEXINGTO

★ LIBRA

LIBRA LIGHT

★ *Lilith*

Liteline Gothic LITELINE

LIGHTLINE TITLE GOTHIC

LOMBARDIC INIT

Lucian LUCIAN

Lucian Italic *LUCIAN ITALIC*

Lucian Bold

Lucian Open

LUTETIA

★ Lydian LYDIAN

★ *Lydian Italic* LYDIAN ITALIC

Lydian Bold **LYDIAN BOLD**

Lydian Bold Italic *LYDIAN BOLD*

Lydian Bold Condensed **LYDIAN**

Lydian Bold Condensed Italic *LYDIAN*

★ *Lydian Cursive*

Mademoiselle

Magnet

MANDARIN

Mandate

MARBLE HEART

Maxime

Melior

Melior Italic

★ **Melior Semibold**

Melior Bold Condensed

Memphis Light MEMPHIS LIGHT

Memphis Medium MEMPHIS

Memphis Medium Italic *MEMPHIS*

Memphis Medium Condensed MEMPHIS

Memphis Bold **MEMPHIS BOLD**

Memphis Bold Italic *MEMPHIS*

Memphis Bold Condensed MEMPHIS

Memphis Extra Bold

Memphis Extra Bold Italic

Metrothin No. 2 METROTHIN NO. 2

Metromedium No. 2 **METROMEDIUM NO. 2**

Metropolis Light

★ *featured in this book*

★ **Metropolis Bold**

METROPOLIS

MICHELANGELO

★ MICROGRAMMA NORMAL

MICROGRAMMA CONDENSED

MICROGRAMMA EXT.

MICROGRAMMA BOLD

MICROGRAMMA BOLD EXT.

MISSAL INITIALS
MISSAL

Mistral	MISTRAL
Modern No. 20	MODERN
Modern No. 20 Italic	MODERN

Modern Roman Extra Condensed

MODERN ROMAN BOLD EXT

Mona Lisa

Mondial Bold Cond.	**MONDIAL**

Moreau-le-Jeune

MOSAIK

Murray Hill

Murray Hill Bold

Narcissus

★ **NEULAND CAPS**

NEULAND INLINE

New Caslon

New Caslon Italic

★ News Gothic NEWS GOTHIC

News Gothic Condensed NEWS GOTHIC

News Gothic Condensed Italic

News Gothic Extra Condensed NEWS GOTHIC EXTRA CONDENSED

News Gothic Extended

News Gothic Bold **NEWS GOTHIC**

News Gothic Bold Italic

News Gothic Bold Extended

Nicolas Cochin

Nicolas Cochin Italic

Nicolas Cochin Bold

Normal

HAAS NORMAL GROTESK DEMIBOLD

★ *featured in this book*

Normal

HAAS NORMAL GROTESK BOLD

NORMANDE

Normande Italic

Normande Condensed

NORMANDIA OUTLINE

Novel Gothic **NOVEL**

Nubian **NUBIAN**

ODDESSY

OFFENBACH

OLD BOWERY

Old Gothic Bold Italic ***OLD***

Old English

Old English Shaded

Old Style No. 1 OLD STYLE

Old Style Italic No. 1 *OLD STYLE*

Old Style No. 7 OLD STYLE

Old Style No. 7 Italic *OLD STYLE*

OMBREES

Ondine

★ **Onyx** **ONYX**

Onyx Italic *ONYX*

★ Optima Roman

Optima Italic

Optima Semi Bold

Ornata

Orpheus

Orpheus Italic

Orpheus Bold

ORPLID CAPS

Othello **OTHELLO**

OUTLINE GOTHIC NO. 61

★ Palatino PALATINO

Palatino Italic *PALATINO*

Palatino Semi-Bold **PALATINO**

PALATINO

PALATINO SWASH CAPS

Palette

★ *featured in this book*

Parisian R.

PARISIAN RONDE

Park Avenue

Peignot Light

Peignot Medium

Peignot Bold

Penprint PENPRINT

Perpetua PERPETUA

Perpetua Italic *PERPETUA*

Perpetua Bold **PERPETUA**

PERPETUA LIGHT TI.

PERPETUA LIGHT TITLING—SERIES 480

PERPETUA MED. TI.

PERPETUA MEDIUM TITLING—SERIES 258

Phenix

Piranesi

Piranesi Italic

Piranesi Bold

Piranesi Bold Italic

Playbill **PLAYBILL**

Post Roman Light

Post Roman Medium

Post Roman Bold

Post Italic

Post Mediaeval Light

Post Mediaeval Medium

Post Mediaeval Italic

ABCDEFGHIJKLMNOPQRS

POST MEDIAEVAL SWING CAPS

Post Oldstyle Condensed

POST TITLE LIGHT

POST TITLE MEDIUM

POST TITLE BOLD

POSTER

Primer PRIMER

Primer Italic *PRIMER*

PRISMA

★ **PROFIL**

Quillscript (Thompson)

Radiant Medium

Radiant Bold

Radiant Bold Extra Condensed **RADIANT**

★ **Radiant Heavy**

★ *featured in this book*

RAILROAD GOTHIC CAPS

Raleigh Cursive

Record Gothic Condensed Italic

REGINA

Reiner Script

Reiner Black

★ *Repro Script*

Rhapsodie

RICCARDO

Roman Compressed #3 ROMAN

ROMAN SHADED

ROMAN SHADED ELONGATED

Romany

Rondo

★ *Rondo Bold*

Ronsar

RONSARD CRISTAL

Royal

Royal Script

RUSTIC

Sans Serif Light

Sans Serif Light Italic

Sans Serif Medium

Sans Serif Medium Condensed No. 354

Sans Serif Bold

Sans Serif Bold Italic

Sans Serif Extra Bold

Sans Serif Extra Bold Italic

SANS SERIF LINED

Salto

Salut

Saltino

SAPHIR 1234

Scritta a Lapis

Scotch	SCOTCH
Scotch Italic	*SCOTCH*
Scotch No. 2	SCOTCH NO. 2
Scotch No. 2 Italic	*SCOTCH NO. 2*

SHADOW CAPS

Signal Light

★ *featured in this book*

Signal Medium

Signal Black

Signum

SIMPLEX

SISTINA

Slogan

SOLEMNIS

SOUTHERN CROSS

Spartan Light	SPARTAN
Spartan Medium	SPARTAN
Spartan Medium Italic	*SPARTAN*
Spartan Heavy	**SPARTAN**
Spartan Heavy Italic	***SPARTAN***
Spartan Black	**SPARTAN**
Spartan Black Italic	***SPARTAN***

SPHINX

SPIRE

Standard

Standard Italic　　*STANDARD ITALIC*

Standard Condensed

Standard Extended

Standard Light　　　　STANDARD

Standard Light Condensed

Standard Light Extended

Standard Extra Light Extended

★ **Standard Medium**　　**STANDARD**

★ ***Standard Medium Italic***　　***STANDARD***

Standard Medium Condensed　　STANDARD

Standard Bold

Standard Bold Condensed

★ **Standard Extra Bold Condensed**

Standard Extra Bold Ext.

Stationers Semiscript

Steel

Steel Italic

Steel Bold

Steel Bold Condensed

STEELPLATE GOTHIC BOLD

★ *featured in this book*

STEELPLATE

★ **STENCIL CAPS**

Stop

★ *Stradivarius*

STRADIVARIUS INITIALS

ABCDEF

★ Studio STUDIO

Studio Bold **STUDIO**

Stymie Light

Stymie Light Italic

Stymie Medium STYMIE

Stymie Medium Italic

★ Stymie Medium Condensed STYMIE

Stymie Bold **STYMIE**

Stymie Bold Italic

Stymie Bold Condensed **STYMIE**

Stymie Extra Bold **STYMIE**

Stymie Extra Bold Condensed **STYMIE**

Stymie Black **STYMIE**

Stymie Black Italic

STYMIE OPEN

STYMIE SHADED

Stylescript

SUPERBA ILL
SUPERBA ILLUSTRA

SYLVAN

TEA CHE
TEA CHEST

Tempo TEMPO

Tempo Bold **TEMPO**

Tempo Extra Bold

Tempo Black **TEMPO**

Thompson Quillscript

THORNE
THORNE SHADED

Thorowgood Italic

THUND
THUNDERBIRD

Time
TIME SCRIPT

Time
TIME SCRIPT SEMI BOLD

★ *featured in this book*

TIME SCRIPT BOLD

Times Roman TIMES

Times Roman Ital. *TIMES*

Times Roman Semi Bold

★ **Times Roman Bold** **TIMES ROMAN**

TIMES EXT. TITLING
TIMES EXTENDED TITLING—SERIES 339

TIMES HEAVY TITLING
TIMES HEAVY TITLING—SERIES 328

TITLE GOTHIC CONDENSED NO. 11

TITLE GOTHIC EXTRA CONDENSED NO. 12

Topic Medium (Bauer)

Topic Medium Italic (Bauer)

Topic Bold (Bauer)

Topic Bold Italic (Bauer)

★ Torino TORINO

Torino Italic *TORINO*

Tourist Gothic Italic

★ Tower **TOWER**

TRADITION

★ *Trafton Script*

Trajanus

Trajanus Italic

Trajanus Semibold

TROCADERO
TROCADERO ORNAMENTED No. 3

Trylon

Twentieth Century Medium

Twentieth Century Medium Ital.

Twentieth Century Medium Cond.

Twentieth Century Bold

Twentieth Century Bold Italic

Twentieth Cent. Ex. Bold

Twentieth Cent. Ex. Bold It.

Twentieth Century Extra Bold Cond.

Twentieth Cent. Ex. Bold Cond. Italic

Twentieth Century Ultra Bold

Twentieth Century Ultra Bold Italic

★ **Twentieth Century Ultra Bold Condensed**

Twentieth Century Ultra Bold Cond. Ital.

★ Typewriter

Typewriter, Remington REMINGTON

Typewriter Remington Ribbon

Typewriter Reproducing
Typewriter (Standard)

Typewriter, Underwood
UNDERWOOD

Typo Script

★ *featured in this book*

Typo Script Extended

Typo Upright

Typo Upright No. 1

Typo Roman Shaded TYPO ROMAN

UMBRA

★ **Univers no.65**

Venus Light VENUS

Venus Light Italic *VENUS LIGHT ITALIC*

Venus Light Condensed VENUS LIGHT COND.

Venus Light Extended VENUS

Venus Medium VENUS

Venus Medium Italic *VENUS*

Venus Medium Extended

Venus Bold **VENUS**

Venus Bold Italic ***VENUS***

Venus Bold Condensed **VENUS BOLD**

Venus Extrabold Condensed **VENUS EXTRABOLD**

Venus Bold Extended

★ **Venus Extrabold Extended**

Virtuosa No 1. and 2

Virtuosa Bold

Vogue Light VOGUE LIGHT

Vogue Light Oblique *VOGUE LIGHT*

Vogue Bold VOGUE BOLD

Vogue Bold Oblique *VOGUE BOLD*

Vogue Extra Bold **VOGUE EXTRA**

Vogue Extra Bold Italic ***VOGUE***

Walbaum

Walbaum Italic

Walbaum Medium

Waverley

Waverley Italic

𝔚𝔢𝔡𝔡𝔦𝔫𝔤 𝔗𝔢𝔵𝔱

𝔚𝔢𝔡𝔡𝔦𝔫𝔤 𝔗𝔢𝔵𝔱 𝔖𝔥𝔞𝔡𝔢𝔡

Weiss Roman WEISS ROMAN

Weiss Italic

Weiss Roman Bold WEISS

Weiss Roman Extrabold

★ WEISS INITIALS NO. 1

WEISS INITIALS NO. 2

WEISS INITIALS NO. 3

★ Whedons Gothic Outline

Zeppelin

★ *featured in this book*

GLOSSARY OF TERMS **tf**

GLOSSARY OF TERMS

AGATE LINE

 Often used as the unit of measure in selling advertising space by newspapers. 14 agate lines equal one linear inch.

AMPERSAND

 The typographic symbol (&) used to designate the word and. *This symbol is the Latin word "et" which means "and".*

ANTIQUE FINISH

 A good quality roughened porous paper, uneven in surface but possessing an interesting, non-commercial surface.

ASCENDERS

 The vertical stems of the lower-case letters b, d, f, h, l, t, k which rise above the main body of the letter form.

BACKBONE

 The bound end of a book. Also called the spine.

BASE LINE

 The imaginary line on which the base of capital letters rest.

BASIC WEIGHT

 The degree of thickness of a sheet of paper given in terms of the weight of 500 sheets (one ream) in the standard size for that grade. (25 x 38 for book papers, 20 x 26 for cover papers, 22½ x 28½ for bristols, 25 x 30½ for index paper.)

BASTARD TITLE

 Short title preceding the title page (also, half-title). On the right hand page, it shows title of book only.

BEARD

 When referring to the structure of metal type, it means the space below the base line, often also called the shoulder.

BENDAY

 A method of obtaining textures or tones by means of a screen of dots.

BLACK LETTERS

 What is generally referred to in a Gothic such as Cloister Black, Old English, etc.

BLEED

 When the print extends beyond the trim edge of the paper.

BLOW UP

 Technical slang for photographic enlargement.

BODY TYPE

 Usually type smaller than 14 points, used for large areas of printed matter. Also called text or book type.

BOLDFACE

 A heavy-face type, usually associated with display typefaces.

BOND PAPER

 A hard-surfaced, substantial antique paper popular for business stationery.

BROADSIDE

 A large printed sheet folded so that, when it is opened, it reads as one large single poster or ad.

BROCHURE

 A pamphlet or booklet stapled in book form.

BUILT-UP-LETTER

 Refers to hand lettering when the outline of the letter is made in brush or pen and then filled in. This is in contrast to the one-stroke technique where the thickness of the stroke is produced by one movement of the lettering tool.

BULLET

 Solid ball-shape type cast used as ornamental device in typographic layouts. Bullets come in various sizes and are classified by point size.

B/W

 Short for black and white (as contrasted to color.)

CALLIGRAPHY

 The art of fine handwriting with brush or pen applied to lettering.

CAP LINE

 Imaginary line which aligns the top of capital letters.

CAPS

 Abbreviation for capital letters. Also called upper case.

CAPTION

 Headline display letters used as focal point in a typographic layout.

CARBRO

 A photograph in full color frequently used for process color work.

CASE BOUND

 Refers to the binding of a book with a stiff cardboard cover, as against a "paper back".

CHARACTER CASTING

 Computation of number of characters in a piece of copy to determine the bulk when composed in type.

CHASE

 The rectangular metal frame in which type matter or plates are assembled in proper position.

COATED PAPER

 Generally refers to printing paper which has a hard, smooth surface coating which provides a good printing-surface.

COLOPHON

 A trademark or logotype design usually associated with a publishing firm.

COMBINATION PLATE

 A halftone and line work combined in one plate.

COMP

 Short for comprehensive *or semi-finished layout in black and white or color.*

COMPOSING ROOM

Refers either to a particular room or commercial firm devoted especially to setting type. It does not necessarily imply that the actual printing operation is performed there.

COMPOSING STICK

A narrow, oblong metal tray which is used to set up the spelled out type as it is taken out from the case, prior to placing it into the galley or chase.

CONDENSED

Narrow version of a typeface.

COPY

A general term referring to any material which will be reproduced. This includes manuscripts, art, photos, etc. In art, the term "original" is often used.

COPY FITTING

Computing the amount of space it will take to set up copy in a specific size and style of typeface.

COUNTER

When referring to the anatomy of a type it means the inside area, or space, within a letter, such as the enclosed triangular-shaped space in the A or the inside cup of the lower-case e or the space between the main strokes of the H.

CRASH FINISH

A paper finished with a surface similar to coarse linen.

CROP

To cut down in size, usually a photo or plate. "Crop marks" are indications for cutting dimensions.

CURSIVE

A species of flowing script, representing a cross between italic and handwriting.

CUT

Refers to any kind of printing plate; also to the printed impression from such a plate.

DECKLE EDGE

The untrimmed feather edge of a sheet of paper which has a "handmade" quality.

DESCENDER

Stems that extend below the main body of the letter form in lower case letters as in the g, j, p, q and y.

DISPLAY TYPE

Usually type larger than 17 points which, because of size or heavier face, is especially suited to headlines, feature copy and titles used in advertising and publishing.

DROPOUT

A halftone picture where the screen dots have been removed in the highlight areas.

DUMMY

A paste-up or pattern of a proposed piece of printing, magazine or book.

DUPLEX PAPER

A printing paper which has a different color or texture on each side.

ELECTROTYPE

A printing plate duplication of the original type matter and engravings.

EM

A piece of type metal which is used as a space bar and represents the square of the body of a particular size type. An 8 point em is 8 points high and 8 points wide. Also refers to a unit of measure which represents the square of the body of any type size.

EN

Half an em, or half the square of a letter.

EXPANDED

An extended version of a typeface.

FACE

The actual printing surface of a piece of type. Also the particular character or design of a font of type.

FAT LETTER

Letter with heavy stems, usually bold faced and appropriate for display.

FELT SIDE

The good side of the paper for printing. Paper has a right side and a wrong side.

FILLET

When referring to the anatomy of a type, fillet means the wedge-shaped brackets which smoothly join the serif to either side of the vertical stem or other major element of the letter form.

FLOWERS

Name given to various stock type-cast ornaments, such as the star, leaf, acorn, bullet, etc.

FLUSH

Boxed-in positions of type, without indentions. Also referred to as "no indent". Another name for "line up".

FLUSH PARAGRAPH

A beginning of a paragraph that starts flush with the left margin, having no indention.

FLY LEAF

The blank page in front and back of a book.

FOLIO

Another name for page number.

FONT

A complete alphabet of any one type in a given point size. Upper case, lower case, numerals, punctuation marks, etc.

FORM

One or more pages locked up as a unit ready for press or electrotyping.

FOUNDRY TYPE

Individual metal letterpress type manufactured by type foundries. This is in contrast to on-the-premises-produced type such as Monotype, Ludlow, or Linotype.

FRENCH FOLD

A sheet folded four ways like a handkerchief, producing four double sides, used extensively in the printing of greeting cards.

FRONTISPIECE

An illustrated page facing the title page of a book.

FURNITURE

Measured-off pieces of wood or metal, below type-high, used for filling in blank spaces between the set-up type in the chase.

GALLEY

A shallow tray or pan used to hold type matter. Type matter is generally proved in the galley as a preliminary check on spacing, spelling, etc. before it is locked up in the chase.

GALLEY PROOF

A preliminary proof, made on a proof press, of type matter in the galley before it has been made up into pages.

GANG UP

This is an economy measure to cut down the number of impressions by "ganging up" multiple duplicates of one plate and running them simultaneously on a larger sheet which will be cut to size after printing.

GLOSSIES

Short for glossy photographs.

GOTHIC

A loosely defined term referring to a black letter such as Old English, Cloister Black, as well as to any serif-less letter.

GRIPPER

Metal prongs that hold the paper as it receives the print in register. Gripper marks refer to the sides of the sheets which were fed into guides for registering the print.

GUTTER

Edge of a page nearest the binding.

HABERULE

A copy-casting system charted by style and point sizes, developed by the Haberule Company of Wilton, Conn.

HAIRLINE

The thin element of a letter form. Also refers to a fine type-high rule.

HALFTONE

A photo-engraving plate used to print photographic copy in a dot texture representing graduated tones in the copy or art.

HIGHLIGHT

The lightest or whitest part in a picture, usually devoid of tone or dots.

HOT PRESS

A method of stamping black or colored metallic leaf by means of heated type which presses the leaf into a printing surface. Hot press printing can be done on any flat surface such as paper, acetate, leather, etc.

HOUSE ORGAN

A private publication issued periodically by a firm.

IMPOSITION

Printing form locked up in position in a chase, ready for printing or electrotyping. The proper placing of page forms so that, after printing and folding, the pages will appear in the proper sequence.

INDENTIONS

White spaces at the beginning of a printed line, such as paragraph indention. This is measured in terms of ems.

INTAGLIO

A printing plate in which the image to be reproduced is below the surface of the plate. Gravure, etchings and engravings are examples.

INTERTYPE

A company name for a type setting machine, similar to Linotype.

ITALIC

Lettering or type design which leans to the right at a fixed angle, as contrasted to Roman which stands perpendicular to the base.

JUSTIFICATION

Spacing out lines of type so that lines are of equal measure or length.

KERN

The ball-shaped or swash terminal of a letter face which extends beyond the main body of the type metal.

LEADERS

In composition, dashes or dots used to direct the eye across a page, usually used in tabular work, tables of contents, etc.

LEADING

Metal strips below the printing surface which are usually used to separate lines of type; they are measured by point size.

LEGEND

Caption describing a photograph or illustration.

LETTERPRESS PRINTING

Printing from a plate of type whose ink-taking surface is raised above the level of the ground of the plate.

LETTER SPACED

Extra spaces inserted between letters of a word as compared to "solid" spacing.

LIGATURE

A combination of two or more letters cast on one body. Examples: æ, ff, fi.

LINE GAUGE

A measuring rule graduated by picas and half picas, or other markings, used in copy fitting.

LINOTYPE

A type-setting machine which casts a complete line of type as one slug.

LOBE

When referring to the anatomy of a letter form, it means the curved stress of round elements of a letter form.

LOGOTYPE

Refers to the name of a product or a company, usually in a special, unique design used for identification. Short form is called "logo".

LOWER CASE

The uncapitalized letters of the alphabet abbreviated as l.c. Also sometimes referred to as minuscule letters.

LUDLOW

Trade name for a special type of slug-casting machine in which matrices are hand set. Usually employed for the larger display faces.

MACHINE COMPOSITION

Type composition by machines such as Linotype, Monotype, etc. as compared to hand composition.

MAKE-READY

In letter press, the building or packing up of certain parts of the press form so that heavy and light areas print with uniformity.

MASTHEAD

The unique design, logotype or distinctive style of type used as a permanent identification of a newspaper or magazine.

MATRIX

A mould in which type characters are cast in linecasting machines and foundry type. In stereotyping, matrix refers to the paper mold made from a type or plate.

MAXIMUM STRESS

The heaviest rounded part of a letter.

MEASURE

Width or depth of type matter, usually expressed in picas.

MECHANICAL

Complete paste-up of all elements in a layout, squared up, touched up, and ready for camera.

MINUSCULE

Archaic term meaning small letters; a lower case.

MONOTYPE

A type-casting machine that sets the individual-type, as opposed to linotype which casts type in linear slugs.

MORTISE

A cut-away part of a printing plate to admit the dovetail insertion of other printing matter.

MUT

Or "mutton", slang for an em quad, used in spacing.

NEGS

Short term for negatives. *A photographic image on film or paper which reverses the black and white values of the original. What is white on the original is black in the reproduction, what is black on the original becomes white in the reproduction. (See Positive).*

NONPAREIL

Originally a name given to a 6-point type. Today it refers to six points (½ pica).

NUT

Slang for an en quad or half an em.

OCTAVO

A form made up to print 16 pages, so arranged, that upon folding, each page is in consecutive order. Each leaf is ⅛ of a page.

O. F.

Abbreviation for Old Face. Refers to a typeface such as Caslon Old Face, which is characterized by inclined bracketed serifs with little definition between thick and thin.

OFF ITS FEET

When a metal type is so poorly locked up or damaged that it is off balance and results in a print only part of which receives ink or touches the paper.

OFFSET

Lithography or other planographic process which pre-prints an image in reverse on a "blanket" which comes in contact with the paper, the image having corrected itself. It is actually a print from a wet print, in the manner of a blotto.

OLDSTYLE FIGURES

Arabic numerals, though of a specific size, are so designed that they vary in height, and when grouped together, the various digits seem to jump up and down above and below the horizontal field. They are ornamental and quaint, often used as book folios, but not too practical for tabular work.

O. S.

When referring to typefaces, it means the "Old Style" series of such faces as Caslon, Garamond, etc.

PAGINATION

Numbering the pages of a book.

PARENS

Short for parentheses. The left side of the set is referred to as "open paren", the right side of the set is "close paren".

PICA

A standard unit of measure equaling 12 points or approximately one sixth of an inch. Lines of type are usually measured in picas rather than in inches.

PHOTOCOMPOSING

Casting type by means of instantaneous photography, activated by a punched paper system which has been previously prepared in the manner of a monotype machine. The printed copy can be made directly on acetate which is ready for photo offset without any intervening steps.

POINT

A unit of measure which equals .013836 of an inch, or approximately 1/72nd of an inch. It is the standard unit of measure to identify the size of all typefaces.

POINT OF MAXIMUM STRESS

The heaviest part of a curved letter. Also called the "accent".

POSITIVE

A photographic image which retains the black and white relationship of the original copy, as counter-distinguished from a negative, which reverses the relationship.

PROGS

Short for progressive proofs. A printer's proof of each color in sequence, in a multicolor job.

QUAD

Below-type-high metal blank used to space out lines of type.

RAGGING

Irregular margining.

REAM

According to varieties of paper stock, a quantity or package of 480, 500, 516 or 520 sheets of paper.

RECTO

The right-hand page of an opened book. The left-hand page is called verso.

REGISTER

Printing of several colors in a fixed relationship of alignment with each other.

REGISTER MARKS

Hairline cross marks placed at four or more positions in margins outside the printing area, to check the alignment of successive colors in a multicolor printing job.

REPRO PROOFS

Hand-pulled proofs on specially smooth paper to assure perfect copy for reproduction.

REVERSE PLATE

This term has two meanings: a) A plate when the image is made to appear in reverse, as if seen in a mirror. b) A plate where type or design is the part that does not print. In other words, where the image represents the unprinted part of the paper.

RIVERS

White space between words accidentally forming a "river", or blank channel, running through a number of consecutive lines of copy.

ROMAN

Type where the letter is vertical and square to the base, rather than on a slant as in italic.

RULES

In typography, the word rules refers to thin type-high metal bands which print lines of varying thickness. The finest is the hairline thickness and is called by that name. Rules come from ½ point to six points in thickness and can be combined. Also available in multiple rules of varying thickness running parallel.

RUNAROUND

Fitting type around an illustration, decorative initial or irregular shaped design.

RUN IN

To set type without paragraphs.

RUNNING HEAD

The line of copy (usually the title or chapter) which appears on top of a page of a book or advertisement.

SADDLE STITCH

The method of binding sheets of a publication by sewing wiring through the center of the fold.

SANS SERIF

Type of lettering without a serif or finishing terminals.

SCRIPT

Type of lettering based on handwriting usually without links, like Kaufmann Script.

SERIF

The finishing-off stroke of a letter.

SET SOLID

When referring to lines of type it means that there will be no extra space inserted between lines. When referring to spacing of letters it means that one piece of type touches the other and there are no additional space slugs inserted to arbitrarily separate one letter from another.

SHORT RANGING FIGURES

Numerals of one font which are all the same size, as counterdistinguished from "old style" figures which range above and below a set height.

SHOULDER

The non-printing area surrounding a typeface below and parallel to the face of the character. The platform on the piece of type metal on which the raised printing surface is mounted.

SIGNATURE

Segments or multiples of page sheets in sets of 4, 8, 16, 32, 64, etc., bound in units in the book.

SLUGS

Leads of 6 points or more in thickness used as separators between lines of type. Also refers to the bar connecting the letters in Linotype and Ludlow.

SMALL CAPS

(s.c.) Capitals of a size smaller than the regular capitals of a given font of type.

SOLID MATTER

Type lines set without leading between lines.

SORTS

Individual letters of a font, rather than a complete font.

SPECS

Short for specifications.

SPLIT FOUNTAIN

A method of printing one or more widely separated colors at the same time.

SQUARE HALFTONE

Halftone plate with four straight edges.

S.S.

Abbreviation for same size; a notation relating to reproduction size of art copy to be photographed.

STET

A proofreader's mark meaning "let it stand". This designates that on original notation of a correction is to be disregarded.

STOCK

Generally refers to paper on which the printing is done, but the term also includes cardboard, acetate or any other material on which printing is to be done.

STRAIGHT MATTER

Copy, all of the same size and style of letter, set up as a block or grouping.

SWASH LETTERS

Ornamental variations of a typeface, in caps, used chiefly for initials or the beginning of a word.

THUMBNAIL

A sketch in miniature, serving as a preliminary for the more finished rough called comp.

TITLING

A face which is cut only in capital letters and cast "full face" on the body.

TYPE HIGH

0.918 of an inch. The standard for letterpress printing.

TYPE INDICATION

A hand-rendered "preview" or visual of the finished type done in pencil, paint or other media, which simulates the typeface so the type is identifiable by name, size and tonal effect.

UNCIALS

Archaic rounded letters from which evolved lower-case letters.

UPPER CASE

(U.C.) Capital letters.

VIGNETTE

A halftone with a background gradually fading away and blending into the surface of the paper. This is in counterdistinction to silhouette, where the figure is sharply defined against the paper.

WIDOW

A single word left at the end of a paragraph or page which runs over from a block of copy. An isolated "left over" word, especially at the top of a page, is considered typographically undesirable.

WORD SPACING

A unit of measure to designate a specific space between words.

X HEIGHT

The height of lower case letters excluding the ascenders and descenders. The height of the lower case as measured by the letter x.

STANDARD PROOFREADERS' MARKS

Marks	Explanation	Marks	Errors Marked
ℐ	Take out letter, letters, or words indicated.	ℐ	He marked the prooof.
#	Insert space where Indicated.	#	He marked theproof.
ℐ	Turn inverted letter indicated.	ℐ	He maɹked the proof.
ɾ	Insert letter as indicated.	ɾ	He maked the proof.
lc	Set in lower-case type.	lc	He Marked the proof.
wf	Wrong font.	wf	He marked the proof.
×	Broken letter. Must be replaced.	×	He marked the proof.
ital	Reset in italic type the matter indicated.	ital	He marked the proof.
rom	Reset in roman (regular) type the matter indicated.	rom	He marked the proof.
bf	Reset in bold-face type word, or words, indicated.	bf	He marked the proof.
⊙	Insert period where indicated.	⊙	He marked the proof.
tr	Transpose letters or words as indicated.	tr	He the proof marked.
stet	Let it stand as it is. Disregard all marks above the dots . .	stet	He marked the proof.
/=/	Insert hyphen where indicated.	/=/	He made the proofmark.
eq. #	Equalize spacing.	eq. #	He marked the proof.
[or]	Move over to the point indicated.	[[He marked the proof.
	[if to the left; if to the right]		
⊔	Lower to the point indicated.	⊔	He marked the proof.
⊓	Raise to the point indicated.	⊓	He marked the proof.
⌃	Insert comma where indicated.	⌃	Yes he marked the proof.
⌄	Insert apostrophe where indicated.	⌄	He marked the boys proof.
⁶⁶ ⁹⁹	Enclose in quotation marks as indicated.	⁶⁶ ⁹⁹	He marked it proof.
H̲	Replace with a capital the letter or letters indicated.	H̲	he marked the proof.
sc	Use small capitals instead of the type now used.	sc	He marked the proof.
⊥	Push down space which is showing up.	⊥	He marked the proof.
⌒	Draw the word together.	⌒	He ma rked the proof.
⌄₂	Insert inferior figure where indicated.	⌄₂	Sulphuric Acid is HSO_4.
⌃²	Insert superior figure where indicated.	⌃²	$a^2 + b^2 = c$.
Out, see copy	Used when words left out are to be set from copy and inserted as indicated.	Out, see copy	He proof.
a͡e	The diphthong is to be used.	a͡e	Caesar marked the proof.
fi	The ligature of these two letters is to be used.	fi	He filed the proof.
spell out	Spell out all words marked with a circle.	spell out	He marked the (2d) proof.
¶	Start a new paragraph as indicated.	¶	reading. The reader marked
no ¶	Should not be a separate paragraph. Run in.	no ¶	marked. The proof was read by
(?)	Query to author. Encircled in red.	(was ?)	The proof read by
?	This is the symbol used when a question? is to be set. Note that a query to author is encircled in red.	?	Who marked the proof.
=	Out of alignment. Straighten.	=	He marked the proof.
/1 em/	1-em dash.	/1 em/	He marked the proof.
/2 em/	2-em dash.	/2 em/	He marked the proof.
/1 n/	En dash.	/1 n/	He marked the proof.
□	Indent 1 em.	□	He marked the proof.
⊓⊓	Indent 2 ems.	⊓⊓	He marked the proof.

Courtesy of Intertype, Brooklyn, N. Y.

TYPE IDENTIFICATION AID

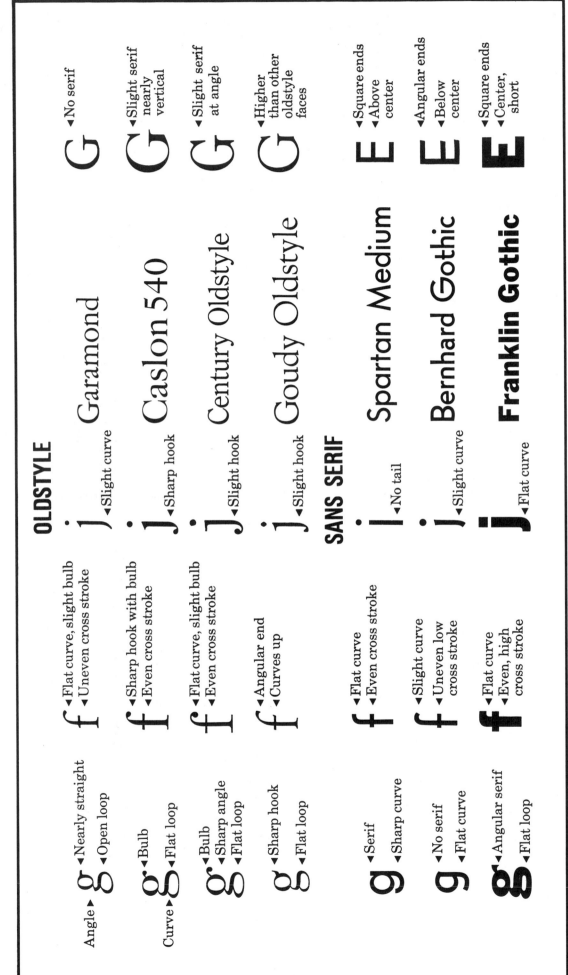

OLDSTYLE

Garamond
- G — No serif
- j — Slight curve
- f — Flat curve, slight bulb / Uneven cross stroke
- Angle ▸ g — Nearly straight / Open loop

Caslon 540
- G — Slight serif, nearly vertical
- j — Sharp hook
- f — Sharp hook with bulb / Even cross stroke
- Curve ▸ g — Bulb / Flat loop

Century Oldstyle
- G — Slight serif at angle
- j — Slight hook
- f — Flat curve, slight bulb / Even cross stroke
- g — Bulb / Sharp angle / Flat loop

Goudy Oldstyle
- G — Higher than other oldstyle faces
- j — Slight hook
- f — Angular end / Curves up
- g — Sharp hook / Flat loop

SANS SERIF

Spartan Medium
- E — Square ends / Above center
- i — No tail
- f — Flat curve / Even cross stroke
- g — Serif / Sharp curve

Bernhard Gothic
- E — Angular ends / Below center
- j — Slight curve
- f — Slight curve / Uneven low cross stroke
- g — No serif / Flat curve

Franklin Gothic
- E — Square ends / Center, short
- j — Flat curve
- f — Flat curve / Even, high cross stroke
- g — Angular serif / Flat loop

Oldstyle
- De Roos Roman and Italic
- Garamond and Italic
- Caslon 540 and Italic
- Goudy Oldstyle and Italic
- Century Oldstyle and Italic

SANS SERIF
- Bernhard Gothic and Italic
- Spartan and Italic
- Lydian and Italic
- **Franklin Gothic and Italic**

SQUARE SERIF
- Stymie Bold and Italic

MODERN
- Bodoni and Italic
- Craw Modern and **Bold**
- Bernhard Modern Roman and Italic

TEXT
- Wedding Text
- Engravers Old English
- Cloister Black

SCRIPT
- Repro Script
- Murray Hill
- Brush
- Bank Script

CURSIVE
- Lydian Cursive

DIVERSE FACES
- Dom Casual
- P. T. Barnum
- Huxley Vertical
- Verona
- Empire
- Onyx

Courtesy of American Type Founders, Elizabeth, N.J.

Personal Directory of Dealers and Sources of Supply

Type of Service	Name of Firm	Address	Phone	Person to ask for